ANARCHIST'S GUIDE TO
HISTORIC HOUSE MUSEUMS

◇◇◇◇◇◇◇◇◇◇◇◇◇◇◇◇◇◇◇◇◇◇◇◇◇◇◇

ANARCHIST'S GUIDE TO HISTORIC HOUSE MUSEUMS

FRANKLIN D. VAGNONE
AND DEBORAH E. RYAN

WITH ASSISTANCE FROM
OLIVIA B. COTHREN

Routledge
Taylor & Francis Group

LONDON AND NEW YORK

First published 2016 by Left Coast Press, Inc.

Published 2016 by Routledge
2 Park Square, Milton Park, Abingdon, Oxon OX14 4RN
711 Third Avenue, New York, NY 10017, USA

Routledge is an imprint of the Taylor & Francis Group, an informa business

Library of Congress Cataloging-in-Publication Data

Vagnone, Franklin D., 1965– author.
 Anarchist's guide to historic house museums / Franklin D. Vagnone and Deborah E. Ryan; with assistance from Olivia B. Cothren.
 pages cm
 Includes bibliographical references and index.
 ISBN 978-1-62958-170-5 (hardback : alk. paper)—ISBN 978-1-62958-171-2 (pbk. : alk. paper)—ISBN 978-1-62958-172-9 (institutional eBook)—ISBN 978-1-62958-173-6 (consumer eBook)
 1. Historic house museums—United States—Management. 2. Historic sites—Interpretive programs—United States. I. Ryan, Deborah E., 1958- author. II. Cothren, Olivia B. III. Title.
 E159.V34 2015
 907.40973—dc23
 2015027304

ISBN 978-1-62958-170-5 hardback
ISBN 978-1-62958-171-2 paperback

CONTENTS

FOREWORD .. 11
by Gretchen Sullivan Sorin

PREFACE ... 15
The Gift of Frustration 15
Franklin's Story 17
Deborah's Story 21
Anarchist's Guide to Historic House Museums 25
Our Special Thanks 27

INTRODUCTION .. 33
Why "Anarchist"? 38
What's the Problem? 40
The Critique 40
How to Use the *Anarchist's Guide* 41
The *Anarchist Chart* 45

CHAPTER 1. COMMUNITY MARKINGS 47
Acknowledge a Disconnect 47
Refocus Your Mission 50
Walk around the Block 54
Engage the Uninterested 59
Leave the House to Find Potential Partners 63
Transposition 67

CHAPTER 2. COMMUNICATION MARKINGS 71
Communicate Diversify 71
Get Chatty 77
Listen and Dialogue 81
Keep It Real 84
Avoid the Bait and Switch 88
N.U.D.E. Docent Communication 92
The Narcissism of Details 97

CHAPTER 3. EXPERIENCE MARKINGS ...101

Overlap 101
Share Short Stories 105
Embrace Rumor, Gossip, and Conjecture 108
Learn by Doing 112
Let Them Dance 115
Allow Access to Denied Spaces 120
Engage All the Senses 124

CHAPTER 4. COLLECTIONS/ENVIRONMENT MARKINGS 129

Transcend the Object 129
Expose Domestic Complexities 134
Expand the Guest List 138
Follow the Sun 142
Fingerprinting 146
Contemporary Interpretations 149

CHAPTER 5. SHELTER MARKINGS ... 155

Keep Perspective and Buy Duct Tape 155
Show Your Age 158
Pull Back the Curtain 162
Mind the Gap 167
Dig Deeper than the Dollhouse 171
Question the Period of Interpretation 175

APPENDIX A: ANARCHIST CHART AND EVALUATION QUESTIONS 181

APPENDIX B: RESEARCH TOOLS ..199

University Research Partnerships 200
One-Minute Video Mapping 202
Habitation and Museum Movement Studies 205
Distinct Activities Study 207
Imagination, Excitement and Energy Graph 210
Sound Mapping 214
Anarchist Tags 215
House Museum Workshops 218
Social Media Communication 221
Mobile Kiosks 223

NOTES ... 227

INDEX .. 247

ABOUT THE AUTHORS ... 261

List of Illustrations

Figure 0.1: Shaming by an HHM guide provided a catalyst for *Anarchist's Guide* concepts. 17

Figure 0.2: "Why do Historic House Museums SUCK?!" notebook entry marking the beginning of the *Anarchist's Guide*. 18

Figures 0.3 & 0.4: This is what is left after a house is demolished. 21

Figure 0.5: Building a house involves more than just money, materials and labor. 22

Figure Intro.1: *Anarchist Guide* diagram illustrating innovative and measurable methodologies. 42

Figure 1.1: *Anarchist Tag* suggests the disconnect felt by an HHM guest. 49

Figure 1.2: Neighborhood indifference towards this HHM may have led to its vandalism. 52

Figure 1.3: Sidewalk Activity Study for HHMs in Philadelphia shows missed opportunities. 56

Figure 1.4: Engaging the heretofore uninterested *Reverse Affinity Groups*. 60

Figure 1.5: Partnerships that extend beyond the historic site have great potential for engagement. 65

Figures 2.1–2.4: Contemporary relevance can be created through photographic re-enactment. 74–75

Figure 2.5: HHMs should use social media to have informal, friendly conversations with the public and to attract guests. 79

Figure 2.6: *Anarchist Tag*: "Scary! Costumes taken too seriously: creep me out." 87

Figure 2.7: *Anarchist Tags* can be a useful tool in understanding visitors' perspectives. 94

Figure 2.8: Morris Jumel Mansion floor plan showing the dropped placement of *Anarchist Tags*. 96

Figure 2.9: An unusual text label can provide idiosyncratic humanity. 98

Figure 3.1: Fred Wilson's Liberty/Liberté at New York Historical Society. 103

Figure 3.2: When reconsidering the guest experience, include tactile and immersive encounters. 114

Figure 3.3: Guests' paths through HHMs are often limited to hallways because barriers block off their entry into rooms. 118

Figure 3.4: A guest's path during an *Anarchist Workshop* shows active engagement in the House. 119

Figure 3.5: *Workshop* participants enjoy investigating out-of-the-way spots in HHMs. 123

Figure 3.6: Enjoying a welcoming tea served in period dishware by the docent at the Matilda Joslyn Gage House. 127

Figures 4.1 & 4.2: The power of a unified whole was evident at the Birmingham home of outsider artist Minter. 132

Figures 4.3 & 4.4: Layering of artifacts communicates everyday habitation, a message lost in many heavily curated HHMs. 135

Figure 4.5: Illustrating daily, yearly and life cycles adds to the interpretation of HHMs. 144

Figures 4.6 & 4.7: *Fingerprinting* encourages HHM guests to have a personal connection with a House. 148

Figure 4.8: Integrating contemporary interpretations in an HHM can be subtle, yet meaningful. 152

Figure 4.9: HHM's architecture and collections can easily incorporate new interpretive concepts. 153

Figure 4.10: Engaging HHM guests in unexpected ways can heighten their experience. 154

Figures 5.1 & 5.2: Hendrick Lott House incorporates multiple eras to illustrate the entirety of its habitation. 160

Figure 5.3: The process of preservation can be as compelling as the HHM's narrative. 164

Figure 5.4: An illustration showing the surprising juxtaposition of the original, conjectural and replaced components of an HHM restoration. 166

Figure 5.5: The changing neighborhoods around HHMs are usually edited out of their official photographs, exemplifying how Houses often ignore their context. 170

Figure 5.6: The value of a measured application of preservation is evident in the 1768 Hyde Hall when the process of restoration is made visible. 172

Figure 5.7: Visitors' experiences in HHMs are often voyeuristic. 173

Figure 5.8: It is difficult to simplify the interpretation of The Watts Towers site to one period, given its multiple periods of importance. 177

Figure A.1: *Anarchist Guide to Historic House Museum Evaluation Matrix.* 182

Figure B.1: UNCC architecture students explored the value of an immersive, overnight experience at Historic Richmond Town. 200

Figures B.2 & B.3: *One-Minute Video Mapping* captures the minutiae of everyday habitation. 203

Figure B.4: A study of a person's movement through his or her home in the first two hours after awakening shows repetitive switchbacks between rooms. 206

Figure B.5: A *Distinct Activities Study* shows the location, varying duration and repetitive complexity of domestic habitation. 209

Figure B.6: An *Imagination, Excitement, and Energy Graph* suggests how docents, movement, artifacts, location, and activity affect guests' experiences. 212–213

Figure B.7: *Anarchist Tag* from a hands-on *Anarchist Workshop* at the Mabry-Hazen House. 218

Figure B.8: The unexpected sound of a piano being played enlivened an *Anarchist Workshop.* 219

Figure B.9: *Anarchist Workshop,* participants are often surprised to see HHMs not as stage sets defined by curatorial furnishings plans, but as places of habitation. 220

Figure B.10: *Mobile Kiosks* provide an opportunity for conversation with community members outside of the HHM. 225

FOREWORD

An August 2014 article in the *Boston Globe* brought the public into what the writer called "The Great Historic House Museum Debate." The article noted that "since the millennium, the museum field has been engaged in a discussion, bubbling up among preservationists, museum professionals, and in scholarly journals, that has now reached a fever pitch, concerning the "sleepiest corner of the museum world"—the historic house museum. The debate was over the proliferation of historic house museums and concerns about their viability for the future.

On one side of this debate are those who believe that there are just too many historic house museums and a new paradigm is needed to insure their survival. On the other side are the traditionalists who see historic house museums as an important source of local history; for them, the death of even one of these treasures would be a significant loss to our cultural heritage.

Of course, this is not an issue that started with the new millennium. For the last 30 years we have seen the beginnings of cracks along the edges of the historic house museum business. Many of these institutions, because of long-deferred maintenance, decreased visitation, aging boards, and stagnant period rooms, started to circle the drain long before 2000.

There are many reasons for this.

The bicentennial sparked an admirable excitement for local history and hundreds of private homes—usually a community's largest house, the one belonging to the richest man in town, or the house or tavern that could be linked to a famous figure (George Washington slept here)—were saved with plenty of fanfare and enthusiasm, but few plans about how, as a new museum, the building could become financially sustainable. More importantly, the salvation of these houses, often a project undertaken by a small number of enthusiastic local preservationists, did not have the continuing

support of the broader community, nor the programs and services that addressed community needs.

Saving old houses and converting them into museums did not stop with the bicentennial. Each year, dozens of historic house museums have been added. A community's first church or synagogue loses its congregation, so to preserve the building, the local folks turn it into a museum. As a town's largest mansion becomes old fashioned—too large or too difficult to heat or cool—it becomes a historic house museum in homage to the founding fathers or to save it from demolition. "Museum" is often the first idea for an historic building's life after people no longer live in it.

Dedicated preservationists often created (and continue to create) historic house museums without asking all of the necessary questions. They looked inward, asking: What can we do to preserve this building? How can we keep this historic structure from being torn down? How do we preserve a history that we love? But often the questions about the intersection between community needs and the history of the building go unasked: For whom shall we preserve this historic house and how will it serve the local community? Why should members of the community care about this house and how can it serve a vital role to its public?

Museums, including historic house museums, must look outward, considering the museum's constituents as important as its collections. Paraphrasing the great museum philosopher Stephen Weil, museums are being transformed from being about something to being for somebody.

With the shift in the nation's demographics and a growing interest in a more inclusive history, the houses and property related to various groups, disenfranchised in the past yet proud of their heritage, have sprung up to add their stories to the national narrative. The Lower East Side Tenement Museum, Martin Luther King's House, Ganondagan (an Iroquois community in Western New York), the Marion Anderson House, and Hull House are notable examples. There are now two recently established historic house museums dedicated to John Coltrane within a couple hundred miles of each other—one in Huntington, Long Island, and one in Philadelphia. And the number of historic house museums just continues to grow. How will more and more historic house museums become sustainable?

Those of us who preserve the past tend to be change resistant, another reason the historic house museum paradigm has remained unaltered. We like things as they were. We love history and objects, and we love historic house museums just as they are. But our visitors are not standing still. Visitors are looking for entertaining experiences, interactive learning, and

opportunities for active participation with other people. The traditional passive operational model for historic houses—guided tours, rooms in frozen tableaus, wooden or velvet barriers that allow visitors to step into, but not really experience, interior spaces—may have worked for some visitors in the past and may work for some visitors now, but with notable exceptions, this model is not sufficiently engaging to sustain these institutions.

The most innovative managers of historic house museums have been experimenting with different approaches to bringing visitors to their doors since the 1970s.

At first they tried greater authenticity. Meticulously researched furnishing plans recreated interiors that more closely approximated the "real" appearance of the period, or at least our best guess about how it may have looked. Adding objects of use—from gout stools to pen wipes and chamber pots, or perhaps a corset laid across an unmade bed—added human presence to sterile arrangements of furniture. Some sites added community gardens or farmers' markets in keeping with their original missions to raise food for the family. Others acknowledged the slaves and servants that made the elegant life of the household possible or added well researched theatrical programs, surround-sound conversations, or wine and food programs to the mix. While some of these experiments do not sound at all innovative, they are a part of a gradual evolution toward a more audience-focused approach.

Museums cannot remain stagnant as visitors, technologies, interests, and the world around us change. In a national survey about history in 1998, historians Roy Rosenzweig and David Thelen discovered that most Americans think the way that history is portrayed in schools is boring but that they nonetheless enjoy thinking about and learning about "the past"— looking at family pictures, hearing first-hand reports from someone who was there, doing their own genealogical research, and viewing films and movies. The public actually enjoys learning about the past—good news for museum professionals! But what excites most people about history involves active engagement rather than passive looking and listening to a forty-five minute lecture-tour.[1]

What will effectively develop new audiences for historic house museums? How must historic house museums expand their missions to meet the needs of their constituents? Certainly there will be multiple answers to these questions, depending on such variables as community demographics and interest, community needs, location, the nature and size of the surrounding property, the nature of the house itself, and the history and

importance of its collection. What is clear is that we need more research and much more experimentation.

Into this dilemma comes *Anarchist's Guide to Historic House Museums*. If you are a traditionalist, you might think that Vagnone and Ryan are heretics, blasphemers or, at the very least, bomb throwers. You may be right. Many of the ideas in this book go against the standard rules of museum practice. But this is, for many historic house museums, a time of crisis, and crises require bold action and creative thinking. The *Anarchist's Guide* encourages us to think differently, to challenge conventional procedures, to put visitors first, to take risks. The authors approach the problem from many directions. You may not agree with all of their conclusions. I certainly found recommendations with which I could not agree. But the creativity in this volume is refreshing, bringing to the conversation some of the only new ideas that have surfaced in some time. Vagnone and Ryan have jump started the conversation. If historic house museums are to thrive and become more meaningful to modern visitors, it is now up to all of us to continue the discussion.

> Gretchen Sullivan Sorin
> Director/Distinguished Professor,
> Museum Studies, The Cooperstown Graduate Program

PREFACE

The Gift of Frustration

Laughter and tears are both responses to frustration and exhaustion.
I myself prefer to laugh, since there is less cleaning up to do afterward.

Kurt Vonnegut

If you are anything like us, your interest in history and cultural experiences has led you to visit a good many Historic House Museums (HHMs) and historic sites. While some visits turn out to be wonderfully memorable experiences, others fall surprisingly short of expectations, ranging from simply lackluster, uninspiring, and forgettable to frustratingly disappointing.

Frustration is the operative word here, because many of us Historic House nerds know intuitively, on some level, that every site we visit for the first time must have something new and exciting to offer, even if we do not know exactly what it will be. While it is true that we do not all go to HHMs for the same reasons, we probably all share in the hope for some degree of enjoyment, as well as a pleasant surprise. Full of anticipation, we open that gift box full of potential and possibilities, only to discover a pair of socks similar to the ones we were given last year, the same old blasé attitudes, a predictable and controlled House tour walkthrough, and maybe a half-decent gift shop at the end of the line.

Have you ever felt unwelcome at an HHM, like an unexpected, last minute guest at the table? When we have that experience, we seldom return.

Like us, some of you may have worked professionally in historic preservation and related fields, and as members of the HHM tribe, are sometimes given special attention and granted broader access when visiting a new site. In and of itself, this premium experience can greatly enhance and personalize the visit, especially when it includes opportunities like a private tour, after-hours access, behind-the-scenes considerations, or a peek into the attic or other off-limits areas. Though more often than not, we visit HHMs as members of the general public and experience the House Museum as any other visitor would. An HHM does not necessarily have to give us special access for us to feel welcomed. But for some Houses, we get the impression that they are doing us a service by simply allowing us to visit in the first place. Perhaps it takes too much effort to make guests feel welcome; besides, making too much fuss over the visitor experience may be overly intimate for them. Right? No? Hmmm... feeling frustrated yet? We are.

Many HHM visitor experiences would benefit from a far greater degree of intimacy and humanity. This critique is just one of several calls to action we make in this book. Historic Houses need to drop their reserve and allow for more chemistry between museums and visitors so a mutual bond can form, making for a much more enjoyable time together. Otherwise, a first meeting can be like the proverbial bad date, listless and un-engaging, with awkward, stilted conversation and an urge to leave early.

Through the years, we have collected both good and bad House Museum experiences. The ones that frustrate us the most, and which we will expound upon in the coming chapters, have been the real motivators for us in writing about the need for change and reimagining the status quo. This frustration has been a gift in the making because it was the genesis for the *Anarchist's Guide*.

The book represents the coalescing of a swirl of observations into a series of insights that we feel are worth sharing. *Anarchist's Guide* is equal parts manifesto, guidebook, and laboratory of ideas. Keep in mind, this is a work in progress, and is still in its initial phases, so please bear with us. Let us make our case. We will tell you who we are, why we care, and how you can join with us to help grow and expand the next edition of *Anarchist's Guide to Historic House Museums*.

Franklin Vagnone is a Historic House Museum anarchist.

Deborah Ryan is a Historic House Museum anarchist.

Franklin's Story

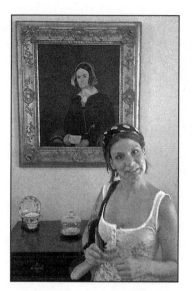

Figure 0.1: While touring a Historic House Museum, Vagnone and his daughter Claire took an unauthorized photo using a smartphone. For the rest of the tour, they were shamed and made to walk up in the front of the group with the docent. This experience became the catalyst for the initial *Anarchist Guide* concepts. *Photo: Franklin Vagnone.*

The ideas for the *Anarchist's Guide to Historic House Museums* grew from one of those aforementioned visits, when my then 18-year-old daughter Claire and I were road-tripping on the Delmarva Peninsula one blisteringly hot summer day. We stopped at an HHM, and as is often the case, began a house tour in the stair hall with an orientation lecture, after which we were instructed to move single-file, much like a chain gang, into the adjacent front parlor. There, the docent provided unnecessarily detailed information on each and every piece of furniture, followed by an overview of the entire family genealogy. Claire and I were perspiring, and began shifting our weight from one foot to the other in an effort to remain composed and avoid passing out from the oppressive heat. After 45 minutes of an endless array of mind-numbing facts, the docent allowed us to proceed to the following room. As we exited the parlor, there was a rather unflattering portrait of the patriarch's wife. Claire momentarily lost control of her inner silliness, and aped the wife's expression, while I snapped an illegal cell phone picture of her. The docent immediately spotted our infraction and openly scolded us, while the other attendees surreptitiously gave us a fair number of smiles,

eye-rolls, winks, and knowing glances that resulted in a shared experience and a momentary feeling of humanity. The docent pulled us to the front of the group and made us follow closely behind her for the remainder of the tour. After reeling us in, she picked up from the script where she had left off and continued her endless barrage of fact-laden statements, arranged in perfect chronological order. One room blended into the next as we encountered that Historic House sameness where stringent levels of preservation efforts denude a place of much of its character. I have experienced this purist model of preservation in other HHMs as well, and sometimes pondered whether it is worth the effort when it results in such striking homogeneity. The docent kept an eagle eye on us for the remainder of the tour, making sure that neither Claire nor I stood too close to any of the collection items, or partook in such cardinal sins as levity and digital photography.

Clearly, my daughter and I had forgotten the unwritten and unquestioned code of conduct for Historic House Museums:

> Be still. Be silent. Listen and learn. Be respectful of the important people who once lived here. They were important, proper people and more important than you. So act accordingly.

But why?

On the ride back from the HHM, Claire drove while I furiously scribbled in my journal, "Why Do Historic House Museums Suck?" I began to wonder in earnest why visiting HHMs often seems so ponderous and boring, especially to those of us who love learning about history through them, and why visitors are expected to act in a certain way. I compiled a list of all the various and sundry frustrations I could think of and began to contemplate ways in which HHMs could address these problems. These challenges were sometimes big, but mostly it seemed like people were averse to trying something

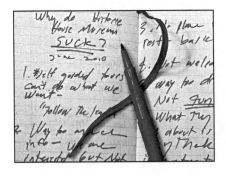

Figure 0.2: The frustration coming from a particularly disappointing vacation experience at an HHM compelled Vagnone to begin thinking seriously about "Why do Historic House Museums SUCK?!" This notebook became the basis for the *Anarchist's Guide to Historic House Museums. Photo: Franklin Vagnone.*

new. My venting that day proved valuable in many ways, and those original notes form the basis for what would become the next five years of research.

Having worked with a good number of Historic House Museums in the past, I knew that few of my thoughts were shocking revelations. But as I thought about the HHMs as a whole, a bigger picture started to emerge, where disparate, seemingly isolated problems began to appear interconnected, and the fog started to lift. The docent-shaming incident was a watershed moment for me. It illuminated the fact that in their infinite wisdom, a great many House Museums place visitor and community concerns at the bottom of the barrel. This fundamental mindset of House and history first, visitors last is truly what needs to be inverted! Visitors and, especially, the surrounding communities should take primacy. In our desire to deify museums and historic sites, we risk alienating those very people we feel should flock to appreciate us.

Many of the concepts described throughout this book find their beginnings in my own real-life experiences and outside observations, events that have expanded my consciousness in so many areas related to HHMs. My interest in the concept of habitation now includes behaviors in everyday life activities. While studying for degrees in architecture and anthropology at the University of North Carolina at Charlotte, my senior thesis included primary research through participant observation into the territoriality of homeless individuals in the city. Through this work, I realized firsthand that for these homeless men, their knapsacks and the objects they contained were their homes. The more private, quotidian moments most of us experience at home, like sleeping and personal hygiene, were lived out in the open. Consequently, the definition of habitation for me expanded beyond simply a place or space to include the much more focused concept, the intimacy of occupation.

As a graduate student studying architecture at Columbia University, I discovered a love of collections. I had my first professional foray into the field of archiving at Avery Library. Using wheat paste and rice paper, I mended beautifully drawn Greene and Greene's architectural drawings, under the direction of Janet Parks, Curator of Drawings and Archives. I remember the first time Janet unrolled the linen drawings and explained to me how one mends such artifacts. I felt like I was doing something important— something relevant. Later, at Cairnwood in Bryn Athyn, Pennsylvania, I was given a unique opportunity and responsibility to systematically collect and sort thousands of domestic artifacts. The contents of the archive were primarily culled from months of looking through every nook of this

abandoned 28-room Carrère and Hastings Beaux Arts style estate. There was such a joy of discovery being able to go through all the contents of closets and drawers in every room from the basement to the attic. I remember climbing into dark basement rooms and dragging out boxes of glass negatives. I remember the first time I entered the enormous attic space. I just stood there and paused my work. This collection was eventually named the Mildred and Raymond Pitcairn Archives. These experiences at the Avery Library and Cairnwood were fully tactile and immersive, and provided me such a profound relationship with things that the anticipation and surprise of them has stayed with me and found its way into this guide.

Later, I became the Director of the Philadelphia Society for the Preservation of Landmarks (PSPL), whose offices were located in the Old City neighborhood of downtown Philadelphia. It is from my time in Philadelphia that I grew to understand how challenging it can be to manage all the budgetary realities and constraints of Historic House Museums and still find leftover money to pay the electric bill. I was struck by the enormous chasm between what the Historic House Museum community denoted as success and what the funders and visitors thought was working. When the stewards of HHMs feel they are doing everything right, and we feel that the house is wearing a beautiful garment of success, we often fail to realize that the public and the greater community have not been brought into the fold and remain uninformed, unappreciative, and simply uninterested. I remember thinking, the emperor has no clothes!

The final step in my conversion into museum anarchy came during this same period of my life when my wife and I undertook an intense restoration of our Arts and Crafts, Colonial Revival home, and it was getting to the point of feeling just right. There was not a surface in that house that we did not scrape, sand, paint, hammer, or replace. As someone who works in the non-profit sector, I did not have a lot of money, so we completed most of the work ourselves, and with three young children running around, that was not easy. We filled the house with a collection of third-rate Arts and Crafts furniture and objects, which, with the right amount of dimmed light, looked pretty good.

Eventually we sold the house and moved on. We knew the new owners would change things, just as we had done, and make it their own. But less than one month after leaving, we were stunned to see pictures on Facebook of the house being demolished. All of our restoration work was piled into one dump heap, including the antique hardware, restored window sashes,

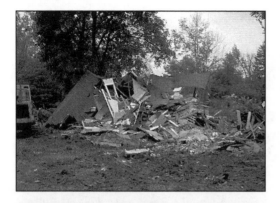

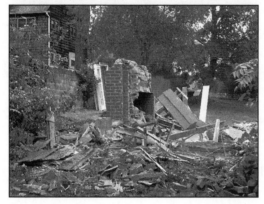

Figures 0.3 & 0.4: Following a nine-year restoration effort, the Vagnone residence in Philadelphia was sold. Less than a month later, the house was demolished to make way for a bigger, newer home. The emotional shock of seeing the house compressed into a small pile of rubble convinced Vagnone of the central element that intimacy plays in habitation, giving new meaning to John Hejduk's observation that "the death of a house is announced by the only standing struc-ture—the brick chimney." Bryn Athyn, PA., August 2009. *Photos: Franklin Vagnone.*

and stripped wainscoting. Two things surfaced in my mind while looking at the pictures. The first was that John Hedjuk was correct when he wrote, in his poem *Sentences on a House and Other Sentences II*, "The death of a house is announced by the only standing structure—the brick chimney."[1] The second thought was just how small a pile of stuff there was when a house was demolished. But after all, it's mostly empty space. The breath of a house is the living that takes place within it, not the structure or its contents.

Deborah's Story

I spent part of my childhood rummaging around a house that could have become a Historic House Museum. It was my grandparents' home in Muncy, Pennsylvania. My grandfather saved a lot of lives in the Army and

Figure 0.5: The historic home of Dr. Harold and Eleanor Baker in Muncy, PA, where Ryan briefly lived as a child. The house was partially built and maintained by her grandfather's patients in return for his medical services when they were unable to pay. *Photo: Deborah Ryan, 2000.*

as the small town's doctor, and the people of Muncy helped to build and maintain his home in appreciation. Because his patients were often unable to pay for his medical services at the time they needed them, they donated their time to work on the house once they recovered. My grandfather died when I was a baby, so I only know him through his house, and I only learned of its story once I was an adult. By then, the house had long since passed out of our family. When my mom died a few years ago, my sister Connee and I took her ashes up to Muncy to be buried alongside our grandparents. It was the first time I had seen the house in over 40 years, and I felt like I remembered everything all at once.

I was eight years old the last time I was in my grandparents' house. We stayed there for Grammy's funeral. But today, I can still vividly remember what it was like. I remember the big brown, slippery leather chairs in the library outside my grandfather's home office. I remember going through the cabinets in his office and pricking myself with a syringe (!), and then my mother's panic when I showed her my accomplishment. I remember fiddling around on, and trying to play the electric organ in the living room and playing games with my sister on the cold, brick floor of the sunroom. I remember that in the dining room there was a silver bowl of sugar cubes, because Grammy let me have one each day. It was one of our many daily rituals, like putting a coin in my locked glass piggy bank that she kept on the kitchen counter. I remember sliding into the kitchen nook watching

her cook our breakfast. I remember her tiny sewing room, and the sewing machine I was not allowed to touch. The room was beside the steps that led to the dusty attic, that seemed like a treasure trove filled with boxes that begged to be explored. I remember the jewelry box in Grammy's bedroom, and that she let me wear her necklaces as I pranced around the house feeling like a princess. I remember the cabinets in the upstairs hallway where she kept the sheets that my mom used to build a tent around my humidifier to help me breathe when I had the croup. I remember the furnace in the basement and watching Grammy shovel the shiny, smelly black coal into it. I remember all the nooks and crannies in the yard where Connee and I played hide-and-go-seek and the spooky car barn off the back alley that eventually became part of our game. I remember diving into the huge piles of raked leaves in the fall and the smell and heat from them when they were burned. I remember the white, shiny snow, the snow angels, and the snowmen we made with our mittened hands before reluctantly coming inside in our snow covered boots. And I remember that Grammy pulled the boots from our feet and left them by the door, where the milkman delivered our ice cold, glass-bottled milk.

The poetics of my experience at Grammy's far exceeded what I lived in the house and town where I spent the bulk of my childhood. I grew up in Jacksonville, North Carolina, a military town, where my father served as a career marine. My home, like most of my friends' homes, was a quickly built ranch financed with money from the GI Bill.

Like me, almost all my friends' parents were born somewhere other than Jacksonville, and few of us had grandparents nearby. We lived in a new town, an ahistorical place, where we had almost no sense of history because there were so few remnants of a time before our own births.

Since my mother was the daughter of an Army doctor and a descendent from a Revolutionary War soldier, she was a proud member of the Daughters of the American Revolution; she spent countless days of her childhood visiting the battlefields of both the Revolutionary and Civil wars. She hated the experience and vowed never to subject my sister and me to a similar fate. Yet, when it came time to vacation, she carted us up to Colonial Williamsburg because it just seemed like the right thing to do. I remember the pool at the hotel, a carriage ride, some really big cannons, putting my head and hands in the stocks, and people being dressed up in costumes. The most lasting impression, though, was that history was a place you went to, not something you lived within, much less contributed to.

That was my thinking until the early 1980s when I was a graduate student in one of Dr. John Stilgoe's classes at Harvard University. Until I met him, I had no need for history. I had no interest in the political history of great white men doing heroic deeds. But Dr. Stilgoe taught a different kind of history. He gave value to the ordinary acts of everyday people, and claimed that the remnants of their actions created a historic record worthy of mining. He invited us students to discover narratives that resonated over time and which held some sort of personal relevance.

> The whole concatenation of wild and artificial things, the natural ecosystem as modified by people over the centuries, the built environment layered over layers, the eerie mix of sounds and smells and glimpses neither natural nor crafted—all of it is free for the taking, for the taking in. Take it, take it in, take in more every weekend, every day, and quickly it becomes the theater that intrigues, relaxes, fascinates, seduces, and above all expands any mind focused on it. Outside lies utterly ordinary space open to any casual explorer willing to find the extraordinary. Outside lies unprogrammed awareness that at times becomes directed serendipity. Outside lies magic.[2]

Dr. Stilgoe's focus is the American landscape. Mine is as well, since I am a registered landscape architect. But why not transfer his logic to Historic House Museums? They, too, have been "modified by people...layered over layers, the eerie mix of sounds and smells and glimpses" that could quickly become a "theater that intrigues, relaxes, fascinates, seduces, and above all expands any mind focused on it."[3]

I am also an Associate Professor of Architecture and Urban Design at the University of North Carolina Charlotte, and that position has allowed me to build on Dr. Stilgoe's initial teachings and form my own perspectives. As the only woman on a 20+ person faculty for eight years, I was drawn to feminism to explain the disconnect I felt from my colleagues. I soon began to question the patriarchal authority of the university structure and got into all sorts of mischief as I found my own voice. As the Founding Director of the Charlotte Community Design Studio, the outreach arm of the College of Architecture, I worked with elected leaders from across the country to assist them in dealing with growth issues in their communities. I learned of their shared frustration in not hearing from the cacophony of voices that made up their communities, as their thoughts were drowned out by the same handful of old white guys that showed up at public meetings. In

response, I created Wikiplanning™, an online site for building civic engagement in the community planning process. Instead of hearing from the same ten or so men, we provided a shared platform for thousands of voices to be heard. My subsequent urban design work reflected this broader input, as I sought to create the vibrant, activity filled places these voices cited.

My work focuses on the design and planning of places that build community and give a diverse range of people a sense of belonging. Theoretically, it is based in building social capital and trust across cultural divides, as well as in improving public health through the design of accessible, inclusive, connected, and active communities that arise from their unique attributes. Underlying these goals is my dedication to civic engagement and expanding participation in the community planning process through urban activation.

It was within this context of my own work that Frank shared with me his and Claire's experience and his frustration with how HHMs are typically run and the small number of people who visit them. We decided to join forces to address these challenges, I would steer my expertise in civic engagement and creating vibrant places toward historic activation and lend it to Frank's extensive experience in thinking about, reimagining, and managing historic sites. Our intent was to come at the work through a primary perspective of community-engaged, experiential habitation, rather than collection building and preservation.

Anarchist's Guide to Historic House Museums

Together, we often speculated about how our Pennsylvania houses colored our perspective on Historic House Museums. The commonality seems to be that we did not just know about the history of our one-time homes, we felt the love and loss they once embodied. In building on museum scholars before us, *Anarchist's Guide to Historic House Museums* is our attempt to create a methodology that encourages the transference of that experience.

Our joint, applied research began at the University of North Carolina Charlotte in 2010 in an advanced architecture studio. We collaborated with 12 students to create and test a methodology for creating experiential habitation. We continued to test and expand the methodology in three additional studios at the University of North Carolina, a graduate class in historic preservation at Columbia University, workshops at the Cooperstown Graduate Program in Museum Studies, and at House Museums around the country.

In addition, we presented and published our work at national and international peer-reviewed, academic conferences, and gave lectures and keynote addresses at more than a dozen professional museum gatherings. Frank also created an *Anarchist Guide to Historic House Museums* LinkedIn site, where he facilitates ongoing discussions with over a thousand museum professionals. As a testament to the combined knowledge the Historic House Museum community holds, we liberally share many of their references and ideas in this book. We also include text from *Twisted Preservation*, a blog Frank writes that is "an intimate portfolio of ideas by the Museum Anarchist."[4]

Because we have criticized HHMs, it seems important to state our intense admiration for the field. Our argument lies with the practices that seem irrelevant today, especially as our contemporary perspective broadens relative to what and who is of historical importance. We hope that our work cultivates a culture of experimentation and speculation, as did that of the many artists, thinkers, writers, and professionals who inspired us and that we cite in the *Anarchist's Guide.*

A most special thanks goes to Olivia Cothren, Historic House Trust Manager of Development and Special Initiatives and museum anarchist. Olivia has been integrally involved in the evolution of these *Anarchist's Guide* ideas for several years through her work at the Historic House Trust and her involvement in our graduate seminars. While she does love a good rant, she is passionate about heralding this clarion call to excite and empower the next generation of Historic House Museum leaders. Olivia assisted in teaching, contributed text to this narrative, and provided a thorough review and edit.

Many thanks to our students whose willingness to suspend their disbelief made our research possible, to our employers and partners, the College of Arts and Architecture at the University of North Carolina at Charlotte, the Historic House Trust of New York City (board of directors, staff, and professional collaborators), and the Department of Parks and Recreation of New York City, for supporting our research, and the colleagues in our fields that read our white papers, came to our lectures, allowed us to hold onsite workshops, and encouraged us to write this book. We acknowledge that many of our supporters come from HHMs where the executive director is the lone staff member in charge of just about everything and who often is overwhelmed by the minutia of maintaining a historic structure. We have been told that our research helps them be able to see a bigger picture and try new things. We hope our book does just that and is not perceived as adding to their

burden. From that perspective, we constantly personify HHMs throughout the *Anarchist's Guide* so as not to imply it would be the singular responsibility of the executive director to fix all the ills he or she probably inherited.

Our Special Thanks Go to the Following Organizations and Individuals for Their Ongoing Support

PERSONAL

(Franklin Vagnone thank yous)

Johnny Yeagley (for making me watch "Mon Oncle" by Jacques Tati), Claire Vagnone (for driving while I ranted the first *Anarchist's Guide* utterances), Laura Orthwein, Emma Vagnone, and Sophia Vagnone for tagging along to "just one more Historic House Museum."

(Deborah Ryan thank yous)

Mike Panveno, Addison Wahler, and George for their never-ending support when not asking… "And when will you be done with the book?"

DEDICATED COLLEAGUES

Lisa Ackerman—For her careful reading of the manuscript (twice) and thoughtful comments and direction.

Ulysses Dietz—For understanding the importance of that third floor bedroom at the Ballentine House and providing guidance with the manuscript.

Paul Reber—We wish to acknowledge the important contributions from our friend Paul. He considered himself a "Charter Museum Anarchist"— always supportive and full of guidance. We will miss him greatly.

Margarite Williams—For modeling and teaching the behavior of a writer and lending her editorial talent as a reader for this book.

Dr. Gretchen Sorin—For reading the drafts and authoring the Foreword. More importantly, for jumping off the cliff with us and letting us test AGHHM ideas at CGP.

Alice Cooney Frelinghuysen

Amy Freitag

Andrew Dolkart

Brandi Levine

Catherine Gilbert

Dr. John Stilgoe (for sharing the value of everyday acts through his infectious enthusiasm)

Frank Sanchis II

Franny Eberhart

Heather Benning

John Carr

John Mitner

Ken Turino

Kevin Greenland

Linda Norris

Lisa Junkin-Lopez

Michelle Wilson

Olivia Cothren

Robert Jaeger

Robert Wuilfe

Stephen Morely

Tricia Van eck

Mark B. Schlemmer (@ITweetMuseums)

SUPPORTIVE ORGANIZATIONS AND GROUPS

To the organizations where we lectured, for inviting us to share our ideas, giving us a professional critique, and offering much appreciated support for moving forward.

All of the *Anarchist's Guide to Historic House Museum* LinkedIn discussion participants.

The many participants in our AGHHM data collection events.

1772 Foundation (shatterCABINET funders).

American Association of State and Local History and Bob Beatty.

Architectural Research Centers Consortium (ARCC) (for early peer review of our work).

Association of Collegiate Schools of Architecture (ACSA) (for early peer review of our work).

Bryn Athyn Cathedral and Historic District.

Chipstone Foundation, Jon Prown, and Claudia Arzeno (shatterCABINET partners).

Columbia University Historic Preservation Department, and all the graduate students who helped develop and test our Anarchist ideas.

Cooperstown Graduate Program, Dr. Gretchen Sorin, and all the graduate students who helped test the ideas.

Greater Hudson Heritage Network and Priscilla Brendler.

Historic House Trust of New York City House executive directors, staff and board of directors (particularly Lisa Ackerman, Franny Eberhart, John Gustafsson, and Cynthia Wainwright), and 2014 and 2015 Edward I. Koch Fellows.

History Channel and Libby O'Connell.

Metropolitan Museum of Art (NYC).

Mid-Atlantic Association of Museums.

Museum Association of New York.

Museumwise.

National Society of Colonial Dames of America.

New York City Department of Parks and Recreation.

New York Community Trust (LatimerNOW funders) with Kerry McCarthy.

New York Landmarks Conservancy and Peg Breen.

New York Preservation Archive Project and Tony Wood.

New York State Council on the Arts, Kristin Herron, and Fabiana Chiu.

Small Museum Association and Allison Titman.

University of North Carolina at Charlotte, and the never-ending support of University Provost Dr. Joan Lorden, the School of Architecture led by Professor Chris Jarrett, and all the students who helped develop and test our *Anarchist* ideas.

Historic House Museums, Organizations, and Professionals of Note

Alice Austen House and Janice Monger (Staten Island, NY)

Ballantine House and Ulysses Dietz (Newark Museum)

Bartow-Pell Mansion and Ellen Bruzelius (The Bronx, NY)

Blandwood Mansion and Gardens (Greensboro, NC)

Clermont Historic Site and Conrad Hanson, New York State SHPO Office (Germantown, NY)

Cole Historic Site and Betsy Jacks (Catskill, NY)

Dyckman Farmhouse Museum, Meredith Horsford, Naomi Rodriguez (NYC)

Eames House (Pacific Palisades, CA)

Farnsworth House and Whitney French (Plano, IL)

Franklin D. Roosevelt National Historic Site (Hyde Park, NY)

Gamble House and Ted Bosley (Pasadena, CA)

Graham Home Place at the Billy Graham Library (Charlotte, NC)

Great Camp Sagamore (Blue Lake, NY)

Greenbelt Historic House and Megan Searing Young (Greenbelt, MD)

Hay House and Jonathan Poston (Macon, GA)

Heurich House and Kimberly Bender (Washington, DC)

Historic Brattonsville (McConnells, SC)

Historic Hudson Valley and Waddell Stillman (Tarrytown, NY)

Historic Richmond Town, Ed Wiseman and his dedicated staff (Staten Island, NY)

Historic Rosedale Plantation (Charlotte, NC)

Hollyhock House and Jeffery Herr (Los Angeles, CA)

Joslyn Gage Foundation and Sally Wagner (Fayetteville, NY)

Judd Foundation (NYC)

Knox Heritage, Kim Trent, and Todd Morgan (Knoxville, TN)

Körner's Folly and Dale Pennington (Kernersville, NC)

The Levine Museum of the New South (Charlotte, NC)

Lewes Historical Society (Lewes, DE)

Lewis H. Latimer House and Monica Montgomery (Flushing, NY)

Locust Grove and Ken Snodgrass (Poughkeepsie, NY)

Lyndhurst Historic House and Howard Zarr (Tarrytown, NY)

Mabry-Hazen House and Calvin Chappelle (Knoxville, TN)

Menokin, Sarah Pope and Ro King (Warsaw, VA)

Merchants House Museum and Pi Gardiner (NYC)

Minnesota Historical Society and Rachel Abbott

MLK Parsonage House (Montgomery, AL)

Monticello (VA)

Morris Jumel Mansion and Carol Ward, Danielle Hodes (NYC)

Mount Vernon Historic Site (Washington DC)

Museum Council of Greater Philadelphia

NewYork Historical Society

Oak Ridge Historic Site (Oak Ridge, TN)

Olana Partnership (Hudson, NY)

Old Salem and John Larsen (Winston-Salem, NC)

Old Stone House and Kim Maier (Park Slope, NY)

Pabst Mansion (Milwaukee, WI)

Philadelphia Society for the Preservation of Landmarks and George Haitsch (Grumblethorpe, Powel, Physick House, and Waynesborough)

Poe Cottage, Angel Hernandez, and Kathy McAuley (The Bronx, NY)

Pope House Museum (Raleigh, NC)

Rensselaer County Historical Society and Ilene Frank (Troy, NY)

Schindler Studio and House and MAK Center for Art and Architecture (Los Angeles, CA)

Seward House and John Kingsley (Auburn, NY)

Sidney Lanier Cottage and the Macon Historic Foundation (Macon, GA)

Stratford Hall, Paul Reber and Abigail Newkirk (Stratford, VA)

Strawberry Banke Museum and Larry Yerdon (Portsmouth, ME)

Val Kill (Hyde Park, NY)

Van Cortlandt House Museum, Laura Carpenter and the National Society of Colonial Dames (The Bronx, NY)

Vanderbilt Mansion and Frank Furtel (Hyde Park, NY)

Watts Towers (Los Angeles, CA)

Wilton House and Keith MacKay (Richmond, VA)

Woodrow Wilson Boyhood Home (Augusta, GA)

Wyckoff Farmhouse Museum (Brooklyn, NY)

... and the many other members of the always supportive Historic House, preservation and museum community who kept asking the same questions and provided the impetus we sometimes needed to keep going. If we left you out of this list, we apologize. Our research has been so collaborative that it is impossible to list everyone who has helped us along the way.

INTRODUCTION

Eventually the bus moved on to Arlington. There it met other busses and immediately a swarm of women and children were leaving a trail of peanut-shells through the halls of General Lee and crowding at length into the room where he was married. On the wall of this room a pleasing sign announced in large red letters "Ladies' Toilet." At this final blow Gloria broke down.

"I think it's perfectly terrible!" she said furiously, "the idea of letting these people come here! And of encouraging them by making these houses show-places."

"Well," objected Anthony, "if they weren't kept up they'd go to pieces."

"What if they did!" she exclaimed as they sought the wide pillared porch. "Do you think they've left a breath of 1860 here? This has become a thing of 1914."

"Don't you want to preserve old things?"

"But you can't, Anthony. Beautiful things grow to a certain height and then they fail and fade off, breathing out memories as they decay. And just as any period decays in our minds, the things of that period should decay too, and in that way they're preserved for a while in the few hearts like mine that react to them. That graveyard at Tarrytown, for instance. The asses who give money to preserve things have spoiled that too. Sleepy Hollow's gone; Washington Irving's dead and his books are rotting in our estimation year by year—then let the graveyard rot too, as it should, as all things should. Trying to preserve a century by keeping its relics up to date is like keeping a dying man alive by stimulants."

"So you think that just as a time goes to pieces its houses ought to go too?"

"Of course! Would you value your Keats letter if the signature was traced over to make it last longer? It's just because I love the past that I want this house to look back on its glamourous moment of youth and beauty, and I want its stairs to creak as if to the footsteps of women with hoop skirts and men in boots and spurs. But they've made it into a blondined, rouged-up old woman of sixty. It hasn't any right to look so prosperous. It might care enough for Lee to drop a brick now and then. How many of these—these animals"—she waved her hand around—"get anything from this, for all the histories and guide-books and restorations in existence? How many of them who think that, at best, appreciation is talking in undertones and walking on tiptoes would even come here if it was any trouble? I want it to smell of magnolias instead of peanuts and I want my shoes to crunch on the same gravel that Lee's boots crunched on. There's no beauty without poignancy and there's no poignancy without the feeling that it's going, men, names, books, houses—bound for dust—mortal—"

A small boy appeared beside them and, swinging a handful of banana-peels, flung them valiantly in the direction of the Potomac. (F. Scott Fitzgerald, *The Beautiful and Damned*)[1]

Visiting a Historic House Museum (HHM) is usually not a visceral experience nor particularly memorable. The experience is not grounded in what Randy Roberts of John F. Kennedy University calls the "framework of being," in which

> people can be truly present, without distraction and "busyness." This does not necessarily mean a quiet, contemplative space; it is, rather, about holistic involvement in experience whether it is filled with joy, anguish, awe or any other mix of emotions. To understand museums as sites of being rather than educational institutions challenges the notion that museums are about learning. It suggests, rather, that museums are about immersion in exploration of self and spirit, about experiences that lead to fulfillment of human nature, to authenticity, and to being present in the present while being aware of the past and the future.[2]

Yet, good museum practice is often described as "rigorous, precise, penetrating, factual, methodical, systematic, critical, definitive, objective, scientific, and professional. It is defined against everything that is sloppy, woolly, superficial, speculative, subjective, anecdotal, picturesque,

impressionistic, literary, unsystematic, unmethodical, uncritical, unscientific, and amateurish," or just about anything that could solicit an emotional response.[3] *Anarchist's Guide to Historic House Museums* is a call for a selective mix of the two sets of traits.

We have often wondered why HHMs seem so emotionless and dry. It is contrary to the fevered determination often found in us preservationists. Our organizations have not earned the nickname of "hysterical societies" for no reason.

Most HHMs begin their life as museums through a passionate urge to preserve, a perspective that almost always grows out of a state of high anxiety. Family, friends, and neighbors who hold personal attachments to an often run-down house organize to protect it because they desperately fear for the home's loss. But once it is saved, museum stewards usually re-present the house not as a place for living, but rather as a container for collections. These Houses move from being wooly, sloppy and impressionistic, to being places that are systematic, objective, and professional. In the process, the poetry of HHMs is often lost in the translation.

Gaston Bachelard wrote, "Forces are manifested in poems that do not pass through the circuits of knowledge."[4] We believe that those same forces can be harnessed in Historic House Museums. Our hypothesis is that HHMs fail, at least in part, by their inability to draw connections between the real-life, quirky, and emotional experiences from the House's past and the same sorts of feelings in the visitors' own homes. We call the possibility of this shared experience "poetic preservation." Roberts offers a similar perspective, and one that is potentially applicable to HHMs:

> There are moments within the museum visit experience that seem to go beyond the cognitive, affective, and physical realms, reaching into a place that involves transcendence, awe, and spirituality. These experiences are often described in terms of being touched by an object or artwork in such a powerful way that the viewer is held in time and place unable to turn away, or experiences a flow state, losing track of time. Sometimes the experience is noted as an almost indescribable feeling that draws one into a place of deep energy. The object or artwork is central to these powerful moments, which are often associated with an urge to physically touch the material object that is the spiritual link.[5]

We know of at least three HHMs that strive to achieve that emotive level of experience. In each of these houses there is an emphasis on the guest's poetic experience, rather than simply the conveyance of historically accurate

information. However, the fiction does not negate the truth. There is simply a shift in focus.

From our relationship with International Council of Museums (ICOM), we learned of the Gaasbeek Castle in Flanders. The Gaasbeek has been redefined as a *Heritage Laboratory* under the motto: "Whatever is permitted will not teach/learn us anything; the first commandment therefore is to disobey." For the last ten years, the historic site has been experimenting by bringing in contemporary art and scattering it throughout the castle's rooms, corridors, and staircases. They have strategically re-interpreted the site to make guests question the relevance of the place, and to confront the public with many different questions without giving answers, thus drawing them out of their comfort zone. The castle has also incorporated theatrical methods into the visitor experience, not through reenactment or historic evocations, but through contemporary new works that speak about what happens when the residue of a building's memories come back to life and force irrational responses.[6]

Dennis Severs's House in London is a mix of history, conjecture, and outright lies. Its value is that it pushes the limits of fact-based, acceptable HHM experiences into a world of emotion and self-discovery. In his actual living space, Mr. Severs overlaid a series of fictional narratives through tactile and sensory immersion. Rooms are thematically organized as a passage through a "Historic House Museum" where the guest feels as though the historic figures have just left the room. Each room experience exhibits a distinct narrative and conjectural fragile history. Visitors have a slightly uncomfortable feeling that they themselves are historic figures, a confusion that is enhanced by the ability to become totally involved with the domestic environment through all of their senses. Visitors begin to do what they might if indeed they had traveled through a frame into a painting: use what they sense to piece together the scene they had missed.

Our friend Linda Norris's blog, *The Uncatalogued Museum*, introduced us to the Mikhail Bulgakov House in Kiev. This HHM presents the life of the famous author simultaneously with a conjectural presentation of the narrative from his famous book, *The White Guard*. In developing the museum, the decision was made to create a theatrical experience that merges the story of the fictional Turbin family with the real story of Bulgakov and his family. To emphasize the overlay, all of the non-original objects in the museum were painted white, so the original artifacts from Bulgakov's family stand in stark contrast. Midway through the tour guests open an armoire and pass through it to enter another world. They are forced

into simultaneously holding the two narratives at once, while inhabiting a fully immersive site-specific contemporary art environment.

A similar shift to value emotive experience is underway in several Historic House organizations. For instance, in Sydney, Australia, the city's twelve most significant HHMs and gardens were recently rebranded as the Sydney *Living* Museums. "The word 'Living' in the name refers not only to the curatorial focus of the Museums but also the types of experiences people can expect" with the intent of exploiting "today's fascination around lifestyle."[7] Their new mission is "to enrich and revitalize people's lives with Sydney's living history" by being "authentically resourceful, personally fascinating, a sociable host and reviving and revitalizing."[8]

The 23 HHMs comprising the Historic House Trust (HHT) of New York City are involved in a similar re-thinking, as evidenced by statements in the organization's 2012 Annual Report:

> Second guess everything that you think is fundamental to the historic house world. Do not assume that you can't reach a new audience. Do not assume that you have to keep people "at bay" when they are on your site. Do not assume that the story of your house ended a hundred years ago. Open your mind. Create. Cooperate. Communicate.[9]

We realize that our desire to elevate emotive experience to a standing equal with historical exactitude is a controversial one, but certainly not a new idea. We believe that we are in good company in promoting poetic preservation. Our intent is to encourage both lay and professional historians to imagine different scenarios through their individual perceptions. As cultural historian Jacob Burckhardt wrote in 1842, "For me history is always for the most part poetry."[10] Years later, George Macaulay Trevelyan suggested that the field of history ought to be able to embrace history as both an art and a science. He also envisioned a field of professionals who balanced the collection and evaluation of evidence with imagination and the art of the narrative.[11] He wrote, "It is the business of the historian to generalize and to guess as to cause and effect, but he should do it modestly and not call it 'science.'"[12]

In conceptualizing everyday domestic life within the construct of poetic preservation, it is almost impossible to completely avoid speculation. Nor would it be advisable, because it is in the spaces between presumed life and recorded history that relatable experience occurs. The essential notion is that these places matter. As Paul Reber, executive director of Stratford Hall, stated, "Historic House Museums are important for the very reason

that they are *domestic dwellings*, and through that personal space, we can learn about real people, lives and history."[13] As landscape historian John Stilgoe wrote, "A great many Americans would be far more interested in history if historians made the main stream a little wider."[14]

Why "Anarchist"?

Many of the opinions in *Anarchist's Guide to Historic House Museums* are not entirely new. As Fitzgerald's Gloria expresses in the opening quote of this introduction, the very richness of historical narratives is sometimes lost in attempts to be good stewards. We understand the risks we take in putting these ideas down in print. In the past four years of lecturing, workshops, and research, we have had people get up and leave in the middle of our presentations and been told that we are both idiots and a menace to the preservation profession. We know that some of the ideas in *Anarchist's Guide* go against many of the currently accepted best practices in preservation, education, conservation, and museum studies. Nevertheless, we ask that you suspend your initial disbelief and educated prejudice, and enter this guidebook with an understanding that these ideas are not just ours, but rather a collection of disparate ideas from a wide range of sources that coalesce to make what we believe to be a step in the right direction.

We are House Museum lovers and professionals who care deeply about these fragile sites, but at the same time, we want to take a critical, but practical, look at shortcomings of Historic House Museums. As we discuss HHMs, the first question we often hear is: "Are there are too many of them?" Although many of our colleagues seem to revel in arguing over the answer, we wonder if the question is really a smoke screen of sorts, distracting HHMs from working on the problems many of them share. We have also often heard that "if we just were awarded more grants, we would be fine," and the umbrella statement that "people just don't care about history any longer; it's not taught in schools anymore." These perspectives blame outside forces for the plights most HHMs are facing today, and by focusing on absolutes, they leave little possibility for a course correction or a more nuanced understanding. In fact, it is rare that anyone discusses the inherent, systemic challenges facing Historic House Museums.

Because the traditional HHM audience is aging, attendance is shrinking, budgets are tightening, competition from both nonprofits and commercial offerings is increasing, and new types of communication methods

are growing, we believe that House Museums need to take bold steps and expand their overall purpose not only to engage communities surrounding them, but also to become deeply collaborative with the type and quality of experience guests receive.[15] Our interest is consciously outside of the widely accepted American Alliance of Museums' (AAM's) *Characteristics of Excellence for U.S. Museums*, in large part because museum accreditation, although important on some levels, does not necessarily produce a House Museum institution that is compelling or exciting. We believe most visitors give no automatic, inherent value to such a label and judge the value of an institution based upon their experience.

It is a fact that many of America's historic sites are experiencing declining attendance, financial instability, and an inability to maintain a high level of stewardship. Likewise, they are increasingly viewed by their communities as irrelevant and unresponsive to the demographic and technological changes around them.[16] Historic House Museums are increasingly pressured to demonstrate their value and relevance, not just from a perspective of historic value, but from one based in contemporary life. In response to these new pressures, HHMs must look at familiar issues from new perspectives and using new methods.[17] We believe that merely tweaking the pervasive Historic House Museum experience will not accomplish much. It is why we title our work as *Anarchist*. Our intent is not to be sensational, but to acknowledge the depth needed to address and correct pervasive problems.

Instead of using the term "Anarchist," we could have used the word *parrhesia* which simply means frank speech. As Foucault wrote, it infers a position that is "not concerned with absolutes; it does not seek to find 'the truth.'" Rather, it is about "having the courage and ability to speak up against a dominant or commonly held opinion... contesting what is often taken for granted or what has become sedimented and routinised."[18] [19] Or we could have used the term *reculturing*, meant to encourage the shifting of "the core values and practices of a museum community, starting with its education practices."[20] Such a shift would "require working with visitors' agendas in mind; developing a sense of shared purpose, practices, values and beliefs; a deep commitment for collaborating with all visitors; developing reflective and collaborative practices for improvement; and, most crucially, sharing power at all levels."[21]

Regardless of what we label our work, our goal is not to separate HHMs from their founding principles, but to help make them more relatable. As Chandler Battaile, director of development at Stratford Hall, suggested, Historic Houses should pass a relevant "smell test" answering questions

like: "What difference does this place make today? What can we learn from this place today? If the answers aren't moderately compelling (as part of a mission statement) it might be time for some soul searching."[22]

What's the Problem?

Most early HHMs were enshrined as physical manifestations to promote moral and patriotic concepts to benefit the greater good. Mount Vernon, the estate of George Washington, was built during the years 1735 to 1799. Its period of interpretation is 1799, representing the time that Washington inhabited the house. It became a shrine in 1860, and has been open to public viewing to varying degrees for over 150 years. The Van Cortlandt House (c. 1748) in The Bronx has been a public venue for over 120 years, and Thomas Jefferson's Monticello (c. 1772 +) has been open to the public for over 90 years.

Historic House Museums in the United States, as in these three examples, were primarily founded, interpreted, and staged to celebrate a romanticized American legacy. As Patricia West wrote in *Domesticating History*, the selection of homes to commemorate was less about their famous inhabitants and more about the political climate when they were transformed into HHMs.[23] In writing about this mixed message, Ruth Taylor, Executive Director of the Historic Newport Society, shared a similar perspective, remarking that "I do not think that we can ever assume that someone is an unbiased reporter—especially from a single report. We have to be aware that people of all times engage in propaganda, etc."[24]

The Critique

After gathering the thoughts from a wide range of individuals and all types of organizations who have interacted with House Museums in some manner (i.e., private funders, elected officials, museum professionals, guests, and even uninterested parties), we have distilled five fundamental critiques of HHMs:

Critique One • *Historic House Museums reflect political and social propaganda,* often telling only partial truths to the communities that surround them. Those of us in the HHM field see our work as telling accurate, historic information, while guests sometimes see what we do as reductive, selective, and biased.

Critique Two • *Historic House Museums have nothing relevant to contribute to conversations.* Many people perceive House Museums as elitist, insular, self-referential, and culturally old-fashioned.

Critique Three • *Historic House Museums are boring.* We are often asked by HHM staff why they do not get repeat visitations. Perhaps it is because the experience they offer is not engaging in a way that fulfills guests' expectations, or as one respondent remarked, "It was a waste of 45 minutes of my life."

Critique Four • *Historic House Museums have been narrowly curated* and do not reflect real life use. Instead, guests often experience HHMs like dollhouses, as they move along the length of a room or hallway while voyeuristically peering into the stage-set of a furnishings plan.

Critique Five • *Historic House Museums are too expensive to preserve, and they engage in deceptive conservation practices.* We have often been told that HHMs are black-holes of need. As soon as one portion of the building is restored another needs work. The goal seems to be to not let the public know how much effort and money it takes to keep up these homes.

How to Use the *Anarchist's Guide*

Using these five critiques as the organizing structure, *Anarchist's Guide to Historic House Museums* (AGHHM) contains 32 markings and 160 evaluative questions grouped into five thematic categories of Community, Communication, Experience, Collections/Environment, and Shelter. Offered as an evolving graphic manifesto, the *Anarchist's Guide* calls for the holistic de-construction of the HHM and the re-establishment of a paradigm from the perspective of human habitation. Our intent is to offer a guidebook for enhancing Historic House Museums by beginning with a fundamental paradigm shift: If Historic House Museums are to survive, they must be turned upside down and inside out.

Typically, HHM stewardship places preservation and conservation of the architecture and the collection of artifacts as their primary activities, then the visitor experience as secondary, with the surrounding community as a tertiary concern. We often feel that House Museums are like libraries whose librarians love the books so much that they prefer that they are never checked out.

The *Anarchist's Guide* has been growing over the last four years, as we have worked to both understand the inter-related challenges faced by

PRESERVATION & INTERPRETATION AS TRANSFORMATION

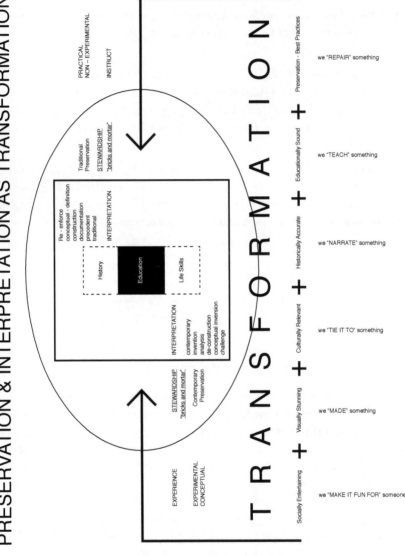

Figure Intro. 1:

The *Anarchist Guide* accepts the various paths to preservation, stewardship, and interpretation. This diagram outlines two approaches to historic site transformation. Originally created in 2006, the diagram illustrates the possibilities for re-evaluation through collaborative efforts. The TRADITIONAL and the EXPERIMENTAL are both needed for long-term stewardship.

Image: Originally created by Vagnone, 2006; diagram reproduced by Kevin Greenland, 2015.

HHMs and build holistic answers that address the complexity of their problems. The *Anarchist's Guide* is organized as follows.

Guidelines: The book's five chapters reflect the basic critiques we isolated at the beginning of our research: Community, Communication, Experience, Collections/Environment, and Shelter. These guidelines will help you conceptually organize the types of problems your site may be experiencing.

Markings: Each chapter is divided into sections we call "Markings." We chose the word "markings" because we have come to see the *Anarchist's Guide* concepts as not exactly tangible, but rather shadows of behaviors and experiences. The 32 Markings describe how to assess and address the challenges most Historic House Museums face. For clarity, each of the Markings has the same format. First, there is a brief explanation of the Marking, which is followed by a "Rant." These Rants have been drawn from various sources, including the AGHHM LinkedIn site, personal interviews, and correspondence. Each Rant is followed by a section labeled "Evidence," which provides the information supporting the need for the Marking and how it has been thought about by professionals other than ourselves. Following the Evidence, we suggest recommendations for moving forward in a section labeled "Therefore." In Appendix A, we offer five evaluation questions for each of the book's Markings, along with a scoring system to help you evaluate progress. This appendix also contains a simplified version of the Anarchist Chart, which is a condensed version of the book's guidelines and Markings. (A full-scale and printable version of the Anarchist Chart is available at www.museumanarchist.com.)

Tools: In Appendix B we offer brief descriptions of ten hands-on tools that we devised as research methods. You can start using these tools immediately to assess your Historic House Museum within its neighborhood context and to begin to find creative solutions to some of your more pressing challenges.

The flow of the *Anarchist's Guide* has been organized to read as a unified statement of purpose. This was done to highlight the interconnectedness of these concepts, recognizing that none of them alone will achieve a substantive result. To better illustrate this unity, we have outlined these relationships as follows.

Community: To better connect HHMs to the communities that surround them, *Acknowledge a Disconnect* between the house and its neighborhood, and *Refocus Its Mission towards Community Engagement.* Towards that goal, *Walk around the Block* and study the neighborhood to determine both its unique characteristics and the shared interests of its residents, especially those who live within a ten-minute walk of the site. Realize that what historians find so compelling may be of very little interest to the people who live nearby, and that the real task will be to *Engage the Uninterested,* by identifying and working with "reverse-affinity" neighborhood groups who heretofore have had little connection to the historic site. The goal of these exercises is to turn strangers into friends who will want to visit the site often. Very little of this work can be completed on site, so *Leave the House* and dedicate time to building relationships and working with the surrounding community. When it comes to the HHM's message, *Take it Outside,* rather than expecting people to come to the site. Listen carefully to learn about and understand local issues and concerns.

Communication: In order to combat the public perception that HHMs are elitist and self-referential, make sure that the historic site *Communicates on Multiple Levels* its openness to represent the diversity of the world around it. This can be achieved by integrating new forms of social media and by *Getting Chatty* using an informal, conversational style. In communicating, make sure the conversation is not just about the House. *Listen* to guests and create a dialogue. When speaking with them, *Keep It Real* and be selective with costumed, pretend play. Make sure a *Bait and Switch* is not made on guests. Be consistent in how special programs reflect everyday tours. *Seek Out N.U.D.E. Tour Guides* who feel comfortable with creative communication, who do not play the superlatives game, and stay away from the *Narcissism of Details.*

Experience: HHMs are boring and lack interpretive diversity. They are isolated and seem removed from contemporary life. So *Overlap* narratives from different eras, and include the guests' lives into the fabric of the site, *Tell Short Stories* to encourage repeat visitation. *Embrace Fragile History That Includes Rumor, Gossip and Conjecture* in these shorter narratives, acknowledging the holes in primary, historic source material. Rather than having a docent lead them through the House, encourage guests to *Learn by Doing* instead of simply watching

and listening. Create unique experiences and *Encourage Guests to Move Freely* through *Unexpected and Distinct Experiences*. Let them dance if they want to. Allow for discovery activities and even *Allow Access to Denied Spaces,* and encourage guests to sneak around the House and have a decentralized experience. Rather, *Engage All Their Senses* through immersive interactions.

Collections/Environment: Not everyone is as interested in artifacts as historians, so *Transcend the Object* and present an environment of habitation. Be sure to *Expose Domestic Complexities* throughout the site. In creating a messy, complex environment, include narratives and scenes that *Expand the Guest List.* Remember that not everyone occupied the House at the same time, or used rooms in the same way. Therefore, *Follow the Sun* through the changes of daily life in ways that induce personal memories from guests, and allow them to *Fingerprint* their visit. By allowing a guest to integrate his or her contemporary life with that of the HHM, the critical experiences that come from *Contemporary Interpretations* can be better utilized.

Shelter: Try not to let the responsibility of preservation be the sole driver of the HHM. *Keep Perspective* on the various levels of preservation and stewardship, and understand that it is okay to *Show Age.* If restoration activities are undertaken, *Pull Back the Curtain* and engage guests in the process of preservation. Do not hide the parts of the House that are not perfectly restored, because guests just came from the world outside of the site, and they know that things change and decay. Acknowledge change by *Minding the Gap* of the world around the house and integrating vistas and neighborhood evolution as a teaching tool. In conveying a more accurate picture of preservation, *Dig Deeper* than just the cosmetics of the House and push for a complex understanding of the site's history by *Questioning the Period of Significance* and expanding the narrative outside of that construct.

The Anarchist Chart

The Anarchist Chart is a manifestation of the organizational concept of the *Anarchist's Guide* depicted on a circular chart to emphasize the interconnectedness of the Markings. The chart is organized into five

pie-shaped sections of Community, Communication, Experience, Collections/Environment, and Shelter, and then each is sub-divided into its respective Markings around a bulls-eye center. Radiating out from the center of the circle is a five-tier grading matrix that allows you to evaluate your site relative to each of the 32 Markings. Do not be fooled by the chart's simple, centralized appearance, as it is almost fractal.

The metric for the scoring matrix is explained in detail, along with a series of Evaluative Questions devised for each Marking. The questions have been formulated to allow for a measurable, but flexible scoring system for qualitative concepts. In doing so, we score elements that are not normally found within standard museum practice, such as issues related to visitor access, tour behaviors, and the flexibility of interpretive content.

We suggest you first use the chart to assess the existing conditions at your HHM, and fill in each slice of the pie that accurately reflects your current practice. The more the chart is filled in, the better. Your work should then concentrate on the unmarked portions of the chart. That is where a further reading of the Markings can assist you as they often will contain best practices from similar institutions that your organization might want to try.

We hope that the *Anarchist's Guide* inspires you to improve upon it, as we see it as a continually evolving document. We hope you will send us your ideas so that we can include them in this living document. We also hope you will send us your case studies so we can keep an ongoing record of what has worked for you, and what failed. While we have tested many of our markings, some are still just hypotheses. As such, some of the solutions are, in fact, our best guesses at what will work.

The fact of the matter is that we have written the *Anarchist's Guide* to mark a pause in our research where we step back and measure results. While the Markings make sense to us, their value is in how effective they can be at a wide variety of sites. We want the *Anarchist's Guide* to be a living guide and help HHMs to not only survive, but thrive in a rapidly changing world. Rather than being read as a series of conclusions, we hope the book is a point of departure towards embracing the poetics of preservation, and making the HHM experience about the trials, tribulations, passions and joy in the lives of yesterday and today.

CHAPTER 1.

COMMUNITY MARKINGS

Acknowledge a Disconnect

Openly acknowledge any philosophic, economic or social differences between your HHM's narrative and the immediate community surrounding your site.

RANT

We discuss connecting our sites to the 'community'; however, that is such a nebulous term, which means different things to different people. Historic houses can no longer just cater to the stereotypical visitors of the past, upper middle class white people with advanced degrees who walk in with vast amounts of prior knowledge. Many of our houses are in areas surrounded by 'non-traditional' audiences; we should be asking first and foremost how to be relevant to them. What can our house do for them?

(Carol Ward, Executive Director, Morris Jumel Mansion)

Anarchist's Guide to Historic House Museums by Franklin D. Vagnone and
Deborah E. Ryan 47–70. © 2016 Left Coast Press, Inc. All rights reserved.

EVIDENCE

HHMs can be culturally elite and removed. Most are unintentionally off-putting and expect the community to be naturally interested in them. How do we know this? We asked. Most people we engaged with our mobile kiosks told us they had never heard of our Historic House Museums, and if they had, they didn't know that the HHMs were open to the public. More importantly, the stories the historic sites offered did not seem to resonate as currently meaningful. In fact, HHMs have a reputation for showing little interest in the neighborhood that surrounds them. In calling for museums to reconsider their underlying purpose, meaning and value, Robert Janes wrote:

> Museums have led a privileged existence as agenda-free and respected custodians of mainstream cultural values.... Museums are privileged because they are organizations whose purpose is their meaning.... The failure to ask 'why' museums do what they do discourages critical self-reflection, which is a prerequisite to heightened awareness, organizational alignment and social relevance. Instead, in the absence of 'why,' the focus is largely on 'how,' or the clichéd process of collecting, preserving and earning revenue.[1]

Being relevant requires finding common ground. As neighborhoods surrounding HHMs change and evolve, the HHM typically stays the same, taking on the noble responsibility for relaying *the* story, or at least their version of what once was. They usually care little to update the HHM's narrative to reflect current events. But the telling of history is nuanced, and what is included, or conversely excluded, speaks to HHMs' willingness to acknowledge its shifting context.

Maybe what House Museums offer is not what the community wants. As Americans become increasingly connected, they are also searching for meaning in their lives and their place in the community. Many people, especially Millennials, claim that they want their work to be transformative and help people, not institutions, and support issues, not organizations.[2] HHMs rarely offer those kinds of opportunities. Douglas Worts writes, cultural organizations are likely to hold tight to their traditional modus operandi, at least until they see that the potential rewards are higher than preserving existing corporate operations.[3]

As the Center for the Future of Museums (CFM) noted in 2009: "As the nation becomes more diverse, and as the gap between wealthy and poor (even

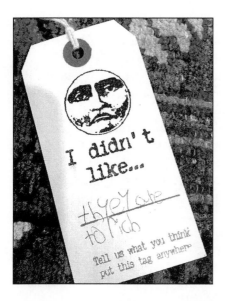

Figure 1.1: Reflective of a social and class disconnect, this *Anarchist Tag* from a seventh grade New York City school group student visiting Morris Jumel Mansion in Manhattan, NY, states, "I didn't like...they are too rich." *Anarchist Tag* pilot project facilitated by Carol Ward, Executive Director, and Danielle Hodes, Director of Education, at the Morris Jumel Mansion. *Photo: Franklin Vagnone, 2014.*

middle-class) Americans grows, museums will have to expand their audiences if they want to remain relevant to society as a whole."[4] Yet we now recognize "how little we actually know about populations who, for a variety of social, cultural, and economic reasons, do not yet enjoy regular access to museums. It has become increasingly clear that most existing evaluation and research studies are not representative of the overall population in the United States."[5]

There are organizations dedicated to better understanding the populations that do not regularly attend museums. One such organization is Cool Culture. Founded in 1999, its mission is to "combat barriers to access—such as high admission fees during regular business hours, lack of information, and deep-seated social differences along class, language, and ethnic lines—while simultaneously educating parents about the positive impact museum-going can have on their child's overall development and success."[6] Their long-term wish is to open the traditionally elitist world of cultural organizations and museums to a much wider audience.

If HHMs remain out of touch with diverse audiences, it may be due to their insistence on adhering to old museum models. HHMs began in an effort to establish national identity. Little by little, however, conversations that question the validity of one unified national identity are positively infiltrating the Historic House Museum landscape. In December 2014, President Obama signed a law to establish a national historical park

at the former home of Harriet Tubman in Auburn, New York. It is the first national historical park named for an African-American woman, an important step towards a more inclusive national identity.[7]

One of the interesting trends in cultural happenings is 'guerilla art' instigated as a form of social advocacy. For example, in post-recession Detroit, where tens of thousands of abandoned and blighted homes and buildings dominate the city's urban neighborhoods, Tyree Guyton and the Heidelberg Project have reimagined the domestic world of Historic Houses. Using abandoned houses and cars in the neighborhood where he grew up as his canvas, Guyton uses discarded materials like record albums, bicycles, vacuums, shoe, dolls, and stuffed animals to create whimsical pieces. The purpose and meaning of the work is clear: as Guyton writes, "If I can do just one small thing to help this community come back then I've done my job."[8] His goal is not so much about preserving a collection, or a moment in time, but rather about connecting people.

THEREFORE

Stop expecting people to be interested in what you have been offering. Be willing to re-think the types and methodologies that shape your visitor's experience and ensure that it is both socially relevant to your surrounding neighborhood and personally compelling. In addressing a cultural disconnect, provide opportunities to build community by doing good. Make sure that understanding your community is a top priority.

Refocus Your Mission: Have an Impact

Allow the needs of your immediate community to modify your mission, goals, focus and strategy.

RANT

When I am working with a historic house museum, or really any type of museum, I get confusing signals. I always want to ask, 'What business are you in?' Some museums seem to be in the business of 'preserving artifacts,' leaving little room for interpretation and telling stories. Others seem to be in the business of 'creating narratives,' and yet their stories can be internally focused. I'm always looking for examples of museums that are in the

business of 'engaging communities'... whether visitors, scholars, donors, or those who live and work nearby. This focus on people rather than things, and living people, not just the people of the past, can be the spark that will keep museums relevant today and in the future.

(Ro King, Trustee, The Menokin Foundation, and
Chairman Emerita, Indonesian Heritage Society)

EVIDENCE

Most HHMs consider the protection, stewardship, and enhancement of their collections as their primary mission. Few Houses focus on how to make their assets useful for, meaningful to, or have an impact on the community. In our research, we repeatedly found only a handful of sites that made substantial civic engagement a priority. Clearly, this is not a strong area for our museum genre.

In the early 1900s, museum leader John Cotton Dana wrote that "a museum's main objective was to be relevant to citizens' daily lives and promote lifelong learning and civic engagement."[9] Lynn Dierking agreed, writing that museums should "strive to achieve strategic impact for and with their communities, rather than merely operational impact for themselves."[10] Similarly, our hope for HHMs is that they be more than repositories of historical artifacts and information, that they be engines capable of having a positive impact on the community that surrounds them. Adopting this perspective will require a philosophical shift in thinking for most HHMs, so we underscore it as one of the fundamental components of the *Anarchist's Guide.*

For many HHMs, it will initially be difficult to find "a place of relevance and meaning, to genuinely contribute to building better communities and serving the needs of individuals, and to define the new normal in a world that no longer derives knowledge from objects, looks to institutions for answers, or defines reality through materiality."[11] But it is possible.

A few House Museums are having a substantive impact (outside of normative House Museum practice) in their communities. Examples include the Jane Addams Hull-House Museum in Chicago with their heirloom urban farm and "Re-thinking soup" event; The Lower East Side Tenement Museum, New York, with their English as a second language classes; Hancock Shaker Village with their community-supported organic farm and market; Fort Snelling in St. Paul with their "sentencing through service" job training for inmates; Lewis H. Latimer in Flushing, New York, and The Stowe House in Hartford, Connecticut, with their social justice

salons, and King Manor Museum and Old Stone House in New York City with their facilitating Naturalization Ceremonies.

One visually stunning example of this outward-focusing perspective was a 2013 exhibition entitled *LAND/SLIDE: Possible Futures* at the 25-acre Markham Historical Village in Ontario, Canada. Over 30 artists created site-specific contemporary installations, many of which grew out of contentious community conversations about development pressures on rural land and the value of history in the contemporary landscape. The exhibition was an attempt to expand the traditional Historic House narrative to include current community issues and employ the region's history as a means to discussing its future.[12]

Another example is Grumblethorpe (c. 1744), a HHM located in in the Germantown section of Northern Philadelphia. In 2006, when we first became involved with the HHM, a brick had just been thrown through one of the front parlor windows. At the time, the HHM had very low walk-in visitorship. There was a strong youth volunteer group who helped give tours, but not much else was occurring that contributed to the community's needs. One of the most pressing issues was that the neighborhood was a

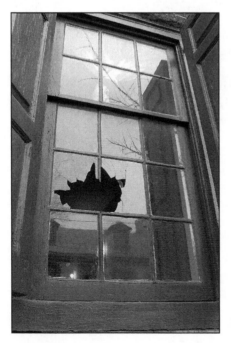

Figure 1.2: Grumblethorpe Historic House Museums in the Germantown area of Philadelphia, PA. In 2006 a brick was thrown through the street-front window, perhaps, at least in part, due to a neighbor's indifference to the HHM's isolation. The vandalism sparked a re-assessment of the House's relationship with the community and the establishment of the Grumblethorpe Farm Stand which was managed by the neighborhood-based Grumblethorpe Youth Volunteers. The project was facilitated by Brandi Levine, the then education director, and the Philadelphia Society for the Preservation of Landmarks. *Photo: Franklin Vagnone.*

food desert, defined as a place that lacks easy access to fresh food. Residents had to rely on convenience stores, where they had very limited choices. To contribute to a solution, Grumblethorpe's Education Director Brandi Levine managed the replacement of the formal, colonial revival gardens with a vegetable garden that provided a source of fresh food to the neighborhood, while also starting a new program to manage the produce with the established youth volunteer program.

> The Grumblethorpe Farm Stand immediately became a welcomed addition to the neighborhood. It attracted the interest and patronage of the entire surrounding community. It also showed that we were paying attention to the real world problem of this underserved neighborhood and how the history of the site could contribute to a healthier community. The farm stand continues today because it is an important contributor to the food sources in this neighborhood.[13]

The Heritage Square Museum in Los Angeles, a living History Museum comprising eight Historic Houses, presents another particularly compelling case for meeting the community needs while also fulfilling its mission. Using the museum's buildings as classroom space, and working with several partner organizations, they created a program called "Preservation in Practice" that trains unemployed construction workers, contractors, and members of vulnerable populations like homeless veterans in basic historic preservation techniques, and then helps graduates find jobs in the industry.[14]

However, most museums rarely involve themselves in societal issues, like hunger, unemployment, or the well-being of their communities. Concerning the financial collapse of 2008, Robert Jones wrote:

> Sadly, during the recent Great Recession, I observed that many institutions drew inward trying to figure out how *they* could survive with very few asking how the museum and its resources could support their communities through these difficult times. Looking in from the outside, it is as though museums have forgotten, at best, or at worst, neglected, their important role as social institutions and community stewards.[15]

When considering a more community-centered perspective for your HHM, ask "How will my community be different in positive and recognized ways because the museum exists and undertook this effort?"[16] Realize you are not alone in making this inquiry. Your HHM is just one within a context of other museums grappling with the same challenges of relevancy within their communities. As Roberts writes, "Times of great

change often create conditions that call for organizations to 'hit the reset button' in ways that can redefine institutional activities."[17]

THEREFORE

Consider refocusing your HHM's mission statement towards achieving an impact in your community.

Be careful to understand the concerns and interests of your neighbors, otherwise you risk concluding that "what the community needs most is a healthy and vital museum. This is a circular and self-serving argument."[18] Accept that change will be perceived as a threat to your HHM's identity, especially if your institution currently defines itself primarily as a place that collects and preserves objects within a valuable, historic structure. If you can redefine your HHM with a meaningful purpose rather than a series of activities, change may be "less likely to be understood as a threat to identity and more likely to be seen as a path to increased possibility."[19]

Walk around the Block (and Often). Study the Neighborhood.

Regularly study the demographics and social life of your immediate community.

RANT

Why are historic house museums always asking how to convince the public that they matter? The path toward relevance within a community isn't to bring the people to you, but to go out to the people. The question should be, how can historic house museums contribute to the health and vitality of their communities? To discover the answer, house museums must identify community groups and ask how the museum might contribute to their goals. Then listen. The responses might seem unfeasible, but exploring these possibilities will lead to meaningful relationships and open the doors to new definitions of relevance.

(Lisa Junkin Lopez, Associate Director,
Jane Addams Hull-House Museum)

EVIDENCE

HHMs ignore their neighbors. House staff make very little effort to learn about local residents or businesses or discover their interests. Though living in close proximity, neighbors are rarely considered in a comprehensive strategy to expand the audience beyond the established constituency of HHM enthusiasts. We often hear that neighbors who walk or drive by HHMs on a regular basis never knew they are open to the public, never knew they are museums, and never feel invited.

More often than not, HHMs target tourists who live far from the Museums in the marketing and communication efforts for the House, believing that these visitors would sustain their Houses' operations. That has proven not to be in the case at almost all Historic Houses, except for a small handful of the most famous sites. Although each site has a unique combination of issues, even at some of those well-known sites, like Historic Williamsburg, attendance figures are dropping.[20] We have worked with Historic House sites that struggled to pay for rack cards at hotels, train stations, and airports, all the while making no effort to advertise to their own neighbors.

Perhaps the disconnect between an HHM and its community is due to the institution's lack of understanding regarding changing demographics. Miranda Joseph cautions that neighborhoods are not fixed in time and place, and that an effective community engagement strategy is dependent on understanding "the fluid, dynamic nature of communities."[21]

Becoming familiar with your neighbors is the first step. Research that focuses on learning about them should be undertaken with the same enthusiasm that has already gone into learning about your HHM and the artifacts it houses. What you now need to know has nothing to do with history or your particular House's narrative. It has to do with everything else surrounding it.

While working in Philadelphia with two different HHMs on Society Hill, we gathered data for a project managed by Kevin Greenland by recording what we saw while simply sitting on the Houses' stoops during various times of day, week, and seasons. While searching for general patterns in our research, we eventually focused on the ubiquitous horse carriages that carried tourists through the neighborhood. We expanded our research and tracked the carriages' paths and the number of people they carried. We took further note of commercial venues that were destination points for the tourists, like a favorite cheesesteak restaurant. We located these venues on a map, and then graphically conveyed the number of people who visited each one of them.

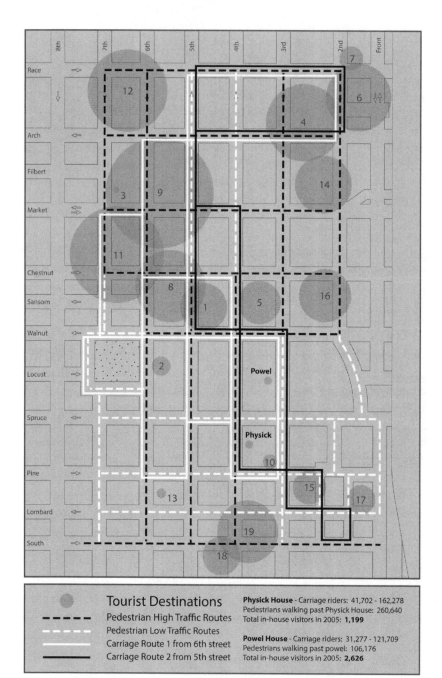

Tourist Destinations

- - - - Pedestrian High Traffic Routes
- - - - Pedestrian Low Traffic Routes
———— Carriage Route 1 from 6th street
———— Carriage Route 2 from 5th street

Physick House - Carriage riders: 41,702 - 162,278
Pedestrians walking past Physick House: 260,640
Total in-house visitors in 2005: **1,199**

Powel House - Carriage riders: 31,277 - 121,709
Pedestrians walking past powel: 106,176
Total in-house visitors in 2005: **2,626**

In 2005, as many as 422,918 people passed Physick House; only 1,199 visited.
In 2005, as many as 227,885 people passed Powel House; only 2,626 visited.

Figure 1.3: Example of a Sidewalk Activity study for the Powel and Physick Houses in Philadelphia, PA. Philadelphia Society for the Preservation of Landmarks, 2007. The research conducted from the HHM's stoop tracked pedestrian and carriage activity for set periods of time throughout a year. The gathered data were extrapolated to predict yearly cycles of use. The circles represent comparative attendance at neighborhood cultural venues. *Image: Franklin Vagnone and Kevin Greenland researchers, drawn by Kevin Greenland in 2007 and revised in 2015.*

We were able to assess that out of 463,488 people who walked or rode past the Physick House, only .25 percent entered the House to attend weddings or other special events, and an even smaller number actually toured it. Likewise, we found that out of 227,885 people who passed by the Powel House, only .65 percent entered it.[22] The historic neighborhood's zone of influence was very clearly defined by our study, as was the fact that the uninterested included both tourists and local residents. Neither group was interested in visiting the HHMs.

With this new knowledge, we suggested changes to the operations of the Houses and recommended new functions be considered. As a pilot, we created the Society Hill Interpretive Center in one of the Houses and suggested finding a caterer who could run a small coffee shop in the quiet walled garden of the other. We thought the House would be more of a draw if frazzled tourists were given the opportunity to rest and be served refreshments while occupying a space that few people heretofore had ventured into seeing.

Using this Philadelphia example as only the baseline, take your investigation to an even wider search. Expand your data collection to include regional trends and relationships. Do not limit it to what you know about your community. What are the trends of your area—new businesses, transit opportunities, immigration, educational offerings? We have found that someone outside of your immediate staff should do these types of research projects—they make an excellent intern or volunteer project.

Once you gather this information, spend some time really dicing it up and seeing what it tells you. Produce a working draft of this information and ask stakeholders to review your findings and identify unrealized opportunities. For instance, in the AGHHM pilot demographic study we conducted for a Dyckman Farmhouse Museum, New York City, project managed by Patrick Dickerson, we found out that the local neighborhood had a large number of households with multi-generational families living together.

This was also a community where English was a second language. Many of the children spoke better English than the grandparents, and the grandparents provided significant daycare for the working mothers and fathers. This provided the Historic House an opportunity to provide something to the community that was not offered—inter-generational, multi-language play/learning events during the day and on weekends.

Another excellent tool for obtaining good neighborhood data is to send out several people (of different genders, ethnicities, and backgrounds) to walk the neighborhood and take short smartphone videos of their surroundings. They should be instructed to walk around the block, and then another, and another until they have extended the study to a ten-minute walk (or the length of about six football fields). In suburban or rural locations, they should undertake a ten-minute drive time, varying the time depending on speed limits. People living within these zones will be most likely to visit the HHM on multiple occasions due to ease of access.

As they cruise around the neighborhood, enter groceries stores, retail centers, barber shops, and doctors' offices, they should take note of what is being advertised on community boards and in newspapers. What is on sale at the pharmacy? Look for items, data, and information that expand the understanding of the contemporary community surrounding the HHM. Out of the raw video footage, produce one-minute clips that document the surrounding neighborhood. Hold a theater night featuring these clips with staff and volunteers. Invite speakers to discuss the demographic information and the ways in which it might expand the HHM's interpretation and programs.

THEREFORE

Consider the neighborhood surrounding your HHM as a key to your future sustainability. Procure publically accessible data to get to know your neighbors. Include as much and varied information as you can find (census, real estate, ethnicity, immigration, language, household composition and size data). Search out deeply imbedded data, most of which can be found easily online with a bit of time and concentration. Make sure that you consider local, state, and federal council districts in your study.

This effort of completing your homework is only the first step in a serious attempt to find and engage the uninterested. Once you understand whom you are surrounded by and whom your potential audiences can be,

you can begin to discuss the best methodology of communicating a more strategically targeted message.

Consider this type of research as essential to the successful operation and management of the House Museum. It is not marginal to the perceived primary effort—the teaching of your historic narrative. In fact, you can become better communicators of your historic narrative if you expand the audiences with whom you attempt to share your story.

You will see that your House's context is not a mix of unsightly contemporary clutter, but rather a meaningful place to the people who live and work nearby. Your Anarchist goal will then be to figure out how to build upon your findings.

Engage the Uninterested

Locate communities of neighborhood residents who are not visiting and engage them.

RANT

We have had some real success in engaging our community in Davidson because we believe in our citizens. We let them know that their opinion matters and that they can and will have a positive influence on town policies, if they take the time to participate. When people are given a real chance to voice opinions and be heard, apathy melts away. In modern life, we have many electronic tools of communication that don't actually help us talk to each other, and we have found in Davidson that nothing substitutes for old fashioned, in-person listening.

(Marguerite Williams, former Mayor Pro-Tem and Town Council Member, Davidson, North Carolina)

EVIDENCE

HHMs rely on attracting the same audiences they have for generations.

Institutions need to become more knowledgeable about the needs of their potential visitors and be more adept at providing enjoyable and worthwhile experiences.[23] Thought leaders in museum studies, curators and museum directors like Rhianedd Smith, Robert Boast, Viv Golding, and

Thomas Campbell have suggested that the longevity of cultural and historic sites may ultimately rest not just in building community, but becoming relevant enough to remain at its center.[24]

Realize that to increase the number of guests to your HHM, you must build an audience by attracting people who have little interest in history in general (much less your House, its contents, or who once lived there). Your goal is to engage the vast majority of people and find out what interests them. Yukie Ohta, an archivist and founder of the *SoHo Memory Project Portable Historical Society,* plans to launch in late 2015 a mobile museum-like cart that will be moved throughout the Manhattan neighborhood and share a peek into its past. As part of the exhibition, she will engage the public by using 3D viewers and reels to show pictures of SoHo as it evolved from a rural area to a center for high-end shopping. These modified toys will also be left in the sitting rooms of local retailers, and while a person waits for someone to try on clothes, he or she can quickly and easily run through several hundred years of history.[25]

To begin making connections to the uninterested, we suggest targeting what we have labeled as "Reverse Affinity Groups." These are groups of people

Figure 1.4: An example of engaging Reverse Affinity Groups at Historic Richmond Town in NYC. The historic site commissioned a Photographic study of Staten Island residents who chose to commemorate the 9-11 attacks on the World Trade Towers by getting tattoos. This innovative collection project engaged non-traditional audiences in the documentation of contemporary issues. The photo is of Paul Cortes, Firefighter, Engine Co. 245, 2002. *Photo: V. Amessé Photography, Staten Island Historical Society, 2011.*

who have no connection or perceived interest in the Historic House, but are a significant base of the community. The goal is to first locate these groups and determine what events, activities and lifestyle interests they value, and then figure out how your House Museum can support them. Reverse your programming and communications to target a particular group's interests.

When locating the reverse affinity groups, don't be concerned about how they will dovetail with your historic narrative or mission; just identify and detail those groups of people who hold a strong connection to the community surrounding your House Museum.

We have sought out craft-oriented, reverse-affinity groups in an effort to enlist 'yarn bombers' to our HHMs. Initiated as a sort of colorful and non-invasive, unsanctioned guerilla public art, yarn bombers cover bike racks, tree trunks, phone booths, railings, traffic bollards, trash cans, bus stops and other public infrastructure with knitted and crocheted custom-made socks, caps, and sweaters. We tweeted #yarnbombing to our followers, saw the message retweeted, and within hours, we had enlisted some enthusiastic volunteers who might not otherwise have ever visited our HHM.

In our community engagement work in community planning, we have the same challenges HHMs do in attracting audiences to public meetings where we discuss future plans for growth, development, and conservation. Rather than expect people to come to us, we have undertaken a series of exercises where we take information out into the community. Inspired by graphic artist Marion Deuchars, we designed and distributed in restaurants *Food for Thought,* a colorful, custom-designed placemat that asked diners to record their thoughts on planning initiatives while waiting for their food to be served. Other planners have developed *Meeting in a Box,* where information that was shared in a public meeting is down-sized and distributed for a kitchen-table-sized conversation. Whether in a briefcase, sack, or box, materials were included to inform, educate and solicit public input, and could be geared to the interests of varying reverse affinity groups.

The idea of a 'museum in a box' is not new and has been especially effective as a teaching aid in schools. But there is no reason to keep HHMs from following a similar method to introduce themselves to groups who heretofore had shown no interest in visiting their sites.

Begin by thinking about your HHM's assets and how they could best be shared with the community. With her *Neighborhood Doorknob Hanger,* artist Candy Chang re-imagined the "Do Not Disturb" door hangers found in hotels as a tool for community engagement. She created 3.5" x 9"

two-sided doorknob hangers as a friendly, low-tech means to invite sharing. As described on the artist's website:

> The Neighbor Doorknob Hanger is a simple, double-sided sign that provides a friendly platform for residents in dense quarters to offer and request things at everyone's convenience. One side says "Please Disturb" and makes space for you to list offerings and choose how you prefer to be contacted—a knock at specific times that are good for you, by phone, or by email. The other side of the doorknob hanger says "Can I borrow?" and provides the same format for requesting things. Think of it as an invitation, a validated request, or a low-tech status update for your door, so we can share more resources without interrupting each other at a bad time.[26]

But what is it you have to share other than history? You might have a fenced yard. That could be a weekly welcoming place for dogs and their owners. And once welcomed, they could learn about the families who once lived in your HHM and the pets they cherished. Local veterinarians and pet shops are often willing to sponsor these events and provide door prizes for attending. Animal shelters and rescue organizations can also be enthusiastic supporters.

If you have a lawn or parking area, you can provide space for cooking and eating at a minimal expense. To reach out and invite residents from three very distinct but diverse neighborhoods that surround the Van Cortlandt House in the Bronx, UNCC architecture student Danielle Scesney proposed parking food trucks at the estate once a week because they bring their own following through an aggressive Twitter campaign that tracks their ever changing location. With each serving, you can *Tell Short Stories* or share snippets about your HHM relative to what the family probably ate and drank and with whom.

Providing space for contemporary art exhibitions can also attract a robust crowd. In Philadelphia, we built an entirely new audience by juxtaposing new art in old rooms. We included both sculpture and installation art to create immersive experiences, and held fashion shoots made more dramatic by the historic context our HHMs provide. In a sold out event at the Morris-Jumel Mansion in Washington Heights, Manhattan, artists and fashionistas came out in large numbers to see the artfully designed corsets inspired by the home's owners.

THEREFORE

Turn strangers into friends. Rather than thinking about increasing the number of visitors to your HHM, focus on building relationships by identifying shared interests.

Do not simply hold one-off programs; consider how you can continuously engage the same "reverse affinity groups" until you reach a point where they feel at home in your space. Engage in a strategy of repetitive messaging to reverse affinity groups so that they see a sincere, ongoing effort towards engagement. Follow the marketing principle that it takes seven touches or seven suggestions/reminders for people to become interested enough to act on the information they have received. Accomplish that goal with communication across multiple media platforms.

Leave the House to Find Potential Partners

Create strong and flexible partnerships with community organizations.

RANT

Collaborate! Partner! Work together! Share staff! Combine efforts!

So say the funders, the laws of best practice, and every keynote at every conference and every consultant writing reports on what's wrong with history museums. Well no one gives you credit for plans— We live in a world of results.

How come no one says anything about how hard collaboration really is? That "collaboration" literally does not exist in the real world?

No group with differing agendas comes together for a project easily or readily. There is suspicion, jockeying for position, sniping, snarking, taking aim with long-held grudges, taking credit instead of pitching in. Nothing is more competitive than non-profits trying to work together. So many personalities, politics, and platforms looking to broadcast old hurts rather than build trust to move forward. It's not in the DNA of non-profit history organizations to work well together.

Collaboration takes so much leadership that it's not funny— it's more like getting people to push a car out of a ditch while wearing

roller skates. It involves pushing, pulling, dragging, slipping and falling,
and force majeur—it does not just happen. It has to be made to happen.
Collaboration? More like "Coopetition."

(David Young, Executive Director, Clivden, Germantown,
Philadelphia)

EVIDENCE

HHMs tend to be territorial and rarely partner, perhaps due to their inward focus on their collections, or because they have yet to realize their potential role in or responsibility to the community. HHMs behave as if they have little community responsibility, even though much of the past success these celebrated families enjoyed came from their ability to develop mutually beneficial relationships and build strong coalitions. Whether due to the patriarch's faith, purpose, or plain ambition, the families who once lived in these houses usually sought to contribute to the greater good. It is ironic that today so few HHMs contribute to their communities in any substantial manner.

In 1961, preservation legend Jane Jacobs wrote, "A successful city neighborhood is a place that keeps sufficiently abreast of its problems so it is not destroyed by them. An unsuccessful neighborhood is a place that is overwhelmed by its defects and problems and is progressively more helpless before them."[27] She suggested that communication across the neighborhood staves off the problem, and that in a city, communication occurs on the streets and sidewalks where residents become aware of and responsive to nuanced changes and threats against it.

Jacobs's explanation of a single organism operating collaboratively to benefit the whole can be extended to describe the relationship of an individual non-profit organization to the larger community. The value of the embedded organizational collaboration is based on relationships, social networks, and cooperation between groups and individuals. The result is the building of social capital and the trust that emerges from collective problem solving.

Anwar Tlili argues that the role of the museum in society has evolved from a "repository of self-sufficient cultural artefacts oriented towards a ritualized connoisseur gaze" to that of a public service similar to the health or education sectors.[28] His perspective reflects the new demands of society on its cultural representatives to actually solve problems and positively affect the community that surrounds them. This new push is affecting not only HHM operations and the use of their collections, but also the context of their interpretations.

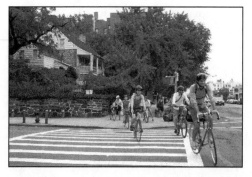

Figure 1.5: Partnerships with outside entities expand an HHM's ability to engage a wider audience. They also have the potential to create a public presence city-wide. Shown here is the Dyckman Farmhouse Museum during the first ever borough-wide bike tour that visited each HHM in Manhattan. The tour was part of the annual Fall Festival, an event created by the Historic House Trust of New York City in partnership with over 20 organizations. *Photo: John F. Yeagley, 2011.*

Cangbai Wanga, writing about a House Museum in China, states a similar perspective suggesting that the museum is moving away from "a narrow and static view of heritage as authentic objectification of the past" in favor of seeing heritage as "dynamic meaning-making processes embedded in a wider social-historical context intertwined with material surroundings" while grappling with "the challenges of... telling the history of a singular household as part of a broader history."[29]

Leaving the House and making these types of contemporary contextual connections suggests the value in partnering with other groups and institutions. In the *Participatory Museum*, Nina Simon refers to community partnering as co-creating and lists three reasons to undertake the exercise:

1. To give voice and be responsive to the needs and interests of local community members,

2. To provide a place for community engagement and dialogue,

3. To help participants develop skills that will support their own individual and community goals.[30]

Part of seeking out and facilitating partnerships is that HHMs can benefit from the knowledge and experience of others, a huge asset given the small number of HHM staff members. In 2012, the Historic House Trust of New York City fundamentally re-structured an annual fall festival by partnering

with food related businesses and other local organizations. Prior to that time, the festival was an internally based citywide open house for all 23 of the HHMs in the HHT portfolio. There was no themed purpose other than promoting the houses as a collection. The new strategy was to locate a city-wide partner with whom HHT could organize a theme. The theme became "A Movable Feast," and we grew from zero partners to over 20 in three years. The festival gained statewide attention and garnered an Award of Merit by the Museum Association of New York for community engagement.

THEREFORE

Expand your mission to include community engagement. Work to embed your HHM into the neighborhood in relevant and meaningful ways.

Hit the sidewalk. Attend community meetings. Participate in the life of the surrounding community to build social capital.

Make a list of local non-profits and government agencies and call on the leaders of each of them. Share the mission of your HHM and explore how there might be existing programs to which your House could contribute.

Initially focus on contacting those organizations that have the most overlap with the interests of your HHMs and the families who once occupied the home. Were they immigrants? Were they the builders or buyers of the home? Did the family practice a particular religion? Did they grow their own food? Did they help feed the hungry? Did members of the family teach English as a second language? Did a wife or daughter die in childbirth? Was there any mental illness in the family? Did they own slaves? Were they part of the Underground Railroad? Did the head of the family have a profession like being a doctor, lawyer, or statesman? Those family narratives can provide direct linkages and partnering opportunities with agencies that support people in need and have already established a long history of assisting them. Whether it is legal aid, a food cooperative, women's health care, the NAACP, or victim's rights organizations, there is probably an abundance of shared ground to which your HHM can contribute. But first you must come to believe that your HHM can be an agent of change, or at the least a place where it can happen.

The easiest way your HHM might contribute is to simply make room for your partners by giving them access to some of the rooms in your house and the property that surrounds the house. Some sites, like the living history museum Strawberry Banke in New Hampshire, rent out empty upstairs rooms to tenants and businesses.[31] Our friends at Washington

DC's Heurich Historic House rent out a carriage house as live/work artists' spaces to both produce income and engage a new constituency.

Spend at least one day a month as a "community day" outside your HHM. Reach out to community organizations. Meet with local social service providers, and the leadership of arts and cultural organizations. Ask about their needs, challenges, and priorities to identify mutually beneficial opportunities to partner. Make this community outreach a part of each staff member's formal job description.

Attend community-wide festivals and stage a participatory activity that invites attendees to learn something about your HHM, while you also learn a little something about their interests. Offer to speak at a partner organization's meeting about your shared interests and tell a short story about your HHM and the goings-on that occurred there. Since most public meetings are small, you could invite attendees to more intimately engage with a series of artifacts you have brought from your collections.

Transposition

In unexpected ways and in unexpected places, implement compelling strategies to introduce your HHM to the community.

RANT

If we want to move forward, we really need to get outside of ourselves and hear from the people who aren't coming. We should be looking toward evaluation data as a way to learn and make our programs better, more inclusive and more impactful, not to have evidence that we're just fine, thank you.

(Rachel Abbott, Program Associate, Historic Sites and Museums, Minnesota Historical Society)

EVIDENCE

Most HHMs believe that the visitor experience begins and ends at their front door. They limit the sharing of their House's narratives to people who venture inside. Walter Benjamin, creator of the controversial *Arcades*

Project, writes of this challenge relative to more mainstream museums, but the same can be said about HHMs:

> Constructed like dreams (of the past) in which there is no escape; their interiority, like the state of dreaming, becomes self-containing as the experience of the past. This self-contained 'tomb'... is an ironic space for the representation of historicity—bringing history inside ... in order to make it seem safe and self-validating ... (and) monumentalize time into something static and enclosed as if there could be no change, no rupture and no glimpse of an outside...[32]

Thousands of potential guests await in the neighborhoods that surround HHMs. Attracting them to the front door is the challenge. We can learn how from other arts and cultural organizations who have gone outside their traditional venues in search of new audiences. Certainly, there is plenty of room for growth.

The National Endowment of the Arts, for instance, estimated that only two percent of Americans have ever attended an opera.[33] Recognizing this statistic as both a challenge and opportunity, while also acknowledging the perception of their art as being elite, inaccessible, and a purview of only the educated and rich, the Metropolitan Opera began to transmit some of their live performances to AMC movie theaters around the world in 2006. The Indianapolis Opera staged *La Traviata* in a flash mob-like fashion during a busy lunch hour at the Indianapolis City Market to raise awareness for an upcoming performance.[34] Following suit, the Orlando Shakespeare Company staged a performance of *One Day More* from *Les Miserables* in the center court of The Mall of Millennia.[35] Over the holidays one year, 650 members of the Opera Company of Philadelphia and other performers emerged from the crowd of shoppers to sing the *Hallelujah Chorus* at Macy's. The moving event was posted on YouTube, went viral, and has been viewed over 8 million times.[36] Admittedly, none of these events provided a complete answer to addressing the challenge of poor opera attendance, but they did extend the reach of performances outside the opera house and potentially engaged new audiences, especially through digital media. That result is apparently a notable trend. The 2013 *Americans for the Arts: Arts Index* suggested the potential of digital content to counter declining attendance, with 65 percent of music industry sales coming from digital downloads in 2011. "The evolving delivery model is digital," so it is highly likely that arts groups will "have to compete in new ways. The public is certainly

not walking away from the arts, but they are walking away from some traditional models of delivery."[37]

Yet regardless of their reach or impact, all these operatic performances were acts of *transposition*, the removal of something, or some act, from one place to another, usually to where it initially seems out of place. Relative to HHMs, transposition could refer to the transfer and replication of historic exhibitions in non-museum spaces, like retail and service settings.[38] Josh Treuhaft has undertaken an act of transposition in NYC with Salvage Supperclubs. Guests are invited into dumpsters to have dinners that feature ingredients that would normally be thrown away, like stale bread and scraps of meat. The goal is to highlight the prevalent but oft-ignored issue of food waste.[39]

Inspired by UNCC Architecture student Paula Benitez-Ruiz's temporary bus shelter ideas, we created three Mobile Kiosks to bring the story of Lewis Latimer out into the community of Flushing, New York, by sharing items that could have come from his nearby historic home. Our work is similar to the suitcase-sized Museum in a Box programs discussed earlier.

The Mobile Koisks also echoed the Wunderkammer-inspired *The Museum*, New York City's one-room exhibition space in a former freight elevator. The exhibition design company Fabrica Features created a similar collection, but it was made up of items contributed from all over the world curated under the theme of "Family." While unique in each setting, it was displayed at the Milan Furniture Fair, the Victoria and Albert Museum, and as part of Design September in Brussels.[40]

Other precedents of transposition include *Participatory City: 100 Urban Trends* from the BMW Guggenheim Lab, especially relative to the concepts of *Bottom-up Urban Engagement, Department of Listening, Local Knowledge, Non-expert, Participatory Urbanism, Urban History*, and *Urban Sound*.[41] The Street Plans Collaborative's *Tactical Urbanism 2: Short Term Action, Long Term Change* is also noteworthy, especially relative to *Park(ing) Day, Pop-up Retail, Chair Bombing, Food Carts/Trucks, Pop-Up Town Hall*, and *Mobile Vendors* for providing insight into inexpensive, immediately doable projects.[42]

THEREFORE

Through transposition, share your HHM's narrative, rooms and collection with a broader audience. This effort needs to take place at unexpected places and focus on uninterested audiences. The act of community engagement is essentially full of risk, as well as great rewards. A large part of this

activity needs to be informed by an intensive demographic study of your neighborhood and larger social composition. This effort also relies on an understanding of language differences and cultural relationships.

Meaningful partnerships can be found in outreach in unexpected places—retirement homes, special needs educational facilities, barber shops, groceries, movie theaters. If your goal is to expand your reach and engage new audiences, then go to constituents that are new. For instance, mount an exhibition of replicas in places where the audience you wish to attract already goes. Be sure to invite the public to interact with the installation. Encourage them to use the room as the original was intended, to sit on the chairs, put their feet on the furniture, read a book, and have a cup of coffee.

Every time you leave your HHM, consider it an opportunity for transposition, even at your own fundraising events. At the Historic House Trust's Annual Founders Award Dinner, we unveiled an upcoming partnership with Materials for the Arts by hosting a "Tinkering Studio" during the event. The Tinkering Studio would take up residence at Lewis H. Latimer House in Flushing later that year. By bringing this programmatic effort to our organization's main fundraiser, we introduced it to a group of donors and gave them a teaser and a reason to visit the remote Latimer House.

CHAPTER 2.

COMMUNICATION MARKINGS

Communicate Diversity

The HHM organization should reflect the diversity of its immediate neighborhood in all forms of communications.

RANT

Me at a historic house: 'Were there slaves here?' Guide: 'Yes, but they had very nice quarters and were well cared for' and that was it.

See, the primary problem with slavery is not that your house might be bad. It is that you are a slave.

How is it that at historic sites, our stories of slavery still somehow end up being all about the white people involved?

(@AFamhistfail; from three consecutive tweets on January 24, 2014)

EVIDENCE

Most HHMs do not significantly alter their communications strategy to address the changing demographics in their neighborhoods. The lack of

diversity in messaging is a systemic challenge, and it is at the heart of many HHMs' problems with relevancy. Evidence can be found at all levels of the organization, from the narratives shared, the programs offered, and the make-up of the board of directors, staff, and volunteers.

An HHM's dedication to diversity is conveyed by both what is said (manifest) and was is unsaid (latent communication). This missing information conveys an equally powerful message.

> The meaning of even the most prosaic utterance is grounded in a set of implicit assumptions about what the communicators know, believe, feel and think. People experience the world from different vantage points, and the totality of each individual's experience is unique to the particular vantage point that he or she occupies. To accommodate discrepancies in perspective, communicators must take each other's perspectives into account when they formulate and interpret other people's utterances.[1]

Emily Dawson found that minority groups visit cultural institutions less than majority groups, at least in part because they held pre-existing perspectives that museums were *not for them,* and even that best practices for museums reinforced a feeling of exclusion.[2] Similarly, the latent messaging of HHMs may unintentionally be dissuading minorities from visiting.

On the other hand, HHMs purposely leave out known information, because they deem it to be too controversial or potentially offensive to the majority population. In many cases, the very process of preservation results from ideas about anti-immigration, anti-Semitism, racial bias, political and economic class struggles.

The communications from Philadelphia's Powel House also once left a lot of their history unsaid. In 1930, the House was owned by a Jewish merchant and located at the edge of the city's expanding Jewish ghetto south of Washington Square East. Conjecturally, it was purchased and restored by a private preservation organization to stop the northern movement of Jewish migration into the center of Philadelphia. The J. M. Brewer's map of Philadelphia (1934) notes exactly the Northern-most edge of the Jewish population and labels it as "J" (Jewish) and "D" (Decadent), and that edge of occupation rests exactly at the Powel House location.[3] This conjectural relationship with Philadelphia's Jewish community has been largely suppressed in favor of a more romantic Colonial narrative of Society Hill. HHM organizations rarely speak of these complicated and messy beginnings or the motivations that drove the preservation efforts, because an

informed public's perspective results in questioning the validity, sincerity, and accuracy of the entire Historic House genre.

The Wren's Nest, the home of Joel Chandler Harris, author of the controversial Uncle Remus stories, no longer shies away from its history. Located in one of Atlanta's primarily African American neighborhoods, the house was shunned by many because it was the home of a white man who profited from telling slaves' stories, and had a longstanding practice of not allowing blacks to visit, at least not until 1984. Director of the House, Lain Shakespear, says, "We're letting people know the full story, instead of the story that's been told by other people. We talk about it. We don't sweep it under the rug." By preserving both the legacy of Joel Chandler Harris AND the heritage of African American folklore, the HHM has become an educational resource for the city of Atlanta.[4]

More recently, the conversation about diversity has expanded to include the Lesbian, Gay, Bisexual, Transgender and Queer community. The Historic House Trust of New York City commissioned a series of re-enactment photographs reflecting originals taken by photographer Alice Austen. Austen's photographs depicted social parties of the elite Avant-garde in late 1890's New York City. The original photographs were staged in such a way as to hint at the alternative culture of those photographed. Until 2010, the 50-year marriage of Austen and her partner Gertrude Tate had not been fully expressed in the historic narrative of "Clear Comfort," her homestead and now Historic House Museum. These photographs and the accompanying article communicated an openness of the historic site to include marginalized narratives, so much so that in 2015 the HHM openly embraced the full narrative of the couple's lives, and for the first time ever, the House staff participated in the New York City Gay Pride Parade. The site's executive director, Janice Monger, has also established a LGBT advisory group to help the historic site more fully interpret the life of Alice and Gertrude.

In San Diego, activists are seeking to save the Bernie Michels House as a community center, in honor of his creating the San Diego Gay and Lesbian Center. The home is of interest to the Save Our Heritage Organization (SOHO) because of their interest in sites that are important to the Civil Rights Movement. Bruce Coons, executive director at SOHO, says the "Bernie Michels site has been on SOHO's radar for a number of years, first for its architectural significance, as one of only two known New England style salt box buildings in San Diego, and for its significance as the

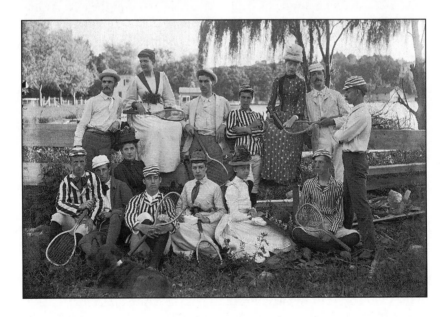

Figures 2.1–2.4: *Top left*: Alice Austen photographing female friends and her-self in cross-dressing outfits, using an umbrella as a phallic symbol. Staten Island Historical Society. *Top right:* 2010 Re-enactment of the original Austen photograph with contemporary Brooklyn drag Kings. *Bottom left:* The original Austen photograph of one of her many avant-garde parties in which she invited a diverse mix of friends whose relationships can be seen in the subtle clues in the photograph. *Bottom right:* 2010 re-enactment of the original Austen party photograph allowing for a more contemporary view of the same conjectural relationships. This photo series was commissioned by the Historic House Trust of New York City in their quarterly journal for a ground-breaking article about the 50-year relationship between Alice Austen and Gertrude Tate. (*Tennis group*) "Large group on tennis ground" (Austen's original title), Lake Mahopac, NY, August 10, 1888. *(50.015.6932) (Dressed as men)* Julia Martin, Julia Bredt, and Alice Austen dressed as men (original title not known), October 15, 1891. *(50.015.6610).* *Photos: Contemporary images organized and photographed by Stephen Rosen.*

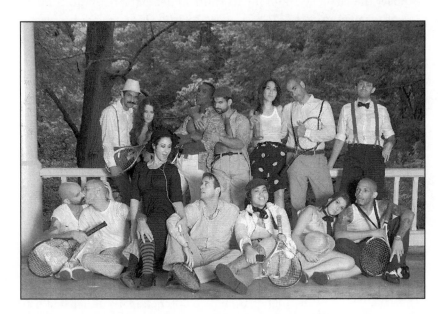

site where the formal organizing of San Diego's struggle for recognizing and protecting LGBTQ rights began in earnest."[5]

THEREFORE

An HHM's organization, staff and historic narratives should be reflective of, and speak to, the community that surrounds it, not simply to the society for which the narrative might have originated. This effort has great implications for re-organizing structure and operations.

On the negative side, increased efforts at inclusion have been treated primarily as add-ons and not as necessary changes to the heart of white institutions. Now, when asked about diversity, most white institutions can point to a particular program or initiatives and say, "We've got that covered." In the worst cases, demographicly-targeted programs can be used as fundraising shills ("poverty pimping") to protect the white privilege machine that most of the budget fuels. The overall result is that white museums are grossly unprepared to meet the challenge of dramatic shifts in demographics and cultural engagement interests. *They've added colorful patches to their garments when the whole cloth needs to change.*[6]

To undertake a more holistic approach, HHMs should acknowledge the complex relationship to minority populations in both the history of the House and in its preservation as a museum. After undertaking significant demographic research, the HHM should consider diversifying the staff and volunteers to better represent the surrounding community and seek to re-state the House's narrative and activities from multiple social/language/economic/cultural perspectives.

Communicating diversity is not simply a matter of crafting a message of inclusion; it is about illustrating a sincere commitment across an organization. Adopting a more enlightened perspective will have a direct impact on visitation, funding and community involvement because doing so addresses market forces. If your HHM is not providing the cultural diversity, services, or products that are valued by the country's changing demographics, then consumers will go somewhere else.

In the United States, out of around 86,000 nationally designated historic sites, only 3 percent explicitly represent minority populations defined by race, ethnicity, gender, or sexual orientation.[7]

Get Chatty

Move toward an informal communication style and integrate social media.

RANT

When one loves history and technology, it is sometimes difficult to observe the way some museums deal with these two concepts. How does one connect people of the present with the people from our past? Certainly it isn't cutting off all use of photographs and smartphones inside the museum. That is the absolute wrong way to go about it. It makes me think they know the museum is only as strong as its best two pieces of the collection. It makes me think they fear if photographs of the 'big finish' as you complete the tour spreading around online may stop future people from visiting... hey, they've already seen the big finish, right? This type of thinking cuts off all FREE ADVERTISING, cuts off all social media; it leaves the museum back in its past. Inspiring the young generation to include the museum in future memories should be the goal of every historic business model. Let them take pictures, Tweet and Instagram!

(Dan Boujoulian, visual effects artist)

EVIDENCE

Historic House Museums have a reputation for being serious, fact-based, and selective to the point of being almost elitist in their communications. They are certainly not known for being chatty. On the contrary, we often have heard from HHM board members and staff that the House's signage and communications need to reflect the dignity and seriousness of the site and its narrative. This perspective often leads to beautiful signage with gold-gilded edges and professional placards upon which announcements are placed that read more like a history course syllabus than an invitation.

This kind of stylistic formality is out of step with how Americans now communicate. As of 2014, 90 percent of all American adults had a cellphone, and a full 58 percent used a smartphone. Most interestingly, 74 percent of all adults over the age of 65 used a handheld device. As of the same year, 17 percent of all internet use was through smartphones.[8]

According to a 2012 Pew Research Study of the United States, the percentage of Latino and Caucasian adults using a smartphone grew from 76 percent in 2009 to 86 percent in 2012, while 90 percent of all African-Americans owned a smartphone.[9]

In response to the growth of cell phone use, the popularity of social media, and the immediate and prevalent exchange of information, traditional forms of mass messaging and branding are being reconfigured across most markets. As the world shifts into quicker, more concise, chatty forms of communication, HHMs must move towards mastering these new methodologies and editing the presentation of their Houses' content accordingly.

Contemporary communication platforms are not merely a means to advertise, they are powerful conduits to engage people. It is hard to overestimate how the ease of access to the internet has impacted socio-political events around the globe, or the ability of social media to mediate compromise and unify disparate identities into a cohesive block. The tone of this kind of interchange is due in part to Twitter allowing only 140 characters, Snapchat's limit of 31 characters alongside a ten-second video clip, and Vine's six-second long strand of repeated images. These forms of micro-blogging have become the online version of the water cooler chat, because they provide the opportunity to make immediate connections between disassociated participants and increase the chance to capitalize on shared interests: "We found that micro-blogging was useful for increasing awareness of what is on each other's mind; this in turn implies that it may help to generate more common ground that can be used to support future conversations."[10]

Clearly, there is a link between history making and new media. In 2012, NASA's Facebook page had over 1.6 million likes, the Mars Rover was averaging about 30,000 Twitter mentions a month, and James Cameron's "deepest tweet" came from the Mariana Trench located seven miles below the surface of the Pacific Ocean. "In an age of despair over math and science acuity, it appears that what was once considered uninteresting or unfathomable has become cool and exciting."[11]

Many historic sites are beginning to use new media in ways that both engage and educate new audiences. Mount Vernon recently Tweeted a picture of a surviving set of George Washington's dentures that are now archived at the site. The Tweet spurred a blog post on their website, garnering enough attention to eventually inspire a *New York Times* article on the topic.[12]

Several HHT House Museums have invited visitors to use social media to announce events as they took part in them. The guests willingly volunteered

I Tweet Museums @ITweetMuseums · Apr 5
From a behind-the-scenes tour @VCHMNYC for an #LGBTnerds meet-up.
Increased visitor access promotes excited tweets!

👤 Van Cortlandt House

Figure 2.5: By integrating the informal, chatty conversations common in social media, HHMs convey a willingness to consider both innovation and diversity. *Above:* The National Society of Colonial Dames' Van Cortlandt House Museum (VCHM) Executive Director Laura Carpenter gives a peek into a normally un-seen aspect of a collection object. This interaction, documented in this Tweet, was part of an *Anarchist Guide* pilot program using a Meetup to produce an "LGBT Historic House Museum Nerds Unite!" Group. VCHM rose to the challenge and produced a social media driven scavenger hunt for the attendees and opened up the entire house from the basement to the attic in an effort to test the Anarchist concepts. *Photo: Franklin Vagnone from a Tweet by @ITweetMuseums*

to advertise the House on their Facebook pages and Twitter feeds. For instance, the Van Cortlandt House Museum held one of our HHT LGBT Meetup events at the house and asked the attendees to roam freely through the HHM from basement to attic and locate artifacts in the collection based upon a series of clues. Participants then Tweeted pictures of the objects to the @HHTNYC and @VCHM twitter accounts in a friendly competition.

During an exhibition on nineteenth century funerary etiquette at the Merchants House Museum, visitors crawled into a display casket and posted a picture of their experiences on their Facebook pages.

THEREFORE

Imagine how you want the community to see your HHM, and use your communications as a means to achieving that vision.

Make sure that your organization's communications are conversational in tone. Be very selective in the ways educational information is conveyed, recognizing that it is hard to engage a community in conversation if all you are doing is talking *at* them rather than *with* them. Just imagine sitting in your own living room and having a discussion with a friend. That is exactly how your communication style should feel. All it takes to get started is a smartphone, a work computer, and a small bit of attention throughout each day, but the impact can be wide reaching.

One of the best ways to get chatty is to make communications a staff-wide responsibility. Unlike larger organizations, small non-profits do not have the luxury of devoting 100 percent of one or more staff members' time to the task. Assign every member of your staff to a different day and media platform. The goal in dividing the responsibilities is to seek out diversity and variation in ideas and tone. Mind you, this advice is going to be inconsistent with what most corporate media officers demand, because they strive to convey a singular voice and perspective across their entire organization. For HHMs, we prefer to encourage a communication strategy that better reflects the same sort of cacophony of voices that would have once arisen from our quirky places of domesticity.

Listen and Dialogue

Do not take yourself too seriously. Be a good host; don't simply tell guests the answers. Let them bring their own ideas to the conversation.

RANT

I worry that we think we're already providing these great participatory experiences for our guests simply because our tour guides ask questions every now and then. Not all questions are created equal. 'Who knows what happened in 1861?' might feel to the guide like an easy, inclusive question but God forbid there's someone in the group who doesn't know the answer. They'll immediately feel stupid and will mentally bow out of the experience. Also what was the point of that question? We need to meet people where they are and ask them about things that a) they care about, and b) they are fully capable of answering.

(Rachel Abbott, Program Associate, Historic Sites and Museums, Minnesota Historical Society)

EVIDENCE

HHMs talk about themselves and their own stuff far too much. We are hyper-focused on our serious missions, our serious narratives, and our serious collections. Unfortunately, the presentations tend to resemble the dreaded situation at a party when an individual dominates the conversation and leaves everyone else personally unengaged. Guests leave with ambivalent feelings because they did not participate in a *dialogue,* but rather suffered through a *monologue.* They may know more about the HHM, but they probably don't care any more about it, because they were not given the opportunity to build a relationship with the historic site or the people who once lived there.

The Happy Museum Community of Practice project examined the importance of building relationships and the potential role of museums in their neighbors' well-being. Twenty-two participating museums created programs that connected neighbors through projects and discussions; provided forums about social justice, environmental sustainability, issues of life and death, and unfair labor practices; and collected local stories, photographs, and artifacts.

What the Happy Museum Project is trying to do is to show that the context is now different. Environmental change, pressures on the planet's finite resources and awareness that a good, happy society need not set economic growth as its most meaningful measure offers a chance to re-imagine the purpose of the museums. Museums should realise their role as connector, viewing people not as audiences but as collaborators, not as beneficiaries but citizens and stewards who nurture and pass on knowledge to their friends and neighbours.[13]

Contextual awareness requires conversations that are about more than just the good times of a place. Earlier inhabitants often endured very difficult events and were not immune to rape, slavery, war, bigotry, and political unrest. Relaying their stories of survival through these and other challenges potentially fosters a conversation, invites a diversity of opinion, and welcomes discord as a healthy component in a civic dialogue. Research even suggests that when students bring their personal experiences and feelings into a discussion, their overall understanding of the topic is enhanced.[14] But this troublesome knowledge is something that HHMs often shy away from.[15]

Listening campaigns that encourage challenging dialogue are common in many fields, if not HHMs. New leaders, especially political leaders, use listening campaigns as a way of getting to know their staff/constituents and their most pressing concerns. Between the election and inauguration of a new mayor in New York City, an extensive public outreach program entitled *Talking Transition* invited residents to share their ideas for the future of the city. Through on-street interviews, public forums, and visually interactive displays, hundreds of thousands of New Yorkers contributed their thoughts to a lively and sometimes discordant dialogue.

Oral histories offer a similar opportunity to record differing perspectives. Using either audio or video recordings, the process can collect personal historical information and place it within a meaningful context. Often the recordings feature a dialogue between two people rather than a single narrative voice. The recording process is not new to HHMs, although the gathering of personal stories is typically limited to being an archival exercise, and the information is stored away for the sole use of future researchers. An exception was *Come Sit a Spell: Memories from a Forgotten Neighborhood*, an art and oral history exhibition in Providence, Rhode Island. The interactive soundscape featured stories told by the former residents of West Elmwood before the neighborhood was deemed blighted,

demolished, and replaced by a new industrial park.[16] *Century Speaks* was an oral history initiative undertaken in 2003 by BBC radio stations to record people's memories from WWII before they were forgotten.

Oral history projects like *StoryCorps* can also build community. The Peabody Award winning program's mission is to "record, preserve, and share the stories of Americans from all backgrounds and beliefs." Their first recordings were made in a sound booth located at New York City's Grand Central Terminal, but people can now contribute via mobile studios in airstream trailers that travel the United States or via a mail order *StoryKit* service. Most importantly, the 45,000+ recordings can be accessed by the public at the American Folklife Center at the Library of Congress in Washington D.C.

THEREFORE

Rather than starting with a lecture, HHM presentations should begin by learning about the guests' personal interests. Be careful not to sound like a know-it-all, and try to draw out differing opinions and perspectives.

Also learn what is of interest to the surrounding community, and become a news source for those subjects, as well. Anything you come across that touches on those areas should be conveyed back out to the world. Use all modes of communication to present your interests as far outside of your own four walls as possible. It is far better to be considered an interesting news source than a self-serving advertiser.

In our Anarchist's Guide Historic House Workshops, we always end with a debrief of all participants, in part to see where we might have had blind spots or been ineffective. We suggest a similar focus group be created at your HHM. Set up a Citizens Advisory Group (CAG) to advise the board. Invite people of all incomes and ages in the community to participate, not just the well-to-do, so that they can share a wide variety of perspectives. Listen to what they say. If the CAG feels as if their suggestions are being heard, and tried, they will invest more time and effort, and eventually bring members of their peer groups to the HHM.

Keep It Real and Openly Acknowledge Dissonance

Be selective in the use of pretend forms of communication tactics and methodologies.

RANT

Although I thoroughly enjoyed the experience, there was one aspect that was less successful in my opinion, and sadly this is one I come across on many occasions... the historical re-enactors. I never quite know how to take on board the ubiquitous scullery maid or house-keeper in Victorian garb (I presume the National Trust buys the costumes in bulk?), especially when they suddenly feel the need to address you and start providing historical information without any prompting. I'm very much aware that this might add to the experience for some visitors, such as family groups or perhaps even those looking for a live Downton Abbey experience, but surely I'm not the only one that likes to explore and use the power of imagination? Of course I'll change my opinion the moment I encounter a historically accurate footman that takes his role seriously enough to serve visitors a nice drink from the table in the library to accompany the roaring fire.

(Jonathan Gration, PhD researcher at De Montfort University [AGHHM LinkedIn, Historic Interiors Blog post])

EVIDENCE

It can be argued that we all wear some sort of costume to mark ourselves as a part of a certain tribe, whether it be gothic, hipster, arty, preppy, creative, professorial, conservative, golfer, sailor, blue blood, or just plain wealthy. As Pravina Shukla wrote, "Costume is deliberately used to project an elected identity, specific to the time, place and audience."[17] But to *others* outside the in-group, these costumes can be off-putting.

How many of us have cringed, if ever so slightly, when we encountered a costumed, overzealous re-enactor performing a historic narrative, especially when it is delivered in ye olde English? While we know the experience is imitative, the re-enactors seem oblivious to the fact, and their performance casts doubt on the legitimacy of the HHM's narrative. There is

awkwardness in the pretense of the pretend, especially if we are forced to participate in an imaginary world that is not of our own making.

Costumed docents in HHMs occupy a place between teacher and performer. While history lovers may enjoy the make believe, less seasoned visitors may find the pretend to be off-putting because it places them in the role of an *other*, confused and unwelcome. From a theatrical perspective, period dress contributes to the construction of a fourth wall, removing guests yet another step from experiencing the House as a home.

However, the conceptual disconnect does not seem to carry through when the costumed docents are undertaking the actual tasks for which they are dressed. We have often experienced costumed docents cooking in HHM kitchens using historically accurate methods and tools, and found their conversation while at their work to be somehow comforting. Maybe it is the familiar smells or the shared food that makes these moments memorable. We suspect it is the authenticity of a shared experience that reaches across eras.

It also seems true that if visitors are invited to take part in the imaginary narrative beforehand, they will often enthusiastically join in. Look no further than the once late night gatherings for the Rocky Horror Picture Show, Star Trek Conventions, Comic-Con, or Renaissance Fairs, where thousands of people from all walks of life dress up in costumes to participate in a shared experience.

It is important to acknowledge the wall between what is real and what is theater. On the one hand, we present ourselves as fact-speaking, trained museum experts relative to our HHMs. But on the other hand, guests often see us as mildly kooky adults playing make-believe, pretending that the long dead owners of the House just left the room.

Educational theory suggests that it is far more effective to invite guests to conjure up a world of their own and imagine how they would maneuver through it, than it is to create a fully rendered, but homogeneously experienced pretend place.[18] Pretend City Children's Museum in Irvine, California, embraces that theory and allows children to roam freely throughout a miniature city and role play in a grocery store, art studio, house, café, bank, hospital emergency room, health center, and on a construction site and a farm. They are not led through the museum, but are rather encouraged to partake in a journey of self-discovery.

It is not that these types of presentations are too confusing or irreconcilable. Research suggests that when people are presented with opposing concepts, they will usually investigate the differences and understand the

narrative at a deeper level if the disconnect is clearly communicated.[19] We believe that our guests have a higher capacity for comprehending ambiguity than we give them credit for. It is good to let go and pretend, but the fiction should be thoughtfully disclosed as part of the HHM experience.

Clearly, costumed characterizations are a challenge for HHMs and should only be used if an attempt is made to bridge the conceptual discord between historical fiction and modern day realities. Otherwise, the obfuscation leaves guests questioning whether their roles are as unwilling participants or exposed voyeurs.

There are some cases where such historical fiction is popularly successful, like at Plimoth Plantation where re-enactors portray actual residents of Plymouth Colony and work alongside museum guides who speak from a modern perspective.

An example of a thoughtful, history-based yet contemporary expression of pretend can be seen in comedian Greg Edwards's (AKA Sparky Sweets, PhD) "Thug Notes." The video series consists of Sparky Sweets, who sits in a formal library wearing a do-rag and tank top, giving verbal plot descriptions of important pieces of Western literature. Sparky's commentary and plot outlines are all presented in hip-hop slang with urban street language and nuances. Of course, Edwards's character is in costume, but the interpretive quality and presentation (by contrasts) also allows the viewer in on the imaginative scene. Even though the action, aesthetic, and inflection are pretend, the purpose is not. "[It is] my way of trivializing academia's attempt at making literature exclusionary by showing that even highbrow academic concepts can be communicated in a clear and open fashion."[20]

A similar play of contrasts can be seen in the acclaimed "Hamilton" theater production by Lin Manuel Miranda. The cast moves freely in and out of rap, hip hop and slang to tell the story of Alexander Hamilton and the founding of the United States.[21] The audience is pulled into the "gag" and feels a part of the action, rather than being passive viewers. In this case, the costumes serve as contrast to the larger whole.

In 2013, re-enactor and educator Azie Dungey began producing an online series called "Ask a Slave" in which she portrays Lizzie Mae, a fictional house slave at Mount Vernon. In costumed character, she answers the outrageous questions she was actually asked when she played a house slave in the education department of an HHM. The series is educational, funny and uncomfortable. What is real? Who is in charge? The costumed actor, the visitors, or Azie? Due to the acknowledged overlaps between historic fact, contemporary fiction, and theater, perhaps they all are.

And in the midst of all this, I was playing a slave. Every day, I was literally playing a slave. I mean, I was getting paid well for it, don't get me wrong, and we all need a day job. But all the same, I was having all these experiences, and emotions. Talking to 100s of people a day about what it was like to be black in 18th-century America. And then returning to the 21st Century and reflecting on what had and had not changed. So, I wanted a way to present all of the most interesting, and somewhat infuriating encounters that I had, the feelings that they brought up, and the questions that they left unanswered. I do not think that *Ask a Slave* is a perfect way to do so, *but I think that it is a fun, and a hopefully somewhat enriching start.*[22]

THEREFORE

Acknowledge that the pretend romance of Historic House Museums is not necessarily the best way to frame public communications or programming. Be selective in using imaginary theater in everyday tours and be sure that the re-enactors acknowledge the fiction of their portrayals, and how their role is disconnected from modern day experience. As long as the discord is verbalized, it can benefit the larger visitor experience in a way that heightens the dialogue between the docent and the guests.

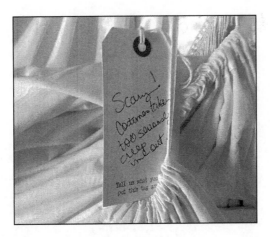

Figure 2.6: *Anarchist Tag* tied to a period costume in a storage room is from the Mabry-Hazen House, "Scary! Costumes taken too seriously: creep me out," records a guest's discomfort with pretend dress-up. *Photo: Franklin Vagnone.*

In some of our Anarchist's Guide Workshops, our guests have used *Anarchist Tags* to express their discomfort with costumes, mannequins, pictorial cutouts, and even "scary doll collections!" In the Mabry-Hazen House workshop, an *Anarchist Tag* was tied to a period costume stating, "Scary! Costumes taken too seriously: creep me out."

Even given the possible failures, Historic House Museums should have the flexibility to experiment with new, innovative methods of communicating dissonance and the complexity of the narrative. The visitor experience should revolve around multiple, creative, imaginative moments of exploration. Encourage both group and personal moments of creative play. Controversial, open dialogue should be the starting point of any informational exchange at your HHM. This subject deserves a greater degree of study as we also acknowledge variation in motivation and quality among historical re-enactors and interpreters.

Avoid the Bait and Switch

Make sure the guest experience at your HHM matches your communications.

RANT

We were pleased when we got an email this morning ... reminding us that today was free admission Family First Sundays... So after making the trek out to the estate we were disappointed when we were told at the gate that we would need to pay $18 if we wanted to get in... I told the woman at the gate that in their email it said that the first Sunday of the month was free but she wouldn't have it, insisting that we pay the $18. So reluctantly I shelled out the $18 and we headed into the estate. At least I'll be able to get some good photos out of it I thought. But then, again, imagine my disappointment when we'd arrived at the estate and I saw a big "No Photography" sign in front of the estate.

Now, before heading out to see the estate I did a thorough review of their website and saw no photography prohibition anywhere on the site. What's more, I was not told about the "no photography" policy at the front gate before they took my money when I had an extra-large Canon

5D Mark II hanging around my neck. No, it wasn't until they already had your money that they decided to inform you about this policy... So I was double bummed after being promised a free Sunday for my family to find that now my joy and past time [sic] of photography was also being denied... Now I know times are tough for non-profits, and for all I know maybe the ticket charger woman was simply scamming us and pocketing the money herself, but baiting and switching people promising them a free family day and then charging them $18 when they arrive is not right.

(Thomas Hawk)[23]

EVIDENCE

HHMs' messages do not always reflect the reality of guests' experiences, whether in terms of entry fees, access to rooms, or display of artifacts. The miscommunication sometimes distances guests from the narrative of the House as they feel duped when the reality does not measure up to the expectations created through outside communications. It is a sort of false advertising that builds distrust, alienates guests, and eliminates repeat visits. Yet, it is a common strategy employed by many cultural sites.

Nina Simon, Executive Director of the Santa Cruz Museum of Art and History wrote of her disappointment with the Indianapolis Museum of Art after hearing the institution's director, Max Anderson, speak of how museums should use the web "to give online visitors the same level of emotional, experiential, exciting engagement that they have onsite" and of moving from the "virtual to the visceral."[24]

I was thrilled by Max's talk and looked forward to seeing how the physical site reflected the transparency and engagement he spoke about. I showed up at the IMA expecting innovation. Instead, I found a standard art museum. Nice art. Impersonal guards. Lovely grounds. Obtuse labels. Interesting architecture. There was nothing that connected me to the visceral, exciting institution Max had sold in his talk, the institution that exists on the web.[25]

Similarly poor reviews of museums can be found across the internet, and it appears that many are due to what visitors perceive as a bait-and-switch. A visitor from New York City reviewed Dran's Castle on TripAdvisor:

The castle is "advertised" as Dracula's Castle (which is also evident when looking at most of the tourist souvenirs being sold by the

countless merchants near the castle), but once you get into the castle the exhibits are mostly about the Habsburgs and discuss how the castle was used centuries after Vlad the Impaler was dead.

Also on TripAdvisor, a visitor from Hawaii reviewed the Whitney Museum, writing that

> the Whitney promotes itself as the place to see works by Edward Hopper. They certainly feature him on their website. But when I went they only had a grand total of TWO (2) Hopper paintings on display... If they don't have any Hoppers on display then how about at least warning potential visitors on the website. It doesn't surprise me when K-Mart or the used car lot practices false advertising, but when a respectable art museum does it that's disgusting.[26]

A person from Cleveland, Ohio, and many other visitors also wrote on the travel review site of a similar frustration with the Salem Witch Museum:

> For all the flashy brochures that were available in Boston, this one had an attractive one. Our time was very short so we chose what we thought would be the most thorough of all the "witch museums" that were being advertised. We were ushered into a huge dark room and sat on plank benches (for a)... loooooong presentation, (after which)... the guide took us to another room which mainly consisted of pictures and a timeline on the walls... After that, we expected to see a museum but were thanked and shown into their gift shop which was two rooms!!! My husband was fuming at the waste of money.[27]

On a more positive note is the response to an exhibit of 1970s pop culture at the Monroe County Historical Society in Sparta, Wisconsin. With the goal of attracting both Gen Xers and their kids, and conveying a message that history is not just about dead people, *A Very 1970s Christmas* "takes visitors back four decades into a mock living room—complete with shag carpet and orange print curtains. An actual 1970-vintage Penncrest television plays a loop of ads from the era... There's even a macramé Santa." Museum director Jarrod Roll said, "Our job is to make history relevant. We do that with history that is 100 years old or 140 years old. But we can also do that with history that's 40 years old." Potential visitors were engaging with the exhibit even before it opened. Roll reported that "people in my age group get super excited right away... They remember giving those toys to their kids, or they wonder why anyone would want to exhibit the junk they threw out 10 years ago."[28]

In 2014, *Forbes* listed "trust" as one of the top issues in technology and communications due to the reach of digital media and the quantity of platforms. What this means to HHMs is that trust is built on the degree to which our communications and advertising are an accurate reflection of the actual visitor experience.[29] The primary problem is that Historic Houses tend to imply that one-off events are emblematic of the everyday experience of touring the HHM.

We understand how difficult it is to change the personality of an HHM's tours and that many Historic House staff undertake the easier task of creating what are often progressive and compelling one-off events but leaving the House experience unaltered, traditional, and boring. The daily tours rarely get the creative and systemic re-thinking that big public events get; thus, the visitor experience remains traditional and static while the public outreach and events surpass the daily visitor experience with progressive happenings. It is a problematic practice because the staff begins to see the House as a place for special events rather than as a cultural asset.

THEREFORE

Strive to build long-term, trusting relationships with guests. Think beyond the one-off event. Remember that trust is lost when HHMs facilitate interesting events, but fail to reinvigorate the basic tour experience. The Fitchburg Art Museum in Fitchburg, Massachusetts, provides an exemplary model. Forty percent of the city is Latino; the museum is enacting an ambitious plan to become the first fully bilingual art museum in New England.[30] The museum's Facebook page is fully bilingual; in the next few years, all exhibit labels and education spaces will have bilingual text.

On the surface, it seems as if innovative programing is the answer to declining visitor attendance and community interest. But in fact, HHMs with stellar, interactive tours and immersive experiences feel less pressure to produce showy, progressive, unique events outside of the everyday experience. We make this statement with the recognition that the activities we suggest would take place in a holistically conceived Anarchist's Plan. All of the guidelines of the *Anarchist's Guide* need to be addressed simultaneously, so that there will not be the perception of a bait-and-switch.

N.U.D.E. Docent Communication

Seek volunteers for their traits and ability to be flexible

RANT

What I most fear about historic houses are docents. The interpreter for a historic house museum is the most important interface between the guest and the house; and a docent who fails not only taints the visitor's experience, but also produces potential damaging word-of-mouth that can spread into the world. A good docent can make a so-so house a memorable experience; a bad one can ruin a wonderful house. Too much information is as bad as not enough; a great docent needs to know a lot, but give out only what the visitor must have to appreciate the house. Any family's history is boring after two minutes; minutiae about the objects in the house are only interesting to hard-core connoisseurs. What matters is the house's story. Houses are stages on which lives are lived. The action is what matters.

 (Ulysses Dietz, chief curator of the Newark Museum
 and curator of the Ballantine House)

EVIDENCE

Throughout our research, we repeatedly heard how tour guides could make or break the visitor experience. In one discussion thread on our LinkedIn site, over half of the participants expressed frustration over the tour guides' presentations.When pushed for further details, we found out that our guests would like to hear why the tour guides love the House so much, what they find so compelling about the narrative, and to hear an anecdote or two regarding their involvement with the historic site. Often, what was missing in the experience was a level of *humanity and poetics to the presentation.*

Reach Advisors, the blog specifically devoted to the museum audience experience, shared some fascinatingly polarizing statistics from their surveys of various museum experiences in Connecticut museums. They cited an almost even split between lovers and haters of docent-led tours. Feelings ranged from accolades, such as personalized, insightful, and stimulating,

juxtaposed with such criticisms as monotonous, condescending, intimidating, or, worst of all, boring.

Much has been written regarding tour guide training, communication techniques, and presentation at historic sites. Many historic sites have regular training and continuing education courses for their volunteers. Rather than add to these, we have chosen to describe a certain set of traits from an *Anarchist's Guide* perspective in the belief that these qualities will result in more positive engagement with guests.

Our suggestion is to seek "N.U.D.E." tour guides who have traits that are *Non-linear, Unorthodox, Dactylic, and Experimental*—traits that when combined allow for a creative and personal presentation rather than one of rote memorization. In our work at Historic House sites, we have experienced a wide gamut of tour guides and are familiar with their strengths and shortcomings. This issue remains one of the more contentious, as the prospect of assessing docents on their personal style is potentially fraught with discomfort. There can be a genuine fear about how to approach this issue, so as not to tread on someone's feelings, particularly as docents generally care very deeply about "their" House Museum, and to suggest change may be taken personally. For this reason, we suggest pulling away from the notion of *training*, and instead focus on gently encouraging thoughts, behaviors, and traits that could foster better guest interactions.

A *non-linear* guide is someone who manages to handle multiple narratives and interpretive environments simultaneously. Such guides will understand the need for flexibility and nuance in their presentation. If, as we suggest elsewhere in this guide, the interior artifacts and room configuration are presented in a more complex manner, then the guide will have the opportunity to take side trips to interesting concepts throughout the tour. If, as we have also suggested, the House Museum staff decides to try un-guided tours, then the *Anarchist's Guide* can become a reference and an at-need resource. Understanding this new demand would dictate that a guide/docent be able to easily manage a non-linear approach to interpretation.

An *unorthodox* guide is open to innovative, creative methodologies for conveying interpretive information. If it works to present an interpretive module in a bedroom from a sleeping position on the bed, then an anarchist tour guide should be okay with that. We do not know if it is the manner in which a tour guide is trained, the expectations conveyed by the trainer, or self-censored behavioral choices, but traditional guides do not feel comfortable to present in unusual ways. We hope that encouraging this trait will allow the tour guide to see the unorthodox forms of presentation as a way

to convey multiple layers of information and increase *distinct activities* for a guest. Other unorthodox methods could include: crowdsourcing questions online, allowing tour attendees to determine overall tour topics, use of song, music, and musical instruments, scavenger hunts, and informal trivia games, just to name a few. The main requirements are docents with imagination and, more importantly, a flexible and encouraging environment provided by the House administration.

A *dactylic* guide understands the need for brevity, but is also able to delve deeper into a subject if the guest asks questions. A *dactyl* is from the Greek word relating to a segment in poetic meter. It is a long syllable followed by two short syllables. We use this term because we feel as though the ability to poetically manage a narrative in expansive and contracted ways will decrease the expectation from a guide that a verbal explanation should

Figure 2.7: *Anarchist Tags* can become a useful tool in understanding visitor experiences and perspectives. In this pilot study, executed by Carol Ward and Danielle Hodes (Morris Jumel Mansion), we were interested in the quantity and quality of visitor comments that were left behind when we handed out the *Anarchist Tags* with prompts. (Floorplan image showing the location and text of some of the *Anarchist Tags*.) We structured the study to collect data from guided tours with the room barriers open and closed and from self-guided tours with the room barriers both open and closed. (See chart) During self-guided tours, there was a docent standing in the space waiting to answer questions. In analyzing the Anarchist Tag comments, the results from this portion of the study were revealing. The more physical access provided, and the less structured the tour guide's narrative, the more deeply visitors became engaged in inquiry and analysis and the less drawn to the individual collection objects. Our theory is that the more physical the access, the more visitors were able to closely analyze the objects and use them as an entry to connect to the larger history of the House. In contrast, a tour with room barriers in place results in a visitor concentrating on the objects, and less about inquiry and narrative analysis. Pilot project conducted at Morris Jumel Mansion 2014–2015, by Carol Ward (Executive Director) and Danielle Hodes (Director of Education and Public Programs), with direction from Franklin Vagnone. Results presented at the New York City Educator's Roundtable Annual Meeting, 2015. *MJM floor plan drawn by Kevin Greenland; results graph created by Hodes, 2015.*

be written and standardized. In our research, we hear that there is a uniformity and overly consistent tone to most presentations. This trait will allow for an interpretive narrative to bust out of a mold of professionalism and find the poetics of presentation.

Experimental guides not only understand the need for a dactylic-like presentation, but also know that, within this system, they can try new things. From our experience, most volunteer guides are trained to not try new experimental ways of doing things, to keep to the script, and to stay within the "lines" of the training manual. Imagine: What if we asked docents to produce their own interpretive methodology and presentation? Would chaos ensue? Or could such experimental, crowd sourced creativity produce a new way of thinking about Historic House Museum presentations? Francis Picabia, the famed Dadaist, boldly stated, "The only way to

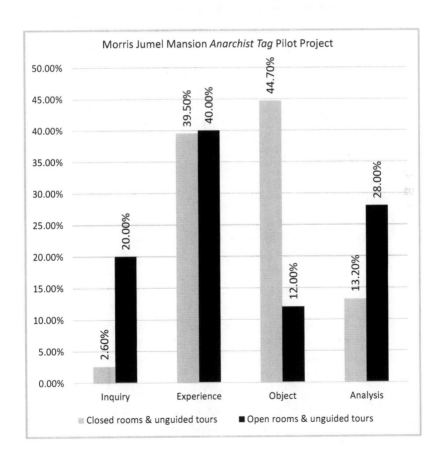

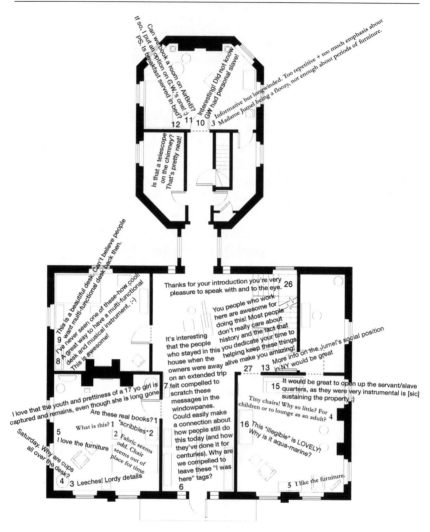

Figure 2.8: MJM floor plan.

save yourself is to sacrifice your reputation."[31] We interpret this quote as meaning that we should not be afraid of trying new methods and making mistakes. In these days of declining House Museum attendance, making waves might be a make or break proposition.

From our own research, through our Historic House workshops, and in *Anarchist Tags*, we saw overwhelming support for variability in tour guide communications and overall tour methods. So, for supporters of traditional

docent tours, the consensus is not about replacing them, but allowing for new options for communicating in new and different ways.

THEREFORE

Encourage docents to focus on N.U.D.E. traits rather than just on information retention and presentation.

Many organizations have docents with years of experience under their belts who may initially be resistant to changing their methods of tour giving. Some, if given proper encouragement and the opportunity, may welcome the prospect of personalizing their tours and deviating from their routine. Others may steadfastly resist despite such encouragement. If this is the case, it may be beneficial to focus on expanding recruitment efforts and adding diversity to the docent pool to include those who are more receptive to N.U.D.E. methodology.

Hearing a personal story is appealing to most visitors.

Volunteer recruitment is lagging for tour guides. Perhaps part of the problem is that the expectations and the type of tour required no longer appeal to a younger generation of volunteers. Reaching out to younger and more diverse volunteers through crowd sourcing may result in new ways of presenting your narrative.

Narcissism of Details

Do not play the game of superlatives. The details only matter to you.

RANT

Many house museums are searching for a 'numinous' quality that will convince visitors (and themselves) that something special happened there. The cliché example of that is George Washington slept here. It's great if you have that special something, but not every site does. Those sites need to come up with something else, because superlatives come off as silly, often inaccurate—or in need of so much qualification that they become tedious.

(Ron Potvin, assistant director at the Center for Public Humanities, Brown University)

EVIDENCE

To justify their significance, HHMs provide visitors with a meaningless recitation of facts and details, especially relative to what they believe are important names, dates and significant genealogies. But to really distinguish themselves, historic sites typically have to frame their importance relative to a particular time and jurisdiction. Doing so allows them to compete in a battle of the superlatives, where they can truthfully claim to be the equivalent of the oldest pink house in the most southern neighborhood of the city.

While it might have once been adequate to simply claim that "George Washington slept here," this official messaging now feels insignificant and affected. Through skilled wordsmithing, we have seen an HHM's claim to fame to be that it was the first house to have indoor plumbing in the area, the first house to use nails, the biggest, tallest, or heaviest house, the house with the most glazed windows, or even the house with the best moldings in the southeastern part of their state. Other HHMs describe themselves as

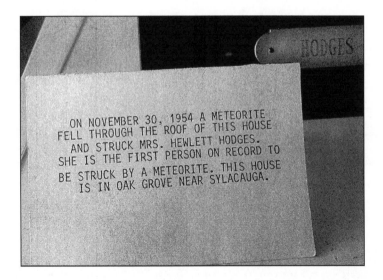

Figure 2.9: Most of the time, details only serve to alienate visitors with useless information, but sometimes the communication of details can add a level of idiosyncratic humanity, as is the case in this text label at the Isabel Anderson Comer Museum and Arts Center, Sylacauga, AL. *Photo: John F. Yeagley, 2013.*

the only museum that exhibits male/female/animal/children/servant life during a particular year, in a particular place. The best superlative is if the house is the "last" of its kind. The possibilities for distinguishing HHMs are seemingly endless, and ultimately eye rolling. All that these fabrications do is minimize perceived value into small sound-bites of useless information. They hurt engagement rather than engender appreciation.

While we understand the need to stand out in a crowd and find the sweet spot of messaging that will bring in donation-leaving visitors to HHMs, the hype all becomes white noise. We have labeled all this one-upsmanship *the narcissism of details,* a term meant to describe this ever-elevating attempt of HHMs to define their importance against every other historic site. On an everyday level, the practice causes House Museums to be extraordinarily territorial, and sometimes adversarial towards other HHMs.

When walking around communities, we are always struck by how complicated and messy the lives of buildings are. Over time, they have contained many lives and served multiple purposes. If a building houses a business that fails, another moves in and thrives. A home's matriarch dies off, and a new, younger family moves in.

So how do we choose the most important facts to highlight? Whose story are we telling? The answers to those questions are embedded in the curation of the HHM and the narrative and messaging that is shared.

Sometimes a single fact is not the important signifier in the narrative. The home of civil rights leaders Amelia Platts Boynton and Samuel W. Boynton in Selma, Alabama, would not easily fit into small fact sound-bites because their influence spanned from the 1940s to the present day. While a replica of the House was featured in the 2014 film, *Selma,* and the narrative of Mr. and Mrs. Boynton's lives was shortened for cinematic affects, it is the breadth of their contributions that deserves attention. The modest turn of the century bungalow was where civil rights leaders planned marches and demonstrations across the country, and where the words were first written to the 1965 Voting Rights Law. Unfortunately, the home is in a state of severe disrepair, having not been occupied for the last 20 years. Fundraising efforts are underway to restore the property, but it will not be an easy task to simplify the important work that took place for over three decades in the home.[32]

Sometimes the distinction for a House is unwanted, unavoidable, and even detrimental. The large, yellow inn where Adolph Hitler was born in Braunau, Austria, has sat vacant for years. The government has paid rent to the owner since 2011, concerned that the empty building could become a

shrine/museum to the Nazi leader and a meeting point for neo-Nazi groups. Local leaders would like to discontinue paying rent and disassociate the building and their town from Hitler's legacy, especially since he lived there for less than three years. Christian Schilcher, Braunau's second deputy mayor, thinks "it is time to move on. The people are fed up. This theme is a problem for the image of Braunau. We want to be a beautiful little town, with tourism and visitors. We are not the children of Hitler."[33]

We were once asked to participate in a discussion about the curated interior of a parlor room in an HHM. The staff wanted to visually express a tea party, but they were concerned that the room layout was wrong. Should the chairs be in a circle or randomly placed? In response to the question, we went to sit down on the chairs, and they stopped us. We went to pick up tea-cups, and they stopped us. We went to pour some hot water for the tea, and they stopped us. The staff got lost in the *Narcissism of the Details.* By wanting to showcase what was probably the biggest and best tea set in the state, they forgot about the purpose of the everyday act. To us, it was not a tea party if we could not sit, chat and drink tea!

THEREFORE

Consider a new paradigm to celebrate everyday practices rather than citing self-defined, monumental events. Be willing to accept that your HHM is important simply because it was built, lived in, and loved by people who were ill-defined, messy, complex, and far from perfect. We suggest that it is the mundane details of everyday living that should define an HHM, rather than the carefully worded list of invented superlatives.

Do not think of other HHMs as competitors, but rather as members of an extended family who work well together. Consider hiring outside marketing consultants to identify commonalities in a group of properties rather than each House's hook. Ask community members for their perspectives. Approach the task with humor. Try to realize that the lack of specialized messaging is not a sign of weakness or poor planning.[34] Recognize that there is nothing wrong, and perhaps even something quite wonderful, about just being a cool house with an interesting history.

CHAPTER 3.

EXPERIENCE MARKINGS

Overlap

Embrace your guests' life experiences and knowledge, and use both as interpretive tools.

RANT

We need to make room for today in our historic houses. Clinging to nostalgic notions and the faded glory of a select few—without acknowledging the great history we all make every day—serves only to push historic houses further into the realm of the obsolete and irrelevant.

(Caroline R. Drabik, Director of Curatorial Affairs, Historic House Trust of New York City)

EVIDENCE

HHMs rarely acknowledge that their guests' interests are shaped by the experiences they bring through the door. Your guests do not arrive at your door as blank slates but rather full of the experiences that have shaped their own lives. We seldom acknowledge the memories they carry like baggage, or attempt to draw parallels between their lives and the earlier inhabitants

of our HHMs. Yet our guests can only have *their* frame of reference, and they cannot disassociate from it or shed it at the door.

In our research, we ask participants to produce both audio and video recordings of conjectural habitation activity at a Historic House Museum, and overlap them on their contemporary life activities. More than the obvious differences in clothes and aesthetics, the project highlights deeper relationships between behaviors and perceptions. What we learned about guests who visit Historic House Museums is that they hold a constant barometer to determine the relationship between the pre-existing thoughts they bring to the tour and what they are told while on it.

Rather than embrace this experiential juxtaposition as an opportunity to engage guests in dialogue, we tend to convey history as something that happened to other people, not something that will happen to them. The implied message unfortunately goes something like this: The people who once lived here were important. You are not.

This attitude echoes the class distinctions that once characterized almost all early museums. We place ourselves above banal but shared commonalities of everyday life, even though it is these acts that are the ties that bind over time and across cultures. Maya Angelo wrote, "In all my work what I try to say is that as human beings we are more alike than we are unalike."[1] But rather than attempting to reveal commonalities and overlap complexities, we tend to find comfort in drawing distinctions and imposing an artificially linear constraint.

Hans-Georg Gadamer believed that people's thoughts constantly move between the past, present and future.[2] This overlap or *simultaneity* is generally not exploited by HHMs, although it is common in film through flashbacks, voiceovers, and other devices. Alfred Hitchcock was a master at this technique. In his 1954 thriller *Rear Window*, he employed the use of multiple narratives to frame the action of his classic film. In the opening scene, the camera panned across a courtyard in New York City and "saw" what Jeffries, the main character, saw from his open rear window: middle-aged couples, a man shaving, a pianist, a sculptor, a salesman with a bedridden wife, and a pretty young dancer. His storyline not only wove together these seemingly unassociated characters, but Jeffries's view provided the catalyst for all the following action.

In HHMs, we seem to have a disproportionate need to tidy up a messy network of personal and architectural relationships for our guests, rather than allow them to find their own way through the House and draw their own conclusions about the different people who once lived there. We build

narratives through our collections, and exhibit artifacts so that they create a coherent, if overly simplified story. We fear that if we take away this order, "not only do the collections become a meaningless arrangement of stuff but their cultural significance and the story that they tell about history runs the risk of collapse too."[3] This artificially imposed order, however, implies a sort of family and political stability that probably never existed.

Some sites embrace overlapping as a positive interpretive tool. An example of the overlay of multiple and diverse stories within in the same narrative site can be seen at the Herman-Grima and Gallier Houses in New Orleans, Louisiana. After a period of great wealth and care, these two French Quarter houses fell into disrepair and one became a boarding house. Today, both eras of the Houses' use are interpreted simultaneously, as exquisite parlor rooms full of fine furniture are juxtaposed alongside boarding bedrooms full of second hand furniture, along with stories of the enslaved women who resided within their walls.

In artist Fred Wilson's 1992 "Mining the Museum" installation at the Maryland Historical Society in Baltimore, the hidden and often unspoken

Figure 3.1: Rear view of Fred Wilson's Liberty/Liberté, originally commissioned by the New York Historical Society in 2006. Shown in this image are slave shackles that are attached to the rear pillars holding the busts of Founding Fathers. This is a powerful visual manifestation of a subversive interpretive mechanism. *Photo: © Jonathan Wallen, 2011.*

internal overlap between museums, their collections, and bias were brought to the surface in startling clarity. Wilson was asked to go into the museum's collection and make connections between disparate artifacts. The installation pushed the accepted limits of historical truth, authenticity, and interpretation by juxtaposing what appeared to be seemingly disassociated objects, but in this new context, told a story of racial bias and censorship. The New York Historical Society adopted a similar attitude in their newly installed Great Hall exhibits. In the Great Hall, beautiful marble busts of American political founders are presented with the shackles of slaves bolted to the bases of each sculpture, questioning truth and bias.

We cannot simply share the same documented content that our guests can find on Wikipedia, mistakenly believing that it is somehow given more substance when reported in situ. We must acknowledge that our guests can tolerate a substantial amount of ambiguity, and may even revel in piecing together memorable moments and guessing as to their meaning, once assembled.

THEREFORE

Embrace the idea of overlap, or "a principle of disruption that endlessly erodes the very idea of stability and order on which ... the museum, interiorising and singular is established."[4] Explore the concept of simultaneity and multiple narratives.

Consider your House as having an ensemble cast rather than one or two lead characters around which everything else revolves.

Provide opportunities that allow guests to overlap their lives with the former inhabitants of the House and allow "a confluence of real events, historical perhaps, or from memory to create an exciting fusion."[5] In UNCC architecture student Aracelli Bollo's proposal for the Met's Haverhill Period Room, she proposed taking a picture of visitors in front of a green screen at the museum's entry, and then projecting their images into the historic room located much farther back in the American Wing. There, they would see their image almost immediately fused into a room from an earlier time.

Overlay multiple periods of interpretation. For instance, Streetmuseum from the Museum in London allows GPS enabled smart phone users to overlay archival photos on contemporary images while in situ. In pre-determined locations, participants simply snap a picture of a present day street scene and a historic image appears, from either an ordinary day or a momentous occasion, perhaps after the great fire of 1666 or a WWII bombing.

Share Short Stories

Be conscious of both the brevity and the level of details provided in your basic narrative.

RANT

A little history is fine—enough to get you oriented. What I want to know is basically "who were these people? What drove them? Why did they do the thing they did?"

(Parker Brown-Nesbit, "How long is too long for a basic hhmuseumexperience?" [Anarchist's Guide to Historic House Museums LinkedIn Discussion Group])

EVIDENCE

HHMs tend to overwhelm guests with too many facts and cover too much material during their visit. In our many visits to HHMs, we are almost always bombarded with the dates of those occurrences: when the inhabitants were born, when they wed, and when they passed, as well as when their children were born, when they wed, when they passed, and then when their grandchildren were born, when they wed, when they passed...

We have been told all the dates of when each HHM we have visited was built, remodeled, and sold. We have then been told the age of the furniture, when it was purchased, and where it was made. Sometimes we have been told the age and the number of place settings in the dining room.

We do not remember any of those dates nor, certainly, any of the numbers.

Instead, we remember hearing the sound of the bells the servants heard when being summoned; the indentations in the stone steps made from years of use; the markings on wallpaper made by the family's mischievous teenagers; the corn cob pipe the nanny smoked when rocking the children to sleep. We remember the short stories, not as chapters in a novel, but as distinct moments when we felt an emotional, empathic connection with the people who once lived there.

The unattributed, now famous, six word novel reads:

For sale: baby shoes, never worn.

Writing about brevity, Elizabeth Edwards recalled:

You know, I once read a short story about how much you could tell about people from their shoes. You could tell where they had been, what they did, whether they were real walkers.[6]

Both of these tales are just stories about shoes. Yet each carries an emotional wallop and triggers a response far bigger than the few words on the page. In Georges Perec's 1974 blunt and powerfully poetic document, *An Attempt at Exhausting a Place in Paris*, he sits in a Tabac near Saint-Sulpice on October 18 at 10:30AM and begins to methodically give an "outline of an inventory of some strictly visible things."[7] His modest first line, of course, is the farthest from his intent. After reading the barrage of endless, disparate items, the reader begins to see behind the visible and is initiated into an epic tale only hinted at by simple, short subjects.

Traditionally, Historic House Museums have been most concerned about the accuracy of details conveyed in their interpretive narratives, but because they lack Perec's poetics, the stories are often not very compelling. For example, during our *Anarchist's Guide* workshops, we begin each by asking a House staff member to give us his or her standard tour. In almost all of the workshops, we find our entire group of 20 plus people crammed into a narrow entrance hallway, while the tour guide stands on the stairway and gives a 20-minute monologue outlining the family genealogy, house ownership, and family relationships. In our experience, most tours are like these: long lists of facts about people and furniture without a compelling story.

Perhaps we should be looking at what is attracting public attention, like today's Flash Fiction, as a new way of telling stories. Known for their brevity, and popularized by the internet since the early 1990s, these very short stories seem to appeal to the interests and attention span of many Millennials, and even to many of us who birthed some of them. We write about social media in the Communications chapter of the *Anarchist's Guide*, but it is worth reiterating how effective 140 characters of a Tweet can be. Just look at the most recent social and political protests to see how fundamental Twitter can be in unifying isolated individuals. As Hemingway shows us, brevity can become a different and poetic way to communicate a story.

Photographs can be presented as short stories. Rather than focusing on just a few posed portraits, *The Museum of Innocence*, both a novel and a museum by Orhan Pamuk, uses a large number of photographs to create

intimations of characters and events rather than representations that fix and crystallize. There isn't a rigid attempt at a coherent photographic narrative; instead, the snapshots of individuals, group gatherings, factory workers, socialites and cars, ships, street scenes and changing seasons function more fluidly as anchoring socio/historic elements but also as evocations of more universal themes.[8]

Photographs are also an ideal form to illustrate moments throughout a day. A photo project by Marina Rosso depicts this rhythm of life through a photo series with her grandparents, Licia and Ryan. The images capture her grandmother combing her hair in the bathroom; Post-it notes with phone numbers and reminders strewn about; the pair side by side on the couch in a mid-day nap, feet propped up against the coffee table; remnants of a home cooked meal on the dining room table.[9] These photographs suggest that these non-events and fleeting points in time are life's short stories.

House Museums often forgo the daily motions of life in favor of communicating epic events or rambling genealogies, but the latter often detract from the activity contained in the HHM. Finding ways to embed these short stories into a historic site is crucial to soliciting emotional reactions from visitors, especially those who are lost in the face of an endless barrage of facts.

THEREFORE

Get comfortable with providing only small parts of the HHM's entire narrative. As stewards of the House Museum, chances are that you know more than almost anyone else about its history. Just do not make the mistake that your guests are as interested in the narrative as you are. Allow visitors to skim your HHM rather than be trapped by a tour that exceeds most guests' level of interest.

Provide historical dates as background rather than foreground. Consider the idea that doing something relevant and relational may be more important than being overly factual.

Decentralizing communication is a meaningful shift in museum interpretation because it acts as a form of crowd sourcing by embracing a non-linear synthesis of information. Just as customers can now go into any Apple/Mac store, find an employee wearing a blue shirt, and buy anything from them, we suggest that stories and communication at a House Museum should allow for such individual transactions and interactions.

Build civic engagement by asking neighbors and visitors to write short stories about their own lives in their own vernacular. Use their contributions to show how the present day can relate to the past. Most likely, the life stories of your HHM's inhabitants share a great deal with those of your guests.

We acknowledge that editing vast content into more discernable snippets is no easy task. The good news is that guests can help. After they tour the House, ask them what was most memorable. Build on their answers and try out new content. Tease them with mentions of new stories and upcoming experiences. When guests arrive at your HHM, treat them like new friends and tell them just enough about your House that they want to hear more of your stories.

Embrace Rumor, Gossip, and Conjecture

Integrate stories and conversation into your narrative that include items outside of the narrow traditional limits of historic facts.

RANT

My biggest frustration is the lack of comfort with ambiguity associated with historic narrative.

(Richard M. Josey Jr., Head Historic Site Interpretation, Minnesota Historical Society ["We all love hhmuseums, But what is your #1 frustration?" Anarchist Guide to Historic House Museums LinkedIn Discussion Group])

EVIDENCE

HHMs avoid conjecture and exclude stories that present historic figures as flawed and human. Perhaps that is why the narratives shared by docents are often so bland. Hearing only the recorded facts about a family is of limited interest. Guests often feel like we are not telling the entire story. But to expand it, some level of conjecture and speculation would be required, and there is much debate as to whether or not that is an appropriate endeavor.

In 2013 in revitalized Mill #5 in Lowell, Massachusetts, a historic plaque was discovered that gave the dates and details of a public fight that occurred between Beat Generation icons Jack Kerouac and William S.

Burroughs over the use of a comma. The fight resulted in a police report. A photograph of the marker went viral on the internet. The problem? It was an act of *historic vandalism*. The plaque is part of the site's new marketing campaign, which includes 25 "historic" plaques placed randomly throughout the building that describe invented events.

There have been mixed reactions to the Mill project. One commenter on the Anarchist's Guide to Historic House Museums LinkedIn Discussion Group abruptly stated: "Nope, not ok. In one word, bullshit. This type of prank is simply the easy way out." But another commenter thought something could be learned from the idea: "By drawing attention to questionable historic themes and events, visitors are confronted with the opportunity to draw connections and build bridges that are not necessarily written on a plaque or interpretive label. Did Kerouac REALLY fight Burroughs? No, but now I wonder what their relationship/interaction/influence might have been like. The concept is a bit guerilla, but I think there's potential in purposely duplicitous historic interpretation."[10]

At the Dennis Severs House in London, playing around with the truth is taken to a grand scale of the entire House. The HHM has become a tourist destination and an international conversation piece as the private dwelling of Dennis Severs, an artist who transformed a dilapidated townhouse into a still-life drama of conjectural histories and hyper tactile experiences. Although the House was his residence from 1979 through 1999, it was opened to the public after his death as a Historic House Museum with the motto *Aut Visum Aut Non!: 'You either see it or you don't.'*

The buzz created from these acts of historic vandalism suggests that history need not be completely factual to be of interest, and may not always be as certain as conveyed—that visitors can usually manage the inclusion of a bit of conjecture, rumor and gossip. In actuality, HHMs engage in truth stretching on a regular basis. They just rarely own up to it. Instead, they imply a level of certainty that may not actually exist.

Jeff Riggenbach claims that "all history is at least partially conjectural" and that historians filter fragmentary information by their own experiences, perspectives, and attitudes.[11] Evidence of this type of historic skewing can be found at Monticello. As far back as Thomas Jefferson's presidency, there were persistent rumors that he fathered children with his house slave, Sally Hemmings, even though he wrote about the dangers of race mixing. In response to these solicitous accusations, award-winning biographer and

historian Natalie S. Bober stated in Ken Burns's 1997 documentary about the president that such a relationship was "a moral impossibility." However, just three years later, the Thomas Jefferson Foundation retracted that shared and long-held belief, stating that there was a very high probability that the president was the father of Sally's six children. Not surprisingly, historians continue to debate the shared parentage. It is unclear whether the foundation's acknowledgment led to increased visitation to the HHM, but it is certain that Monticello's more inclusive decision-making contributed to the national dialogue on race in the United States.

The sexual exploits of political figures appear to be of widespread interest, even for the country's most beloved icons. Abraham Lincoln's sexuality has often been the subject of debate. Bi-sexual rumors occasionally crop up, regardless of the fact that he fathered four children with his wife Mary Todd. Referencing this speculation, artist and activist Skylar Fein created an installation at the c24gallery in New York City entitled "The Lincoln Bedroom." In an immersive, recreated room, she used scant historical documentation to populate the small room as it might have looked when Lincoln and his life-long friend Joshua Speed shared a small bed. Everything in the installation was usable; visitors could lie in the bed and imagine two grown men filling up its small mattress. Fein's statement about the work acknowledges its ambiguity.

> Am I arguing that Lincoln was homosexual? I'll give the answer away right now: that question is probably unanswerable. In the end, Lincoln's same-sex bed sharing may mean less than its proponents want, but more than its opponents allow. The truth may lie somewhere in between, in a third category: messy.[12]

The Morris Jumel Mansion (MJM) and the Historic House Trust of New York City also pursued a grey area of history when we mounted a 2012 exhibition that featured 18th- and 19th-century-style corsets created by designer and couturier Camilla Huey. Entitled *The Loves of Aaron Burr: Portraits of Corsetry & Binding*, the show focused on the lives of Eliza, an earlier wife of Burr's, his mother, and four of his purported 12 mistresses. Most of the women were authors, diarists, or letter writers, and the exhibition attempted to present their creative pursuits as if emerging from their intimate attire.[13]

The exhibition built interest in the HHM by foregrounding the life of Jumel's wife Eliza, who rose from near poverty to become one the wealthiest women in New York. While she was the daughter of a prostitute, was

raised in a brothel, and lived as a kept woman from the age of 16, she rose to respectability through her wily sexuality and advantageous marriages.

Her life and accomplishments have long been overshadowed by Burr's and the House's role in the country's political history. *The Loves of Aaron Burr* brought Eliza to the forefront. According to MJM Executive Director Carol Ward, the exhibition "was part of its new campaign to lure non-traditional museum-goers, like art lovers and fashion aficionados."[14] *The Loves of Aaron Burr* was praised by art critics, and it broadened the typical audience who visit HHMs. Compared to the same period of the previous year, there was a 560 percent increase to an opening event, a 30 percent increase in House visitation, and a 60 percent increase in revenue from the gift shop.

THEREFORE

Do not shy away from stories that portray historic figures as flawed. Visitors come to HHMs with a great deal of prior knowledge, so excluding unflattering details only serves to push guests farther away. Instead of relegating the less than heroic character discussion to the fringe, embrace it, and own the conversation as part of the larger interpretive picture.

There is something about the private lives of public people that intrigues. Perhaps it is the shared reality that we all have secrets so that we can hide what we perceive to be our frailties or our fears. Learning that other people, especially noteworthy and successful people, harbor similar secrets can be empowering. Believe in the intelligence of your guests to create their own narratives from conjectural possibilities and invite dialogue based on these possibilities. If all our guests see and hear about when they visit a House Museum is perfect wallpaper, furniture, and stories of flawless men, then we risk the possibility of them leaving feeling inadequate. Instead, understand that through an acceptance of foibles, we can show our guests that, even though flawed, we all can do extraordinary things.

Including rumor and gossip in Historic House Museum tours is an idea worth exploring, as long as there is sensitivity and clarity about what is being implied. Pretend you are Dame Maggie Smith in the comedic play, *Lettuce and Lovage,* where she earned a Tony award for her portrayal of a docent at a dusty, old 16th-century House Museum who became frustrated when required to recite a rehearsed presentation that was clearly boring visitors. To liven up the tours she started inserting increasingly fantastical stories to the delight of the guests, at least until she was caught and fired. By the end of the play, her career is resurrected in other venues where her narrative embellishments were more valued.

Learn by Doing

Utilize kinetic learning techniques as a primary form of experience.

RANT

Scary as it is, we can no longer afford to be over-protective of our historic sites. The paradigms have changed in the last 20 years. Today's generation of visitors is no longer interested in passive viewing; they want to fully engage and participate in their environment. That means we have to balance the risks of wear and tear from using our valuable historic assets with the risk of them becoming unimportant and forgotten by a public that cannot connect with them.

(Ann Cejka, Program Coordinator at Ushers Ferry Historical Village, "Historic House Anarchy in Action! Is It Ok to Touch? Uptick in Attendance Suggests Yes!" [*Anarchist's Guide to Historic House Museums* LinkedIn discussion group])

EVIDENCE

Information about HHMs is authoritatively but passively conveyed, usually through docent led tours that are often more educational than interesting. This is not to say that there are not amazing docents doing memorable tours. There are. But the vast majority of docents are neither trained educators nor performers, and sometimes they lack the experience to bring factual information to life. Regardless of how practiced their monologue is, the very nature of only talking to or with guests limits the visitor experience.

We believe that guests want to *physically experience* the history of the House, not just hear about it. We have visited many HHMs where we have been told about the music that played on the piano forte in the parlor, but we have never heard one being played. We have seen bells hanging on walls and been told that ringing one would call a servant, but we have never been allowed to ring one. And we have seen a lot of rooms, usually from the hallway, and been told how they were used, but we were rarely invited to enter.

This is an especially unfortunate practice given that research into tactile learning suggests physical experience is beneficial across the age spectrum.[15] Yet, most HHMs still depend on an outdated, hands-off model that is the

least effective strategy for engaging guests regardless of what the associated literature and anecdotal evidence suggests. Some museums, however, have recently adopted a learn-by-doing philosophy, like at the National Building Museum's *Play Work Build* exhibit that chronicles the history of active play by inviting visitors to partake in a number of games and activities.[16]

The recommendations from the 2007 Kykuit II Summit on the Sustainability of Historic Sites acknowledge that "historic sites must no longer think of the 'velvet rope tour' as their basic 'bread and butter' program and must generate more varied ways to utilize their remarkable resources to enrich people's lives."[17] Yet, we continue to hear that docent led tours survive because long-term volunteers embrace both roles of teacher and security guard, as their mere presence safeguards the collection as they shuffle guests through the House. But at what cost? Michelle Moon, Assistant Director for Adult Programs at Peabody Essex Museum, has raised a legitimate concern:

> One thing it means for the quality of tours is that people less inclined to be tolerant than you avoid them like the plague! Having the reigning model of historic house experience be the guided tour comes at a very high cost: we lose the potential support and interest of the majority of visitors who don't enjoy guided tours. That worries me most of all.[18]

Yet, museums still typically rely on traditional methodologies to communicate predetermined messages, even though many museum professions understand that their guests create their own meanings through their individual experiences.[19] The imagined culmination is well portrayed in the 2013 film, *Austenland,* based on a 2007 book of the same name by Shannon Hale. The story follows a single, 30-something woman to Austenland, a British resort where the Austen era is recreated. Guests leave all modern conveniences behind, are expected to dress in period costume and to act like the 1813 ladies of the manor that they are pretending to be. When not partaking in a horse-ridden hunt, the women read, do needlepoint, and entertain the other guests with musical performances. Each guest is guaranteed a romance and engages in a period appropriate courtship with a staff member of the resort. The story develops as guests become confused over what is real and what is imaginary.

We think that this cinematic sort of interpretive model can be useful; however, it is still voyeuristically distant. The guests never really get to make bread or bring food up the servant stairs to the formal dining room. If

Figure 3.2: As part of the Anarchist LatimerNOW pilot project, Action Director Monica Montgomery re-considered the entire visitor experience and allowed for tactile and immersive encounters. Shown here, guests can pick up the phone, hold drafting tools in their hands, play the piano, and experience parts of Lewis H. Latimer's world. *Photo: Franklin Vagnone.*

they are allowed such activity, it is under the guise of pretend. The production of actual work and doing something real and useful would move the experience into the realm of *tactile interpretation* if it is defined by real-time behaviors and movements rather than pretend, imaginative acting. In other words, guests would sit, stand, lie down, and interact with the space just as they might at their own home. The experience does not rely on costumes or speech to convey the understanding; rather, the interaction of the guest is with the room, furniture and artifacts.

In the Zimmerman House at the Conner Prairie, the Smithsonian's only Indiana affiliate, families can sign up for an overnight opportunity and live a 19th-century farm lifestyle for 24 hours, complete with chores, cooking, early bedtime, parlor games, etc. The same kind of experimentation is taking place in live theatrical productions that are experimenting with the removal of the fourth wall between the actors and the audience. *Once,* a Broadway musical in which most of the scenes take place in a bar, invites the audience onstage to join actors for a drink before the show and at intermission. *Sleep No More,* a long running off-Broadway play located in a four-story former hotel building, invites masked audience members to follow the actors throughout the building as they perform. The audience members or "hotel guests" are invited to interact with the set, pull the drawers in and out, sit on the furniture, ring the bell at the front desk, pick up a phone, or

examine the evidence of a supposed crime. If they get in the way of the performance, the actors simply move around them.

THEREFORE

Rethink docent-led tours and offer visitors the chance to learn by doing. Experiment with innovation and collaboration. Know that visitors seek to make a personal connection with the people and spirit of earlier times.[20] Allow your guests to spend time in the House in a manner that replicates the lives of earlier occupants, but doesn't ask them to pretend. Our research is suggesting that in order for visitors to feel a part of the Historic House, they must move through it as if they were on a typical path. The behavior and movements elicited from guests will determine the experience outcome. Remember that guests would like the ability to touch, experiment, and learn about the House and its history through immersive tactile interaction.

What prevents HHMs from this type of experimentation is the concern over preservation of the collection. Perhaps seeing the entire HHM system as an integrated model would allow for malleability of function and use. Obviously, guests cannot be allowed to manhandle a priceless object, but usable artifacts could be placed in each room that could be sat on, opened, and engaged. The Kykuit II Summit suggested reevaluating traditional and seemingly immutable positions held about collection care, preservation, and education practices, stating, "Responsible site stewardship achieves a balance between the needs of the buildings, landscapes and collections, and the visiting public."[21] A positive guest experience requires a holistic approach to all of these factors.

Let Them Dance: Encourage Guests to Move Freely

Allow for decentralized freedom of movement and a variation of activities in your HHM experience.

RANT

The unspoken question when people walk into a Historic House Museum is: What can I do? What's interesting and accessible that's

allowed? There's an unspoken culture of limits and chastisement in Historic House Museums, the repercussions of which keep the most intrepid visitors from fully enjoying themselves, and often from coming back for a return visit.

(Monica Montgomery, co-founder of Museum Hue and action director of LatimerNOW)

EVIDENCE

The movements of guests through HHMs are unnecessarily linear. Their forced *en masse* shuffle through Houses do not reflect actual patterns of use, but rather curatorial decisions weighted heavily towards the protection of the HHM and its contents from wear. But habitation does not occur along a line, and a shared experience cannot be created within this sort of artificial construct.

Unfortunately, guests' experiences are often limited to what they can see by peering into rooms from portrait-lined hallways. There is a great irony in requiring them to stand behind velvet ropes, Plexiglas walls, and wrought-iron fences while suggesting they imagine how other people lived in rooms that they are now not allowed to enter. The insistence on the framed, linear tour denies guests the opportunity to experience rooms as they were meant to be used, and limits their ability to have a have a shared connection to the place.

Relative to movement through museums, Randy C. Roberts wrote, "The museum is experienced as a place in which meaning unfolds, rather than as a place in which knowledge is acquired. Visitors are actively engaged in consideration of meaning as they create their path through the physical space and interact with objects on display."[22]

Abigail Hackett reached similar conclusions in her research. She reported finding a distinction between *space* as an abstract and scientific concept, and *place* as a social and cultural construct. She described walking as a process of "coming to know" and a learning process that can result in a personalized placemaking, where different versions of embodied experience are "produced or reproduced by the path of the walker."[23]

Hackett further argues that even children create lines of movement that contribute to their emerging understanding of the places they inhabit, "including museums during a museum visit. Children in the museum walk to know. As they walk to know they also place make. Where they go and return

to takes on meaning and significance.... Walking and running must not be dismissed as the 'noise' that happens in between focused engagement and learning in a museum (or any other environment), but as a central aspect."[24]

As guests move through and experience an HHM, their perspective is imbued with their own memories and actions. Their *entanglement* with the House changes as "they move through and learn about the place."[25] Consequently, "An understanding of place as a dynamic, shifting, and subjectively perceived entity is vital for acknowledging the agency and perspectives" of guests.[26]

H. J. Klein studied visitor circulation in a museum by drawing visitors' paths on floor plans and noting their pauses.[27] Martin Tröndle used digital position tracking with permanent physiological measurements in the field and found that when museum visitors were left to roam freely, they moved in more circular than linear patterns so that they could gain different perspectives on installations.[28]

Within the context of Roberts's, Hackett's and Klein's research, we undertook a series of mapping studies to understand how the linear, docent-led tour typical to many HHMs differed from the actual habitation of a home. In the first study, we asked our students to map the pattern of their movements in their own homes throughout the first two hours of their morning. In almost all cases, their drawings revealed an overlapping series of large and small flowing loops with a series of distinct activities interspersed throughout the morning.

In the second exercise, we asked the students to map their movement in an HHM. Not surprisingly, their paths were characterized by short, staccato-like lines interspersed between long periods of standing, huddled in masses much like they would be if standing in an elevator.

Our findings echoed those reached by other researchers. We concluded that the forced linearity of most HHM experiences, while packed full of information, limited guests' ability to build a meaningful connection to the place as a home, because they were denied the meaning making that occurs through the freedom of movement.

THEREFORE

Encourage guests to move freely through your HHM so that they can better experience the HHM as a home. Decentralize and encourage them to choreograph an experience that reflects their life, moving where they want, pausing where they like.

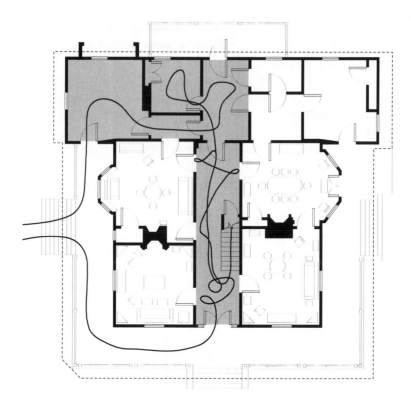

Figure 3.3: A typical visitor's path through the Mabry-Hazen Historic House Museum. The path is limited to the hallway because barriers block entrance into most of the rooms. Gray areas are interior spaces open to visitors, while the black line represents the trajectory of the visitor path.
Image: Franklin Vagnone, drawing by Kevin Greenland, 2015.

The AUNTS Group can provide inspiration. Founded in Brooklyn, New York, in 2005 by a group of dancers, AUNTS is a roving collective of artists and dancers who have no permanent home, but who produce site-specific happenings at theaters and formerly abandoned sites that overlap genres.

> Often taking the form of a live event, AUNT allows audiences to move freely about the spaces it inhabits, engaging with as many or as few of its offerings as they like, choosing their own path through the event and creating their own experiences through chance encounters. The whole can be viewed as a work independent from, but no more or less important than, its individual constituent parts.[29]

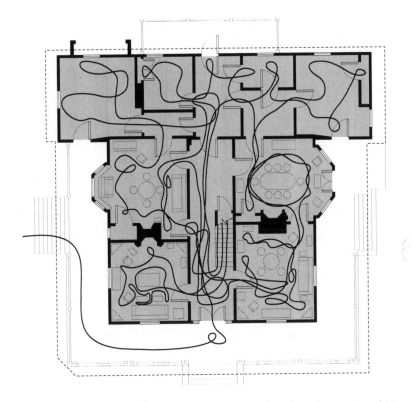

Figure 3.4: In contrast, this drawing shows a guest's path during an Anarchist Workshop at the Mabry-Hazen House Museum. It clearly shows multiple switch-backs, circling, and active engagement in the House. The type of relationship that this path provides is dramatically different from the typical lineal, hallway path. Gray areas are interior spaces open to visitors. *Image: Franklin Vagnone, drawing by Kevin Greenland, 2015.*

The founders of AUNTS, Laurie Berg and Liliana Dirks-Goodman, talk of facilitating chaos: "AUNTS is about having dance happen.... It allows people to enter with their own expectations, with what they want it to be."[30] An example of the type of experience AUNTS provides was seen in their installation at the New Museum for Contemporary Art in New York City, where a visitor joined a flying drone in dance. Another installation, *Auntsforcamera*, consisted of interactive social media and video software that allowed guests to become creators in a collaborative event overlapping eight-second clips of dances into a single loop.

Perhaps an even more useful example comes from the production of immersive theater experiences. Such examples include New York's *Sleep No More* and *Then She Fell*, and *Alice's Adventures in Wonderland* produced in London. All of these theater works involve at their core the physical engagement of the audience as a means of heightening their experience and expanding the narratives. Movement, interaction, and participation are required by the audience in order for the production to proceed. These productions ask guests to eat, drink, dance, and interact with the actors so that the lines between viewer and viewed are blurred. In the Bessie Award winning *Then She Fell*, a mash-up of Lewis Carroll's writings and a hospital ward setting, the audience is limited to 15 people, so it makes for an intimate experience. The physicality of the engagement pulls guests into a "dreamscape where every alcove, corner, and corridor has been transformed into lushly designed world. Inspired by the life and writings of Lewis Carroll, it offers an Alice-like experience for audience members as they explore the rooms, often by themselves, in order to discover hidden scenes; encounter performers one-on-one; unearth clues that illuminate a shrouded history; use skeleton keys to gain access to guarded secrets."[31]

These examples suggest a working model for how House Museums might be able to improve the guest experience. HHMs should thoughtfully consider how to best utilize such trends.

Allow Access to Denied Spaces:
Encourage Guests to Sneak Around

Provide some type of access to areas of the HHM that are typically locked away from view.

RANT

For decades since its opening, the Mabry-Hazen house has been accessible to the public mainly by its corridors. You can step into each room only a couple of feet, and view the original antebellum furniture, the gorgeous marble fireplaces, the family silver and porcelain tea services, the mid-19th-century books, the puzzling tintypes. But you can't touch any of it... Some of us enjoy museum houses as they are, enjoying their perhaps idealistic stories, respecting their careful distance, but many,

perhaps most, don't have the patience to stare at a rocking chair or a corner cabinet full of silver.

(Jack Neely, The Scruffy Citizen Blog, [Anarchist Guide to Historic House Museums LinkedIn Discussion Group, November 14, 2014])

EVIDENCE

We often deny guests access to some of the most interesting spaces in HHMs, where the actions of ordinary, relatable life took place. In our research with *Anarchist Tags*, we found that 30 percent of all negative comments noted a lack of access, or not understanding the layout of the House.[32] Forty percent of all of the tags were dropped either at or over the room barrier, with over 20 percent of all tags dropped in the hallways, on the stairs, or on out-of-the-way window sills.

In another series of studies, we found that less than 50 percent of the space in HHMs is typically made available to the public, and these are usually the honorific and grand public rooms. The denied spaces are the more relatable, everyday rooms that are either roped off or used for office space or collection storage. We have heard that many rooms are off limits because they have not yet been renovated, even though some visitors may find these spaces interesting because they show the wear and tear that comes from the passing of time.

Bathrooms are almost always left out of bounds, but not at the Schindler Historic House Museum in Los Angeles:

> While visiting the House, I asked for a restroom. To my amazement, I was guided to the actual, original bathroom. I hesitated for a second, paused, and asked again for the visitor's toilet. Again, I was offered Rudolph Schindler's very own toilet.
>
> Ok. I shut the door, locked it, and in silence and intensity, just stood there looking around at all that was in the room. I remember how the walls, floor, tub and sink counter were all concrete. I found it wonderful how the plumbing was exposed as sculpture and how it played off the vertical light shaft of the window. It was at this point that I stopped myself and began wondering when (if ever) I was allowed to use the authentic toilet in the actual room. This was the first time ever.
>
> This is the precise moment when I understood that house museums don't give visitors a real, tangible connection to the tactile concept of habitation. What could be more real, honest, and understandable to

visitors than everyday tasks, common life, and repeated functions? These are all the things of the house, the soul of the dwelling.[33]

Yet, regardless of the use of many rooms in HHMs, guests still want some sort of access to them, especially when they are denied by gates, ribbons, walls, bars, and our ubiquitous "Do Not Touch/Sit/Enter" signs. An important factor to understand is that when guests are not able to go into some areas, those denied spaces still remain a part of a guest's experience. By not having full access, guests feel that they are restricted from something, maybe even the best parts of the House.

This exclusionary feeling is at odds with our visitors' cravings for a voyeuristic experience. Peeking into the private lives of HHM occupants is a compelling draw for guests. Once considered a sexual deviation, voyeurism now includes a wide range of activities, as long as they allow viewing other people's intimate lives.[34] The immense popularity of reality television series suggests a widespread interest in glimpsing into other people's private lives, perhaps even more so than learning about their public facades. To some extent, people are voyeurs who would look into the proverbial medicine cabinet of an acquaintance if given the chance. Yet in HHMs, the opportunity for furtive discovery does not usually exist.

Some recent art installations and happenings embrace the human desire to explore spaces that feel off limits. An example of tactile snooping was the art installation, *Yes, These Eyes Are the Windows,* in London. The work was produced in the abandoned apartment of the young Vincent van Gogh, who spent a year there from 1873 to 1874. More recently, the apartment had been a rental property for the last 40 years, but was left empty following the exit of the last occupant. Wallpaper was falling off the walls, ceilings had collapsed, and steel props were in place in an attempt to make the space usable.[35] The temporary installation overlapped the work of the artist Olde Walbers, who choreographed and scripted an art happening with theatre designer Lu Kemp, sound designer Elena Peña, and composer Daniel Pemberton. "Frustrating the desire to uncover a history of one man's time in the house, the artist wove a fictional narrative from the accounts of oral histories, press archives and literary works, and presented visitors with one particular narrative that enabled the space to speak its past."[36] Visitors were guided by sounds and lights: asked to snoop around the apartment, listen to recorded oral histories and finally, when a door bell was heard, leave the apartment.

The idea of tactile snooping also underlies the growing number of "Room Escape" experiences, where guests are willingly locked in, and then

must search around, find clues and solve puzzles to find a way out. These sites are showing up in Hong Kong, San Francisco, New York, London, and Budapest and even in second tier cities like Charlotte and Phoenix. Clearly, the thrill of exploring unknown spaces is still relevant to today's audiences.

THEREFORE

Allow different types of access to previously denied spaces. At the very least, let guests peek around the curtain or crack open a door and discover something that seems intentionally hidden. Encourage them to sneak around and snoop into drawers, cabinets and under beds. Be sure to place inexpensive but meaningful items in those locations to be found. If a family member was known to drink too much, leave out empty bottles of liquor. If there were money problems, leave out a ledger with notes in the margins suggesting a proposed solution. Author Jeffery Brown says his work follows a similar theme. "My books should feel like you're getting a peek into a private world: a diary no one was meant to read."[37]

Figure 3.5: One of the activities undertaken during an Anarchist Guide Historic House Workshop is giving guests full access to all rooms in the House. We ask that all of the doors be unlocked, all the closets be accessible, and that some of the furnishings be used as they were originally intended. Shown here is a participant at the Hay House in Macon, GA, during a Workshop investigating the out-of-the-way spots not normally viewable in a typical tour. *Photo: John F. Yeagley, 2012.*

Acknowledge and embrace voyeurism.

We suggest building on some people's interest in having a privileged position, where they believe they have more and better access than the general public through a behind-the-scenes experience. Contemporary culture would suggest the value of more intimate access, whether it is to open rehearsals of a play, orchestra, or opera; the training camps of professional sports teams, television programs that show fashion designers, chefs, or building contractors. Think about the thrill visitors get when allowed access to normally off-limits areas and figure out a way to allow every visitor to experience that feeling. It is fun to peek into other people's worlds and see how they go about doing things.

Engage All the Senses

Utilize all aspects of learning styles in an HHM tour.

RANT

Collections care shouldn't be a 'one rule for everything' deal. Many house museums, for one reason or another, make use of non-original furnishings and/or reproduction furniture—and then go ahead and apply the same curatorial approach to that as they would to original materials. This makes no sense to me. We all know that the more access the public has to experiencing an historic site, the better it is. Why keep the public from walking into rooms when they have reproduction carpets, or from sitting in reproduction or non-original chairs, when doing so would completely change their experience and perceptions of the site?

(Frank Sanchis III, Historic Preservationist,retired Senior Vice President of Historic Sites, National Trust for Historic Preservation)

EVIDENCE

HHMs do not engage all five senses. They usually limit the visitor experience to the mind and ignore matters of the heart. They privilege the cerebral and visual experience over other sensory ways of understanding.

In 1909, when Italian futurist F. T. Marinetti and his crew wrote *The Futurist Manifesto*, the traditional sensory environment of cities was being

harshly changed by the technologies of modernity. The sights, sounds, and physicality of cars, trains, machinery, and commerce became an intoxicating and exotic theater. This new multi-sensory world was aggrandized in the manifesto as:

> We will sing of the great crowds agitated by work, pleasure and revolt; the multi-colored and polyphonic surf of revolutions in modern capitals: the nocturnal vibration of the arsenals and the workshops beneath their violent electric moons; the gluttonous railway stations devouring smoking serpents; factories suspended from the clouds by the thread of their smoke; bridges with the leap of gymnasts flung across the diabolic cutlery of sunny rivers; adventurous steamers sniffing the horizon; great-breasted locomotives, puffing on the rails like enormous steel horses with long tubes for bridle, and the gliding flight of aeroplanes whose propeller sounds like the flapping of a flag and the applause of enthusiastic crowds.[38]

The Italian futurist, and later the composers of the Futurist movement, were the first to imagine meaning and purpose behind abstract sounds. They understood that the sounds of the everyday were the music of life in an atonal way.

In contrast, most Historic House sites are deathly quiet. The only sounds tend to be the slow creaking of the floors under the drone of the docent. But HHMs were once overcrowded, full of children, and filled with the sounds of everyday life. Music and other amusements often filled the rooms, making the present Historic House site environment seem especially inauthentic.

In 2007, Robert Wuilfe curated an art installation by Roxanna Perez-Mendez called "Declaracion." Perez inserted a Puerto Rican identity into the Colonial milieu of the Powel House in Philadelphia, starting with the Puerto Rican flag hanging in front of the building, tropical island kitsch resting on the mantle and a banana wrapped in shiny beads on the sideboard. Most haunting was a vintage transistor radio playing "La Borinqueña," the national anthem of Puerto Rico, in what was originally the formal, second floor ballroom. The site-specific work was part of a larger installation that addressed the relationship between Colonial America and slave transport from the Caribbean. The simple insertion of the static sound of the radio was a powerful way to convey a message.

When we asked our students to compare their lives at home and their experiences at HHMs, music enthusiast and UNCC architecture student

Seth Baird found the absence of sound and the lack of conversation to be the most glaring difference. To illustrate his observation, he employed sound as a mapping medium, intermixing the sounds of his own life and those he presumed once filled the plantation. The result was a haunting recording that emotionally linked the past and present through the shared experience of sound.

HHMs especially limit touch as a way of connecting, even though tactile experiences are the primary means by which many visitors engage with museum collections.[39] Most HHM directors say that level of accessibility would be impossible if they are to preserve their collections, while other critics surrender to what some think is the inevitable. In one blog review of an Anarchist's Guide Historic House Workshop at the Mabry-Hazen House in Knoxville, Jack Neely wrote: "If we don't let people walk on the oriental rug, or take a selfie in front of the antebellum silver, or sit on the notorious old sofa, in this era of declining museum-house visits, they might all fall apart anyway, because nobody will want to help pay for keeping them up."[40]

Sally Wagner is the former director of the Gage Center, an HHM that celebrates the work of Matilda Joselyn Gage, a progressive visionary of women's rights and writer of many of the arguments that organized the woman suffrage movement in the United States. In a bold move, Wagner allowed unrestricted tactile access to *everything* in the House, including Gage's original desk.

> You're invited to sit down at it, help us figure out words we can't decipher in one of her letters, and write her a note, which you leave in a cubby hole in the desk. People treat it as a sacred space. One woman sat there for over an hour. We can do it because, guess what? I own the desk. And I'm not giving it to the Gage Center until I prove my point—that when you trust people, they will respond in kind. We're new, underfunded, understaffed, and in the nearly three years we've been open, we've not had a single thing walk out the door. But people leave us fascinating comments on our walls, where they are invited to write on an entire whiteboard wall in each of the rooms.[41]

Engaging guests through multiple senses, rather than relying solely on visual experiences, will require a philosophical shift for many board members and directors. Until they are willing to adopt the methodology that both the Gage House and Powel House have embraced, other less intrusive senses cannot be engaged.

Figure 3.6: A compelling experience that engaged multiple senses was found at the Matilda Joslyn Gage House in Fayetteville, NY. Upon entering the House, we were invited to sit at the dining table while the docent poured tea for us in dishware that included pro suffrage movement statements. While enjoying the tea and treats, we watched an introductory film shown on a flat screen TV. Shown here are Ryan and others immersed in the experience. *Photo: Franklin Vagnone.*

THEREFORE

Touch it, smell it, taste it. Kill the silence. Allow tactility. Engage your guests' senses through light, scent and sound installations to bring your HHM to life and provide for more visceral, immediate connections to be made. Present your HHMs as more of a home and less of a museum. Visitors should be made to feel like welcome guests, rather than intruders onto a fragile stage set. Very little of your collections should remain in locked glass cases or behind velvet ropes. Guests should have access to almost everything. Encourage visitors to occupy rooms, not merely be led through or by them.

Be creative with how to engage the senses. Take a cue from Colonial Williamsburg, which announced plans in 2014 to install lighting in its Historic Village to encourage nighttime visitation. Consider the myriad ways of incorporating sensory experiences into your site, and realize the monumental effects even simple changes can engender.

Take, for example, a wonderful site-specific audio installation called *Lullaby Factory* at London's Great Ormond Street Hospital. Designed by StudioWeave, the work is a complex series of pipes and horns installed in a cramped, ten-story courtyard between the hospital's 1930 building and a recent building addition. The pipes expel Jessica Curry's original lullaby that can be heard in the wards by tuning into a special radio station or through listening pipes next to the canteen. The art piece transforms a forgotten urban space between buildings, and turns it into a both visual and audial sensory experience.[42] Imagine a similar sort of art installation at a HHM that interprets the sounds of everyday life in a fanciful way.

Famous Deaths, an exhibit at the Museum of the Image in the Netherlands illustrated the impact of engaging the senses in a public place. Dutch scientists recreated "the deaths of some of the world's most famous personalities by reconstructing their last moments using scents and sounds. From the sweet smell of Jacqueline Kennedy's perfume, mingled with the scent of John F. Kennedy's blood to Whitney Houston's last drug-fuelled moments in a Beverly Hills bathtub," visitors were invited to lie in the claustrophobic, pitch black of morgue-like metal boxes, and for five minutes experience a smell tableau that was a "unique, if somewhat macabre, historical snapshot."[43]

COLLECTIONS/ENVIRONMENT MARKINGS

Transcend the Object

Reduce the primacy and obsession of singular objects and, instead, embrace interaction from a collective environment.

RANT

It really pisses me off when the ego of a curator trying to construct their own personal vision results in the removal of part of an artist's vision: The frame. I have seen a curator remove frames on mid-century modern paintings that had been carefully selected, painted and altered by an artist to enhance a painting, because the 'curator' liked white strip frames and white walls. The perception of the painting was totally changed and I can promise you it was NOT for the better. The arrogance is astonishing!!

(Steven Eristy, painting conservator)

Anarchist's Guide to Historic House Museums by Franklin D. Vagnone and Deborah E. Ryan 129–154. © 2016 Left Coast Press, Inc. All rights reserved.

EVIDENCE

Many Historic House Museums reduce complex, messy domestic environments into a simplified combination of highly curated objects. This practice provides a deadened interpretive experience and suppresses the complexities of actual domestic experiences.

HHMs seem to struggle with constant identity crises. Are they Houses or are they Museums? Is their worth to be found in the objects they contain or the experiences they provide? The problem is that the professional process of curating the Historic House into neatly organized and sparsely furnished rooms leaves out much of reality. Furnishing plans produce a false sense of accuracy and authority.

As part of our ongoing research, we analyzed *Anarchist Tags* from House Museum workshops. We found that guests were more interested in the overall environment, as 61 percent of the Tags took note of the experience and the overall environment, while only 25 percent noted collection artifacts. Interestingly, even if a collection item was noted on a Tag, it was generally noted because the guest wanted to use, touch, or experience the object beyond simply looking at it.

Even though guests are apparently most aware of the overall environment, architecture, and experience at a House Museum, the cult of the object still takes precedence over an expression of environmental habitation. Instead of being about a place of life, HHMs have become repositories of objects. As Hein argues, we must move towards "transcending the object" by focusing on the IDEA of the object rather than the object itself.[1]

> The preoccupation of most museums with the pragmatics of managing matter is therefore misleading, not unlike the pragmatics of parental care, which is similarly taken up with an endless struggle against unwanted substances in undesirable places. In both instances, the distractions disguise the real merits and satisfactions that the institution affords. Museums are actually warehouses of material things only superficially. At bottom they have always been reservoirs of meaning. Paradoxically, however, the objects that Museums collect, pried loose from the contexts that first consecrated their meaning, shed their old meanings when collected and acquire new ones. Notwithstanding expert authentication and recognition by connoisseurs, Museum objects retain only the penumbra of the objects they supersede. Their substantial soul is sublimed.[2]

It is within this suppression of function and usefulness that House Museums lose much of their connection to human emotion. It is at least true that the placement of artifacts within an HHM is contextually correct. However, the objects become part of abstract stage sets, furnished not for habitation, but for object comprehension. Artist Darren Waterston recently explored this quality in his Mass MoCA installation, *Filthy Lucre*, a contemporary re-imagination of James McNeill Whistler's *Harmony in Blue and Gold: The Peacock Room*. The original room was commissioned as an elaborate display of the patron's ceramic collections, but Waterston staged his installation as a beautiful ruin, questioning the use of an entire room as a showcase and people's obsession with material objects.[3]

In a typical period room, slight consideration is given to how people might have actually used the room or its furnishings, or how the room layout makes visitors feel. Does the room provide a moment of emotional security, or is it merely an iconic abstraction? A 2013 study evaluating emotional responses to virtual interior designs of hospital rooms suggested that the more interior elements like furniture and decorative items are placed in a room, the more engaged and positive patients felt.[4] Further research suggests that the museum environment can play a restorative role in people's emotional state by doing the same.[5]

In rooms that are too curated or too done, familiarity is lost, at least relative to what the space can offer about its inhabitants. Andrew Scrimgeour, a university library dean, wrote thoughtfully of how his experiences surveying the personal libraries of deceased scholars revealed their lost personalities to him. He carefully photographed the residential spaces in all their unedited glory before ascribing a regulated, impersonal system to their books, all the while relaying his feelings of a deep loss each time he removed them from their original context.[6] This same system is routinely followed in Historic Houses, concentrating on the objects, adding an unnatural order to them that likely never existed, and making sterile what was once full of quirk and personality.

The once prevalent practice where a small group of professionally trained curators select important objects and compose an interpretive organizing system, however, is evolving. Some museums are now facilitating crowd-sourced, curated exhibitions that allow guests to produce combinations and associations outside of professionally curated interpretation. So strong is this push for public involvement in determining the complexity of a collective narrative that the *Wall Street Journal* featured an article titled

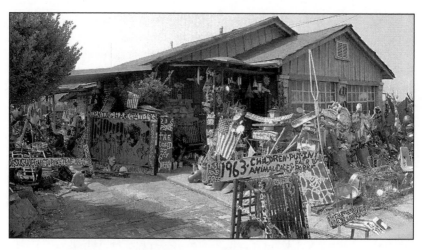

Figures 4.1 & 4.2: After seeking out the home of outsider artist Minter, in Birmingham, AL, we were struck by both the complexity of objects in his collection and the power derived from the unified whole. It was impossible to understand his memorial to the unmarked African slave burial ground, upon which his home rests, without acknowledging the integrated relationships between his individual pieces. Either intentionally or haphazardly, many of Minter's works related to another in close proximity, which he stated corresponded to the many slave's lives removed from the historical record. *Photos: Franklin Vagnone.*

"Everybody's an Art Curator: As More Art Museum Outsource Exhibits to the Crowd, Is It Time to Rethink the Role of the Museum?"[7]

In many ways, the educational philosophy of the typical HHM is, unfortunately, tied to historic artifacts, probably because most House Museums were established in the earlier era of educational philosophy, one that valued teacher-curated details, memorization, and a common, shared history, while de-valuing the students' emotional engagement in the experience. More recently, there has been a shift away from this traditional teacher-led, object focused didactic education system of learning towards a more open-ended, de-centralized diffusion of knowledge. This transition has many historic site educators uncomfortably grasping for grounding given their traditional educational perspective. To be relevant, they will have to look beyond the cult of the object towards a more contemporary emotive engagement, one that is created through experience.

THEREFORE

Move away from concentrating just on the physicality of objects. Consider non-material relationships of material things. Nobel Prize winner Orphan Pamuk realized a life-long dream when he opened in Istanbul The Museum Of Innocence, a House Museum based on his book of the same title. In explaining his motivation for the book and eventually creating this fictional historic site, Pamuk wrote, "What I had in mind was a sort of encyclopedic dictionary in which not only the objects (a radio, a wall clock, a lighter) and places (an apartment block, Taksim Square, Pelur Restaurant) but also concepts (love, impatience, panic) would be the subject headings."[8]

Consider the entire environment of the House Museum as an artifact, understanding that the context will make a meaningful contribution to guests' experiences and possibly produce a positive effect on their emotional state.

Produce a more realistic and compelling learning environment through a more complex interior organization of the House, a more complex mixture of collection items, and a more involved visitor experience. Crowd sourced research is suggesting that guests make thoughtful choices when faced with a diversity of options, and that curating complexity can be facilitated in an open, non-stratified manner. We have found that some of the best ideas and answers to issues of interpretation come from people outside of the professional circles of collections management, education, and preservation. This type of bottom-up decision-making can become the basis for building new partnerships and forms of community programming.

Expose Domestic Complexities

Embrace the physical complexity of habitation.

RANT

My frustration with Historic House Museums is a common one—they tend to remain static. Yes, they look back in time, but there are ways to teach social history, architecture, art and culture that also connect to visitors' current experiences. The saddest thing about some of these Historic Houses is that once you've gone there on your 4th grade field trip, there is nothing to draw you back as an adult because you've already seen all that they have to offer. Many Historic House Museums need fresh ideas, but that doesn't mean getting rid of the history.

(Meredith Sorin Horsford, Executive Director, Dyckman Farmhouse Museum, and Director, Innovation Lab Historic House Trust of New York City)

EVIDENCE

As we argued in the last marking, the interiors of many Historic House Museums seem to be like a galaxy of object-like planets, all with various levels of gravity and atmospheric space. One fine object dare not be allowed to overlap with another, as such an act would undermine the historic integrity of the curated interior. It seems odd that for such intimate spaces, the interiors of House Museums seem to be set up for a first date, where the couple is politely keeping their distance from each other. We sometimes imagine that when we leave and the lights go out, the furniture and artifacts quickly intermingle, much like in Disney's *Beauty and the Beast* or Pixar's *Toy Story*.

In reviewing the *Anarchist Guide* one-minute research videos of habitation, we often saw dirty dishes, overflowing trash cans, messy cabinets, decorated refrigerators, laundry rooms/closets spilling over with clothes, and coffee tables piled high with books, magazines and TV remotes. In comparison, the videos of HHM interiors showed very little of that resultant layering of use. The detritus of habitation was curated right out of the interpretation.

For some reason, many HHMs share a goal to isolate, quantify, and normalize rather than to embrace complexity and idiosyncrasy. Contrary to

Figures 4.3 & 4.4: The notion of curating "dirt and dirty underwear" came to us after cleaning up the apartment one Saturday morning. *Left:* It is rare to actually comprehend the residue of life, so when emptying out the vacuum cleaner, we wondered how the residue could be quantified. When we clean, what do we lose? *Right:* In our research videos, we were struck by the large number of things in our homes, and how they ultimately formed a collection. The layering of such items gives a sense of habitation and use, a quality that is lost in most heavily curated HHMs. *Photos: Franklin Vagnone.*

Martin Heidegger's idea of "the thingness of the thing," where objects hold within themselves connections to intangible concepts, we often see House Museums suppressing the intangible meaning of contextural relationships.[9]

Pedro E. Guerrero's account of first visiting Alexander Calder's home offers a notable example of embracing domestic complexity. He was sent by *House and Garden* to photograph the artist's home for the magazine. Guerrero knew as soon as he entered it that his editor would not, as he hoped, feature Calder's home on the cover of the magazine, because

> one could see immediately that Elizabeth [the editor] was not going to "do" the place.... I ran in to explore the kitchen. A kitchen that was meant to be used, not to impress. It told me everything that I didn't

already know about these people—their charm, their informality, their intense passion, a life lived without pretense or sham.... I had been right—we were leaving. With its antique wood and coal stove and handmade utensils, this House was no subject for *House and Garden*. None of the advertisers' products was anywhere to be seen.[10]

The aesthetics that made Calder's home inappropriate for a style magazine are the same as those found in most historic photographs of real-life situations, where there is plenty of visual complexity and intermingling of objects. Extreme cases like the Collyer Brothers, who famously lived and died within a 140-ton hoard in their Harlem brownstone in the 1940s, are reminders of the how overly important things can be, and how they can overpower the experience of living.[11]

More contemporary examples of the power of belongings to shape lives abound. In *Material World: A Global Family Portrait*, Peter Menzel exposed the radically different lives of people around the world by photographing families among all their worldly possessions, after they were gathered together and placed in front of their homes. A highly textured image of global disparities emerged through these families and the size and nature of their belongings, helping the reader understand how radically different the notion of 'normal' is to different people. House Museums, however, almost never seem to embrace this relative complexity of domestic life, not in the room layout or in the display of collection objects. Instead, visitors to HHMs find a scene set up without any of the detritus and complexity of real life.

Much of the sanitized history of HHMs comes from the intentionally romanticized Historic House Museums/retail centers, and subsequent photographs of Wallace Nutting.[12] These Picture Houses were mostly showcases for his reproduction furniture and stores where it could be purchased. These faux historic homes were never about conveying historic accuracy or even educational efficacy. Instead, they were places for the marketing and visual merchandising of artifacts intended to re-create a romanticized past.

Nutting's rooms were physically static representations of the historical. There was no suggestion that the artifacts were ever moved around or that room functions changed over time or as guests arrived and departed. Unfortunately, this frozen perspective infected HHMs and remains common today.

There was a lack of humanity in Nutting's perfect Picture Houses that has contributed to one of the biggest obstacles in engaging HHM visitors.

Through our research, we have found that guests are most engaged with un-interpreted, un-curated, and messy spaces, and least engaged in the highly curated, pristine period rooms. In other words, the very sparely decorated rooms that HHMs spend so much time designing and noting in multitudinous furnishing plans are the spaces that are least interesting to visitors.

In one HHM, we studied historic etchings of residential interiors for the same time period when the House was first built. We compared those historic images with how the HHM's interiors were being presented as period rooms. Surprisingly, they looked nothing alike. The historical etchings showed wood shavings all over the floor, food bits in the corner being eaten by dogs, irregularly spaced groupings of people, and a messy firebox with cooking paraphernalia. Comparatively, the HHM held fewer than ten pieces of furniture arranged in an immaculately cleaned space. To top it all off, we found that this small House Museum was simultaneously the home of 13 members of a family and went through three major additions and renovation stages. Complex? Yes. Interesting? Yes. Interpreted? No.

THEREFORE

Realize that visitors crave a more realistically presented habitation space and some illustration of the variety of occupation that occurred in it over time. Allow visitors to experience visual complexity and change within the HHM. Expose the detritus of real life habitation. We suggest that House Museums build into their experiences and narratives both changeable and complex environments even while we understand the tectonic changes that this idea may produce because it strikes at the heart of the most traditional view of what a House Museum is.

We also believe that the visitor experience is more important than any other aspect of House Museum stewardship. When conflicts between use, collections, and preservation standards arise, discuss those differences and prioritize accordingly. However, it is most important not to let past methodologies and best practices limit new endeavors. The traditional type of structure requires great effort with few positive results. Remember, visitors are our guests. Our job is to be good hosts.

Expand the Guest List (CAST)

Include an expansive list of characters in your HHM narrative. Reduce the focus on a single inhabitant.

RANT

So many Historic House museums are stagnant monuments to great wealth—the nineteenth- and twentieth-century manifestations of Robin Leach's 'Lifestyles of the Rich and Famous' or 'Cribs.' Visiting them is often simply an exercise in voyeurism rather than education or enlightenment. I don't even find them entertaining. Some are important examples of architecture or house great art collections, but others only offer a distorted vision of the past. At one House I visited in South Carolina they described the 'gracious living' that the family enjoyed and their 'escape to the country to avoid the yellow fever.' Of course they ignored the fact that their slaves (or servants as they called them) were left to care for the rice crops and to die from the fever. The visit just left me with a headache. Certainly in recent years there have been more houses dedicated to people who have selflessly done great things—Jane Addams Hull House, for example, or the Martin Luther King birthplace—but in addition to distorting history, the vast majority of historic houses glorify wealth and power. Are these the only values that we want to teach our children? Is this how we want to encourage a shared vision of our collective national life as Americans?

(Gretchen Sullivan Sorin, Director and Distinguished Service Professor, Cooperstown Graduate Program)

EVIDENCE

Sometimes a House Museum visit feels like a party where only one guest has been invited, because HHMs are often interpreted only from the viewpoint of one or two occupants at the most significant time in their lives. Entire groups of people are left unmentioned, and the HHMs narrative is mostly silent as to their contributions to the home.

Many of America's HHMs began with a historical role and political purpose, especially when overseen by patriotic societies like the Daughters

of the American Revolution (DAR) or the National Society of the Colonial Dames. The DAR was founded in the 1890s with a mission "to teach patriotism by erecting monuments and protecting historical spots, by observing historical anniversaries, by promoting the cause of education, especially the study of history, the enlightenment of the foreign population, and all that makes for good citizenship."[13] This patriotic purpose often served to exalt white males and their grand homes, effectively erasing the other inhabitants from the narrative entirely.

Our national perception of leadership has matured from revering a single man into a more expansive appreciation of a collective hero identity. But HHMs' interpretations have generally not caught up to this shift in public thinking. We are still tethered to Ralph Waldo Emerson's concept of 'representative men.'[14] Nina Simon, Executive Director of the Santa Cruz Museum of Art, agrees, writing,

> The vast majority of American museums are institutions of white privilege. They tell histories of white male conquest. They present masterpieces by white male artists and innovations by white male scientists. The popular reference point for what a Museum is—a temple for contemplation—is based on a Euro-centric set of myths and implies a white set of behaviors.[15]

Including a slave or servant narrative in a Historic House's interpretation is still considered notable, not normative. A recent archaeological discovery of slave quarters at the Martin family's Rock Hall, a Georgian mansion on Long Island, is one of only a small number of examples in the North and suggests that the Martin family slaves practiced their traditional religion and attained a semblance of autonomy over their living quarters.[16] The town of Hempstead has operated the House as a museum since 1953 and long subscribed to the typical object-based tour. With census records from 1790 clearly stating that the Martins owned 17 slaves, it is hard to understand why it took so long to start digging for those stories.

The focus on heroic white men in hushed settings is especially problematic given the changing demographics of the neighborhoods that surround HHMs. We know from census data and research that the demographic structure of society is changing globally. Ethnic migrations are taking place, along with language shifts. Communities that once were primarily Jewish are now Jamaican or Dominican. Interests change, and relevancy acquires new connections.

Acknowledgment, much less inclusion of these increasingly diverse *others* in HHMs, has almost always been dismal, whether they are women, people of color, minority populations, LGBT, the economically disadvantaged, or just plain, average people. There is a widespread assumption that all potential visitors speak the same language, or even more disconcerting, that they all view the heroic, white, male-dominated narrative in the same manner. The number of HHMs dedicated to white narratives aggressively overpowers those that offer a shared narrative. It is impossible to calculate the number of sites that could have spoken to underrepresented and underprivileged populations that have slipped through preservation's grasp because of location, poor funding, lack of architectural interest, or documentation, racism or any other number of issues. A few sites of historical importance are now rapidly decaying, including the 1315 Lapsley Street home in Selma, Alabama, an important site of U.S. Civil Rights formation, and the Malcolm X-Ella-Collins-Little House in Boston. Community leaders are finding it hard to convince the establishment that they are worthy of preservation.

As Americans' collective consciousness expands, more sites representing more complete narratives are gaining attention, like the Jackie Robinson House in East Flatbush, Brooklyn. Still, that site is encountering difficulty gaining landmark status due to disputes over Robinson's years of residency at the house.[17] Given the staggering abundance of Historic Houses and sites dedicated to dead white men, we cringe to see the former home of a transcendent national treasure like Robinson subjected to such scrutiny.

THEREFORE

The impact of demographic change on House Museums is that some are unfortunately digging in even deeper to justify and make more distinct their traditional hero narrative. More hopefully, a small but growing number are expanding the cast of characters in the narrative and including more stories about the women, members of the extended family, and the home's servants/slaves.

Do not shy away from narratives that paint the home's patriarch as less than heroic. Share his struggles or poor decisions, realizing that his foibles may make him more accessible.

Continually update your narrative so that it relates to current events. A focus on the interests and needs of immigrants would resonate today as it did

when many HHMs were founded. But rather than promoting assimilation into a male-dominated white culture, find ways to celebrate the diversity of the neighborhood that surrounds your HHM. The Historic House Trust's innovative *LatimerNOW* initiative is testing this idea in various ways at the Lewis H. Latimer House in Flushing, Queens, by playing records owned and loved by Lewis's two daughters; by creating meeting spaces for neighborhood groups that mirror the political salons Lewis would host for his contemporaries; and by recording oral histories of the women who lived in Latimer House as boarders after Lewis's death.

Broaden the period of interpretation and begin to include different inhabitants of the House throughout history. Realize that a wider array of narratives will bring your HHM closer to possible relevancy and cultural diversification.

One House Museum that we investigated had a very traditional, one-person dominated narrative that had very limited relevancy to a wide contemporary audience. In our research we found that the House had been re-purposed as a school for blind children and young invalids in the early 1900s. During that time period, the large decorated parlors were transformed into dormitories and the large bedrooms became staff offices. We suggested they investigate this time period further and begin to incorporate this narrative as an active component of their interpretation, overlapping the lives of the historic inhabitants with the contemporary special needs community. We asked that they consider changing out some of the period rooms that were full of untouchable furniture into active spaces that could hold programs for local children with disabilities and reproducing a dormitory space that would allow visitors to lie in the beds and experience what that House felt like when it was serving a different audience.

Understanding the inclusion of *others* is a contemporary demand HHMs must embrace if they are to remain relevant. Embrace rather than ignore the changing demographics around your site, and seek diverse perspectives on how your HHM can evolve into a more widely welcoming site.

Follow the Sun

Create an interior environment that suggests daily life cycles.

RANT

My biggest pet peeve with historic houses is the predictability of the visitor experience. I yearn for the element of surprise during these visits. Please don't make me pay for an experience that I can practically outline, block and recite.

(Olivia Cothren, Director of Special Programs, Development, Historic House Trust of New York City)

EVIDENCE

From our experience with Anarchist Guide workshops, we have found that visiting an HHM is often times a homogeneous experience from room to room and from House to House. We use Anarchists Tags to solicit visitors' reactions in real time and have found that guests often want to feel integrated with the kinetic operations of the House. For instance, guests yearn to be able to open and close the shutters, open the curtains, turn on the lights, open and shut the heavy front door, and search for something in the butler's pantry. The tactile act of engaging the Historic House in the daily cycle of use allows a guest to become enfranchised with the history in a tangible way. The *Anarchist Tags* reveal guests' interests in these mundane house operations when they leave in situ comments like "love the open window" and "I want to lie on the bed."

Few rooms in HHMs look truly lived-in, so there is a lack of connection between the guest and the narrative.

It seems that most HHMs have been set up to illustrate a time around 4:00PM, right after nap time, because all of the beds are made, but before dinner, as the table is set prettily for guests but there are no pots yet on the fire. The work of this mysterious room-setting fairy can be seen in thousands of House Museums throughout the United States with very little variation. The fairy gets around.

We call this repetitive time stamp the "similarity of setting," and it works against HHMs because the visitor experience is emotionally abstract, does not allow for a varied and complex reading of real life habitation, or provide

memory cues for guests. Even if the House is full of interesting collection items, their arrangement and interpretation are so similar to those of other HHMs that they create an unintended sense of déjà vu, causing guests to mentally and emotionally check out of the current experience.

This repetition results in a missed opportunity. Research into the cues that invoke the re-surfacing of memories suggests that environmental settings can act as a sort of aid to remembrance. In addition, the behaviors and contextual interactions in the space also heighten the personal overlap. In other words, the organization and presentation of spaces in a Historic House Museum have the potential to be powerful tools in viscerally engaging visitors.

Further, House Museums miss the opportunity to expand the guest experience by limiting the hours they are open to the middle of the day when life in the home was probably at its most quiet point. The family's daily rhythms of opening up the house in the morning and closing it down at night are overlooked because those activities would have occurred at times before the House is now open and after it is now closed to the public. Consequently, an opportunity for tactile engagement is lost, especially when guided tours only offer a quick glance or just a casual mention of the ritual of everyday activities like bathing, getting dressed and undressed, crawling in and out of bed, and opening shutters or closing curtains.

> More generally, memory aids and strategies function as context cues. These cues may be part of the *context associated with a target memory at the time of its original encoding,* just as the images of a restaurant and of the meal may be stored as concomitants of a conversation at the restaurant. These associated cues enrich the target's stored representation.[18]

If guests are emotionally engaged through personal relationships with the environment of House Museums, they are more likely to leave understanding more and at a deeper level than if it were simply an intellectual, didactic experience. As domestic spaces, HHMs have the greatest potential to produce this highly intimate relationship through immersive environmental experiences, but more often, the personal and intimate remain unintentionally hidden under the professional and abstract interpretive and furnishing plans.

Historic photography is often used as a means to validate a professional interpretive/furnishings plan. However, as Claire Robbins suggests, the conscious act of photographing an environment, as an object as opposed to the subject of the shot being of a person or event and the environment

is secondary, usually involved an effort on the part of the photographer to convey a particular idea of domesticity.[19]

Unfortunately, the act of photographing the interior of a Historic House may be more about romance than reality and authenticity.[20] A strong example of this documentation can be seen in the photographs of the Farnsworth House in Plano, Illinois. Early images of the then recently completed home show a gallery-like precision to the furniture placement, just as the architect had specified. However, photographs taken by owner Dr. Edith Farnsworth a few years later show her distraught over the fish bowl like quality of the architecture and her inability to surround herself with things she collected and loved. These later photographs also suggest the disconnect between occupying a domestic environment that was intended more for furniture placement and living amongst the ordinary detritus of everyday life.

In analyzing these two different types of photographs, our research showed 60 percent more pieces of furniture during Dr. Farnsworth's habitation than in architect Mies Van De Rohe's official furnishing plan for the home. Interestingly, shortly following the house becoming an HHM, the architect's spare furnishing plan and early photographs were used to

Figure 4.5: Illustrating daily, yearly and life cycles adds to the interpretation of an HHM. Megan Searing Young, Executive Director of the Greenbelt Historic House Museum in Greenbelt, MD, has outfitted the House with a complexity and tactility that feels real and lived in. *Left:* The outside storage closet is full of lawn equipment, which is used. *Photo: Franklin Vagnone.*

interpret the house rather than the photographs of Edith's habitation. Today, the Farnsworth House has chosen to hold onto the static and abstract idealized vision of habitation, rather than the reality of the changing and gritty conditions that result from the demands of living.

House Museums seem to lack a way of expressing the continually evolving and overlapping episodes of daily life. Often, what is presented in a House Museum excludes the most common and intimate behaviors that most guests understand. The exclusion of these remnant signatures distance the narrative from guests, and reinforce the perception that the former inhabitants were not real people with real life issues.

In contrast, we found a related and very immersive experience at the Greenbelt Historic House Museum outside of Washington, D.C. Not only were guests allowed to use the bathroom as originally intended, they were also provided with a period correct body weight scale so that they could participate in another distinct activity within the space.

THEREFORE

Rather than presenting the HHM at the same, single, moment in every day, allow the House to be experienced through what would have been its daily cycle of use. Consider creating memory connections and cues for the guests by encouraging them to participate in the daily rhythms and rituals of everyday life.

In tracking personal habitation behavior, we began to see some mapping exercises that included quantity and quality of light as it related to their use of the space. We found the introduction of the cycle of the sun to be a clear and direct experience of a space. For instance, we saw some initial evidence that the east side of the house is more active in the mornings, while the west side of the house is more active in the evenings.

Simulate the idiosyncratic habitation experience with artifacts that express a full spectrum of activities. It also is a good exercise to change the HHM experience seasonally. Both subtle as well as dramatic changes take place in a home when it goes from hot summer to cold winter. The core of any Historic House experience should be from the perspective of habitation, and historic narrative follows.

Fingerprinting

Allow guests to individualize their experiences and leave a mark at your HHM.

RANT

It's very important for each visitor to 'fingerprint' in their own way on the museums they visit, and for many people, that is via photography; others through sketching, or sitting, etc. I think in the case of house museums it matters because you inherently know that people lived in that house, that it wasn't always a museum, and each person that lived in the house has been able to leave their mark. Why can't you? Perhaps not a scratch on the wall, but some evidence that you, too, have once been there, and you then become part of the house's history.

(Alli Rico, Bostonian Society Graduate Fellow)

EVIDENCE

Historic House Museums typically do not allow guests the opportunity to make the visit unique or allow for an idiosyncratic experience. After a while, we have found that the Houses start to look and feel the same because of standardization of the experience from one visit to the next, much like those offered by fast food restaurants and chain stores.

To overcome this homogeneousness, we suggest the concept of *fingerprinting* as an essential experience at HHMs. Fingerprinting is emotional engagement that occurs when guests are allowed to mark the house experience in some way as their own. The act allows a visitor to individually *own* the House and experience it as something separate from what other people may value.

As an act, fingerprinting is nothing new, as evidenced by the particularly charming example of the Hess Triangle, a 500-square-inch piece of private property in New York that the owner tiled with the phrase "PROPERTY OF THE HESS ESTATE WHICH HAS NEVER BEEN DEDICATED FOR PUBLIC PURPOSES."[21]

In the best of circumstances, people visit historic sites because they matter to them, and where they can feel a continuum in how their visit fits

into the larger pageant of visitation. In earlier times, people could carve their initials into a tree, or even worse, a brick. We do not support either, or any act that leaves a permanent mark on a historic building or site. Today, guests can do the same type of fingerprinting but with no harm by using digital media or by participating in various other activities that allow for unique experiences.

THEREFORE

Fingerprinting is vital to Historic House Museums because we must make visitors feel more welcome and personally engaged in the making and marking of history. It is one reason why we support the use of photography and personal smart phones as a participatory means of marking a visit. When guests see a site that does not allow photography or smart phone use during a visit, it tells them that their relationship with the site is so limited by what the HHM organization wants them to feel and see that there will be no room for their thoughts and tactile integration with the narrative or the environment.

In some cases, passive fingerprinting can be accomplished by simply allowing guests to use a room as it was originally intended. This kind of access gives guests a choice to actually sit in rooms, rather than being forced to stand at their edges; find a private space to engage the House on their own terms; and partake in an uninterpreted environment in which they can individualize their experiences. These three activities have nothing to do with an HHM's traditional interpretation, collection stewardship, or educational program competence. But they do allow for personal freedom and engagement based upon what the visitor wants, not what the House Museum thinks they should learn.

In other cases, fingerprinting can happen when a visitor needs a break from the activities of the typical tour. This type of experience should not be seen as inappropriate. In fact, it should be viewed as a positive sign that the visitor considers the site a safe space to relax without any worries or judgments. We often find the best way to convey a site's spirit is to allow a space for a visitor to lie on the grass, rest from the day's activities, and simply listen to the sounds of the site.

One of the most engaging concepts of fingerprinting can be found at the Yellow House in the Heidelberg Project in Detroit, Michigan. The project encourages contributions toward the restoration of a house and art project by inviting donors to write on the house itself, literally leaving their

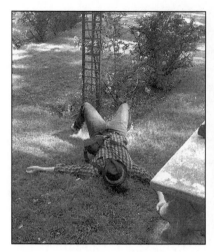

Figures 4.6 & 4.7: Fingerprinting allows HHM visitors to feel a personal connection with a House. *Left:* The act can range from setting aside space and time for a quick nap, as this guest enjoyed in the rose garden of the Lyndhurst Mansion in Tarrytown, NY. *Right:* Fingerprinting also allows visitors some tangible way to leave their mark, as can be seen at the Heidelberg Project in Detroit, MI, where a guest can contribute financially toward the restoration of a house in the district and then sign his or her name with a water soluble pen on the walls. *Photos: Franklin Vagnone.*

marks on the process of preservation. In addition, the owner of the Yellow House engages the visitor/donor on her porch and poses for a selfie as part of the experience. In this way, visitors leave their signatures behind and take an individualized memento away with them.

From an urban perspective, fingerprinting has long been acknowledged as a means of marking a territory by making it personal. It is not hard to see why tagging with street art is a form of place-making, or how forms of guerrilla art, such as artist-produced leaflets glued to posts, walls and fences mark urban space and personalize it.

The survivors of the 2011 tsunami in Japan used fingerprinting on a massive scale to turn the last surviving tree in the storm-ridden area into a giant sculpture.[22] The tree died 18 months after the tsunami and had to be chopped down, but before it was gone, locals made a sculpture from molds of the trunk and branches of the tree. They fingerprinted the former site of the tree with this sculpture that serves as a symbol of triumph over devastation.

On the Pont de Arts bridge in Paris, couples partake in a sentimental form of fingerprinting by attaching padlocks that are inscribed with both lovers' names to the bridge. Unfortunately, the city announced plans to remove the locks and replace the railings with thick glass panels to end this practice, citing preservation of the bridge as one reason for ending the tradition.[23] This high-profile example pits fingerprinting against preservation. We advocate instead for a responsible coexistence, as the benefits of fingerprinting are too impactful on the visitor experience to ignore.

More often than not, we arrive at a long-awaited visit to an HHM, only to find a large sign outside of the front door stating, "no photography, no touching, no strollers, no children, etc." We usually turn around and visit someplace else more welcoming and aware of the importance of fingerprinting.

Contemporary Interpretations

Seek out contemporary reflections and critiques of your HHM site and narrative.

RANT

It sounds a bit like the fashion industry, but maybe there's a clue there. Whether it's hosting contemporary art installations, allowing visitors to play that historic piano, or replacing an ignored garden with another that is thoughtfully considered, visually exciting, and relevant for today's audience, the institutional mission may best be served by hacking away at the way we've preserved our sites, in amber.

(Ted Bosely, Executive Director, Gamble House
[Response to a blog post entitled "You are an idiot"
on the *Twisted Preservation* blog])

EVIDENCE

"Struggling Museum Now Allowing Patrons to Touch Paintings" was the crazy 2009 headline of the satirical newspaper, *The Onion*, as it lambasted one of the most feared worries regarding the protection of cultural treasures.[24] The worry is that all that is valuable about these fragile resources will be destroyed in order to engage new audiences and ensure the long-term sustainability of museums and Historic Houses.

In actual execution, however, results of contemporary interpretations of collections are far less dire and can be placed solidly within a long history of similar artistic endeavors facilitated by the original inhabitants of many homes that have been turned into HHMs. Historic records and photographs show not only the landscapes as settings for contemporary follies and sculpture, but also that the architecture itself was considered specially and technologically innovative. Some examples are the structural ingenuity of Frank Lloyd Wright's Fallingwater, the artistry of Greene and Greene's Gamble House in Pasadena, John Soan's inventive lighting of his townhome in London, and Le Corbusier's Villa Savoye as a machine for living.

Further, the walls, doors and materiality of many important structures have acted as canvases upon which site-specific artworks were facilitated. An example of these art relationships include Henri Matisse's home, where his famous cutouts were added as embellishments to pre-existing walls. Only later did they become the widely known, documented, and two-dimensional images they are today.

Perhaps more important is that these site-specific artistic relationships acted as stage sets for the real life activity of parties, dinners, celebrations, wakes, births, and deaths. We believe that one of the best ways to bring back this type of vibrant life is to allow contemporary art happenings into the site. Outside perspectives force a new platform, upon which new commentary and relationships can be seen that otherwise would be hidden. We have found that there is a wide spectrum of ways in which contemporary art can become a part of an Historic House site, ranging from minimally invasive to totally immersive.

THEREFORE

Incorporate various kinds of contemporary art installations in your HHM. On the one end of the spectrum is the more traditional model of contemporary art installations where the project is artifact based, placed within the existing context of the House, and communicates a commentary from a cerebral perspective. On the other end of the spectrum are more experience-based projects that use a recombination of the existing context to heighten the commentary, with an immersive, tactile involvement of guests.

We have worked with curators Robert Wuilfe and Michele Wilson on a number of site-specific art happenings at the Philadelphia Society for the Preservation of Landmarks (PSPL) that incorporate the full spectrum of this continuum. *Rules of Civility* by Virginia Maksymowicz at the Powel House was a minimally invasive installation, where specially crafted items that

commented on the role of women during colonial America were strategically placed around the House Museum. The artist produced plaster copies of artifacts related to Elizabeth Willing Powel to illustrate the relatively silent, but important role that women played in the formation of the new country.

The 2008 Fiber Arts Biennial held at both the Powel and Physick Houses in Philadelphia moved further into the realm of recombination and deeper immersion of new items within the existing collection. The Physick House projects related to the 1796 yellow fever epidemic in Philadelphia. Dr. Physick was one of the few doctors that stayed in the city to assist the afflicted. Marie H. Elcin's work, *Water, Water, Everywhere,* provided a commentary on clean water both in 1796 and today, through conceptual sculpture expressing traits of water, flow, and germ and virus transmission. On the second floor of the Powel House, artist Phuong X Pham's *Stasis* made comment on the House's history, which at one time was converted into a horsehair and boar hair factory. The artist's piece was made from fabric woven with horse and boar hair, and it rested in what is now a beautifully restored ballroom.

In 2006, again at PSPL, Pew Fellow artist Candy DePew's *Between Worlds* fully embraced the existing collection context of the Physick House to produce a visual conversation between the stunning Federal Style interior period rooms with her equally robust decorative artifacts. Often guests could not tell which objects were historically correct and which were contemporary subversions.

Also in 2006, Wuilfe and Wilson curated an extensive video installation at the Powel House by Megawords for Philagrafika. In every room, guests to the Historic House encountered moving video projections of contemporary life in Philadelphia that provided a commentary on issues of poverty and wealth.

Beyond the visual art exhibitions, we have seen the number of site-specific theater, dance, and event happenings grow steadily at HHMs. Some projects that we have been involved with include the PIMA Dance Group in 2007 at the Powel House, Caitlin Perkins's *Playing with Ghosts,* and the Bowerbird series of avant-garde music and artist collaborations at HHMs in Philadelphia.

In 2010, the Historic House Trust of New York City formulated its *Contemporary Art Partnerships* to beget site-specific contemporary art happenings at its member Historic Houses. The programs include *Corseted* (2012), *Unpacked* (2014), and *Touch History* (2014–2015) at the Morris

Figure 4.8: Integrating contemporary interpretations in a Historic House Museum can be subtle, yet meaningful. Seen here is Peter Hoffmeister's Ball and Chain (per capita) from a 2013 exhibition at the Morris Jumel Mansion. Using black felt, Hoffmeister's compared the per capita ratio of slaves at the time of the House's occupation in comparison to incarceration rates today in the same states. In many cases there remains a direct correlation between states that formerly had high slave populations and those that now have high per-capita incarceration rates. *Photo: Peter Hoffmeister.*

Jumel Mansion; *Art This House* at Historic Richmond Town (2015); and *Writing on It All—LatimerNOW* at the Lewis H. Latimer House (2015).

In 2014, Morris Jumel Mansion and HHT collaborated on Peter Hoffmeister's *Unpacked* and illustrated how site-specific contemporary art installations can bridge the gap between historic narrative and contemporary issues. In the front parlor of the Colonial American House, Hoffmeister produced felt cut-outs of states whose relative size corresponded to the number of incarcerated people in them, as well as the proportional number of slave holdings in each state at the time of the construction of the Morris Jumel Mansion.

Other Historic House Museums are beginning to produce some equally intriguing shows. For a number of years, the Merchant's House

Figure 4.9: There are many ways in which collections and architecture can incorporate new interpretive concepts. Shown here is *Touch History* (Kathleen Granados, 2014, Acrylic yarn, 19th century chairs, 21st century household objects) at the Morris Jumel Mansion. The contemporary art happening involved methods that a visitor could become involved with in the House in a tactile way. This project was also presented to people with special needs through workshops. *Photo: Kathleen Granados.*

Museum in New York City has been engaged in contemporary art installations. The projects included the *NEON CHANDLIER, Servant's Wings,* and *Christmas in 1850,* a jarring portrayal of a 1950s kitsch holiday scene in the posh 1850s townhome, making connections between traditions and eras.

In 2014, the Gamble House in Pasadena facilitated its first contemporary art happening, entitled *The Machine Project.* The show consisted of both landscape and interior installations, and garnered substantial press for its bold vision. The same can be said of Wilton House's *Anywhere but Now,* a work that consisted of strategically placed contemporary art within the existing period rooms. Edwin Slipek, a writer for the Richmond Style Weekly Newspapers, reviewed the Wilton House's exhibition and quoted

the curators who said that "crossing the threshold of an historic house metaphorically represents a temporal disjunction for visitors who envision they are stepping into another time." In response, he asked, "Rather, might patrons find such places fertile ground for thinking more deeply about nostalgic tendencies?"[25]

Figure 4.10: Engaging HHM guests in unexpected ways can heighten their experience. Some Historic House Museums are beginning to produce some intriguing events with contemporary art installations in their period rooms, like at the 1832 Merchant's House Museum in NYC. When the Museum's original 1850s bronze gas chandeliers were removed for conservation in 2006, neon chandeliers were installed by Lite Brite Neon Studio of Brooklyn. The temporary work consisted of a loaned pair of neon glass sculptures designed by Matt Dilling until the conservation project was complete. The ghost-like silhouettes of the three-dimensional neon chandeliers were intended to evoke the original nineteenth-century fixtures, inviting visitors to view the parlors in a whole new light. *Photo: Pi Gardiner.*

CHAPTER 5.

SHELTER MARKINGS

Keep Perspective and Buy Duct Tape

Keep the cost of your HHM's preservation in check relative to the value and importance of the site.

RANT

We are afraid to do anything because someone told (Historic House Museums) that they needed a conservator and an architect and a curator to vacuum a mat. And that's not an attempt at placing blame—it's a call for us to try and understand how to proceed—the field has been ratcheted to the level we can't afford ourselves. It is better to buy duct tape than go down that path.[1]

(anonymous international conservator)

EVIDENCE

Historic structures are expensive to maintain, and the preservation work never ends. Since its inception as an HHM over 150 years ago, Mt. Vernon has undertaken approximately 63 major preservation projects. Frank Lloyd

Wright's famous Fallingwater has spent over \$11.5M on structural work, and the Gamble House spent \$3.5M just on rafter tails. Even the humble Edgar Allan Poe Cottage in The Bronx, New York, recently spent \$500,000 for restoration work.

Few small HHMs have sufficient resources to preserve their site with the same standards and intensity as major institutions, or the willingness to acknowledge that not all HHMs are created equal. In fact, Historic Houses vary widely relative to their architectural value and historic significance.

The U.S. Secretary of the Interior's Standards for Treatment of Historic Properties (STHP) are intended to assist state and local governments, non-profits and private owners of historic sites in determining the appropriate degree of preservation they should pursue. While the STHP suggests flexible preservation practice standards, HHMs do not seem willing to adopt such a range in their efforts. We have adopted, in concept at least, the standard evaluation measure used by auction houses: Good, Better, Best. The problem with most House Museums is that to them, Good is simply not good enough. Yet, in truth, most Historic House Museums are not Monticello or the Gamble House. Nor do they have the resources or staff needed to achieve the highest standards of preservation. We all become crippled in our attempts to keep up with these "king-daddy" Historic Houses.

From our experience, the best preservation standards can be achieved only by losing funding for something else. Programming and preservation almost always compete for whatever resources are available in the small operating budgets of most HHMs. Some Houses run on single-digits, and are staffed largely by volunteers. The most common operating budget for a House Museums hovers between \$50k and \$200k a year, and a single employee wears almost all the hats. It is not surprising, then, that the usually all-volunteer boards struggle to maintain a professional staff, offer programming, and meet the high standards of preservation that they believe are necessary, at least relative to their reading of the Department of Interior guidelines.

Even the most standard practices in preservation and collections care, like humidity control data, or paint or mortar analysis, can be difficult to fund, let alone accomplish. In compiling data regarding the costs of these types of preservation projects, we found that a paint analysis can run above \$20,000, with a mortar analysis running even higher. In our experience, most preservation projects at HHMs can run three to four times the basic operating budget. Clearly, this is an unsustainable business model, especially for those of us who are finding it a difficult task just to get the gutters emptied once a year.

HHMs have shelves of research on what are now shovel-ready projects, but no money to actually do them. Many grants today require a one-to-one match, which sets a very high, if not unobtainable bar for small non-profits. We have even seen many HHMs forced to give back preservation grants because they were unable to raise the matching dollars.

So HHMs are stuck, at least until a way is found to judge the appropriate level of preservation, whether that be absolute purist restoration, stabilized ruin, or somewhere in between. Each Historic House Museum has a unique position along that spectrum.

There is no question that well-preserved historic buildings benefit the local economy. In Philadelphia alone, houses in districts listed by the National Register for Historic Places have a 14.3 percent premium over comparable properties not in historic districts. Further, houses in local historic districts command a premium of 22.5 percent over comparable properties not in historic districts.[2]

Perhaps a building does not need to be fully restored to hold meaning and value for the community that surrounds it. Even if in less than perfect condition, historic buildings can become valuable as centers of community pride when marginally or temporarily preserved, especially when put in the hands of public artists. In 2008, Erik Sturm and Simon Jung created *Haus in Schwarz (House in Black)* in Möhringen, Germany, as a final farewell for a graffiti-covered, three story house that was about to be demolished. The artists covered every square inch of the building with matte black paint, giving it a sort of funerary send-off. Wedged between the white-faced, red-tile roofed houses in the neighborhood, the *House in Black* was a dramatic sight that made a not-too-subtle statement about the loss of a once beautiful structure.

In *Homage to Lost Spaces,* artist Mike Hewson attached façade-sized digital prints of happier times to the still standing but about to be demolished buildings on the Christchurch Normal School campus, which were damaged by the 2012 earthquake in New Zealand. If only temporarily, the artwork, that featured scenes from the everyday activities of the faculty and students, "brought the buildings back to life.... [They] ceased to be just ruined rubble."[3]

When a former bathhouse, then famous nightclub, in Paris was declared unsafe in 2010, it was turned into a giant canvas for street artists, at least until the building could be fully renovated in 2015. Called *One Day One Artist,* the ephemeral exhibition played homage to the building's artistic DNA.[4] While the public was not allowed onto the site, the artists' real time work-in-progress was made available on the internet.

THEREFORE

Consider a more nuanced approach to preservation standards so that your implementation efforts do not break the bank. Realize that every historic property is not a Monticello, Gamble House, or Fallingwater. Your HHM is probably not a world monument either, nor is every part of it precious. Free your House from the ponderous weight of preservation and figure out what reasonably can and cannot be done. Be comfortable with grading your preservation efforts as Good, Better, Best.

Adopt preservation standards that are appropriate to the importance of the architecture, narrative, and your HHM's public function. The board should collectively write a preservation philosophy statement that outlines their understanding of the Good, Better, Best categories. All preservation efforts should fall within that preservation statement.

Understand that there are shifting priorities relative to the long-term stewardship of an HHM. We suggest that community engagement is a higher priority than is instituting best practices in the preservation of your HHM. A balancing act needs to take place between undertaking *good* preservation standards within the HHM and engaging with the neighborhood outside. For too long, the preservation of HHMs has taken a toll on just about every other initiative that might have been considered by the staff and board. While obviously important, preservation activities should be seen as a means to fulfill your mission, not merely the end.

Show Your Age: Do Not Go under the Knife

Embrace age and its effects on your HHM.

RANT

The layered history of a site, whether that be architectural alterations/ additions or finishes such as wallpaper, are too often sacrificed in favor of reproductions. The end result is more often than not a sterile 'restoration' that does succeed in bringing a room/house/site back to its appearance at a particular time in history, but erases the historic character that developed over centuries.

(Jonathan Mellon, Senior Architectural Conservator, Historic House Trust of New York City)

EVIDENCE

Most Historic House Museums try to disguise that they are aging. There is a never-ending attempt to suppress the process of conservation and hide curatorial maintenance from public view. Many guests who were just children when they first visited a Historic House, return with their grandchildren and happily note that "nothing has changed, it all looks the same." The grandparents marvel at the erasure of time, even as it marks their own lives.

English artist and writer William Morris, one of the founders in 1877 of the British Society for the Preservation of Ancient Buildings, an organization that was eventually nicknamed the Anti-Scrape Society, believed that the splendor of a building is its age.[5] He and his colleagues lobbied for a form of conservation that embraced the effects of time, rather than suppressing those traits through continuous restorations, especially since the work was usually conjectural in nature.

Morris no more believed that a building could be brought back to its original condition than he could be brought back to his own infancy. Instead, he posited that *stabilization*, not restoration, should be the goal in the treatment of historic structures.[6]

We have often wondered how the human aging process affects conservation philosophy, as it cannot be divorced from our thinking about our own mortality. Do we so fear death that we want to hide, if not control, the passing of time? Or do we see our world as evolving and recycling and simply in need of stabilization? These questions begin to suggest why HHMs are at the center of a very personal conservation debate, because there are few things more intimately tied to the cycle of life and death than our own homes.

There is a quiet philosophic structure to historic conservation, whether acknowledged or not, that relates to our own mortality. In a conversation with Socrates, Phaedrus remarks, "By dint of constructing, I truly believe that I have constructed myself."[7] Rather, in our case, by dint of restoration we are preserving ourselves and keeping change at bay. This is really an issue of honesty, not preservation.[8]

Whether conscious or not of this transference, most HHMs struggle to find their own balance along the conservation spectrum. The proponents of stabilization are not many, but there are some notable examples. For instance, South Carolina's unfurnished Drayton Hall has no electricity or plumbing because they are "bound by our mission to preserve the property, and keep it in near-original condition just as the National Trust received it from the Drayton family in 1974."[9] The nearby Aiken-Rhett House fits

Figures 5.1 & 5.2: *Left and Right:* A door detail in the 1720 Hendrick Lott House (a member site of the Historic House Trust of New York City) in Brooklyn, NY, shows multiple eras of hardware, paint, and in situ wallpaper. Although the exterior has been fully restored in a period specific manner, the interior is planned to be stabilized and left as a narrative representing the entirety of habitation within the house. *Photos: Franklin Vagnone.*

into its pristine, downtown neighborhood with a well-preserved exterior. But unlike other HHMs, the interior has not been restored, only stabilized, and "looks like it has been all but abandoned."[10]

The Hedrick I. Lott House in Brooklyn is similarly treated. While the exterior has been restored, and the building has been made structurally sound, the interior of the House remains as it was when it was vacated in 1986, complete with all the layers of change it witnessed from as far back 1720.

As in these three examples, the decision to stabilize is philosophically based. Other times, it is just a rational response to economic realities. Some critics believe that there is deception in any act of conservation, suggesting that the very act of choosing what to keep and what to remove is tinged with bias, politics, and conjecture. *The 1964 Venice Charter for the Conservation and Restoration of Monuments and Sites* acknowledges that dilemma and offers some direction for decision makers.

The valid contributions of all periods to the building of a monument must be respected, since unity of style is not the aim of a restoration. When a building includes the superimposed work of different periods, the revealing of the underlying state can only be justified in exceptional circumstances and when what is removed is of little interest and the material which is brought to light is of great historical, archaeological or aesthetic value, and its state of conservation good enough to justify the action.[11]

Even in some of our most revered HHMs, like Monticello, this debate continues. Critics to the current conservation practices claim that "never in Jefferson's lifetime did Monticello appear the way it does today."[12] In 1824, Samuel Whitcomb, Jr. visited Monticello, and his description of the house is telling: "His house is rather old and going to decay; appearances about his yard and hill are rather slovenly."[13] Jefferson biographer, Merrill Peterson, wrote: "[It] is not a Monticello as it was in Jefferson's time, overrun with children and slaves, battered from daily use and showing the ravages of debt, but the Monticello expertly restored as an architectural masterpiece, a fascinating museum, a shrine to Jefferson's memory."[14] Gone are the wounds of daily living, the signs of activity, and the constant construction that characterized the estate when Jefferson lived there and very little construction and maintenance were ever truly completed.

THEREFORE

Realize that the lack of conservation variation has been one of the factors for the financial instability of HHMs. Use multiple types of conservation in the same House, and furthermore, understand that no matter what form of conservation is chosen, it contains some amount of conjecture.

Nathan Silver, renowned preservationist and author, suggested a four-tier categorization for conservation efforts that can be useful for HHMs:

Tier One: Due to the significance of the architecture, only changes in use should be allowed and the building should be restored to the highest standards.

Tier Two: Due to the significance of the façade of the building, it should remain unchanged, but the interior could be hollowed out.

Tier Three: When only remnants of buildings remain, because they have been ruined by acts of man or nature, the conservation should retain the scars as a memory of the events.

Tier Four: When the architecture of buildings is not significant, it is the memory of it that should be conserved. For plain old buildings, experimentation should be encouraged. The result should be "outrageous but beguiling."[15]

Allow for an authentic reading of changes over time. Retain evidence of the process of weathering, decay, renewal, and conservation. Consider that for some HHMs, it may be of educational value to allow the House to be consumed by the ravages of time. As an international painting conservator remarked:

> Grime, discolored varnish and bad repairs on an artwork can prevent the viewer from connecting with an artist's message in a painting. In general, great works of art should be presented with as little interference from the ravages of time as possible (grime, discolored varnish, bad repairs) so that the viewer can receive the artist's message. Some artifacts are made more interesting by time ... worn painted surface on furniture for example ... and these should not be "over restored." Occasionally there are paintings, usually ones that were not very good to begin with, that have been made more interesting by the ravages of time ... a case could be made for leaving these paintings alone.[16]

Pull Back the Curtain

Make the aging and preservation of the HHM an integrated part of the narrative.

RANT

To me, 'restoration' is the most frustrating concept in house museums: that we can best understand the story of a space by freezing one particular second of time in amber, rather than weaving through the whole history of its existence; that we, living so far outside of that moment, even think we can decide which second is the most important; that we spend years determining (and paying for) the exact shade and tint of a paint color in a room, rather than trying to understand the people who sneezed, screamed, or farted in it; that we think a painted, polished, covered space can communicate its authentic history better than the

untouched cracking, peeling, fading one; that by eliciting so much control over a space, we muffle its ability to speak for itself.

(Kimberly Bender, Executive Director, Heurich House Museum, Washington, D.C.)

EVIDENCE

Historic properties that become HHMs are rarely found perfectly intact, although they are often presented as if they were, because the process of conservation is hidden. We often find that HHM boards and staff feel the pressure to have every element in the House perfectly restored before a guest experiences the room or artifacts in it. Data collected from the *Anarchist Guide* "Imagination, Energy, and Excitement Graphs" clearly indicate that the most compelling experiences in HHMs occur in the un-restored, un-curated spaces.

Most HHMs are shaped by the presumption that the best-preserved HHMs are the ones that do not show the work that has been done on them. We painstakingly try to keep the public from learning how hard it is to keep the House looking so good. Like the *Wizard of Oz*, we stand behind the curtain and feverishly operate and restore our HHMs, hoping no one will see all of the efforts and money involved to keep them so pristine. It almost seems as if there is a code of silence regarding the actual steps taken to achieve a perfect restoration, or the painful levels of minutiae that are undertaken to keep an HHM in pristine condition. Instead, most HHMs present a nostalgic version of what it might have been like in the home at a particular point in history, while simultaneously hiding the actual conservation process that was employed to create the myth. It is a pervasive attitude that seems to suggest that if the act of preservation were revealed to guests, that knowledge would detract from the educational mission of the HHM as shared through the narrative conveyed during their visit.

Once, in a meeting at Stratford Hall in Virginia, we were given a wonderful, private tour of this stunning building. We entered a room where the plaster had been gutted down to the wood framing and were told that after many years of solid research and study, it had been determined that the wall needed to be moved about a foot to the east, re-plastered, and the wood moldings rebuilt to reflect a different and more desired time period. While we were sure this room would be stunning in this latest rendition, we wondered what visitors thought of the room while under construction. We were

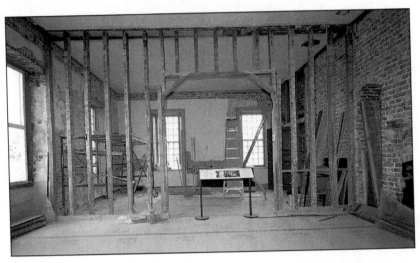

Figure 5.3: The process of preservation can be just as compelling as the interpreted narrative. Such is the case at 1738 Stratford Hall, where the dining room was gutted to prepare the room for a complete restoration. The staff commented that it was often difficult to get people to leave the room because they were so interested in the process and project scope. *Photo: Stratford Hall.*

told that the staff had a hard time getting people to leave that room, because they were so interested in it.

Yet, most HHMs typically present their restoration projects as if all the design and materials were original, rarely acknowledging the replacement of parts, or that the reconstruction of cosmetic surfaces are often based on some learned professional's best guess. A dirty little secret shared by most HHMs is that when it comes to preservation, there are few absolutes. Perhaps that is why the process is seldom discussed in public. If it were, there would have to be an acknowledgment of what is unknown, and that is never a comfortable scenario. As an alternative, we suggest embracing what we call "Conjectural Reproduction" and sharing with guests the idea that preservation is a creative act.

One of the most stunning, yet not uncommon examples of conjectural reproduction is in the second floor ballroom of the Powel House in Philadelphia. The reality is that almost all the room's original woodwork and plaster ceiling were sold and moved to the Philadelphia Museum of Art in

1917, where they were conjecturally reconstructed as a period room by famed museum conservator Fisk Kimball. Years later, when the Powel House was purchased by the Philadelphia Society for the Preservation of Landmarks, the second floor room was expertly reconstructed as the ballroom.

In 2006, we undertook a research study with project manager Kevin Greenland to determine what was original and what was conjectural reconstruction in the ballroom. Drawings were produced to show the extent of the reconstruction efforts. The result was an amazingly powerful illustration of the power of preservation to gloss over history and present a reproduced room as the original. This process has been labeled the *Vandalism of Completion* by Lomas and Ring, who observed that this kind of restoration has led to an incredibly homogeneous collection of expertly restored buildings.[17]

In reaction to this homogeneity, new models of engagement that reveal the restoration process have been tried and have proven to be very popular. One noteworthy example was the *Discovering Columbus* site-specific installation in New York City's Columbus Circle in 2012. When scaffolding was put in place to clean the 1892 Russo sculpture of Christopher Columbus that sits atop the column in the center of Columbus Circle, Japanese artist Tatzu Nishi designed a typical living room at the top of the temporary construction that allowed visitors to climb up two flights of stairs and intimately observe the life size statue as if the famous explorer were a guest in their own home. The sold out experience provided both unique access and a meaningful connection to the conservation efforts that were to follow.

Another example of *Conjectural Reproduction* is in the ruins of Menokin in Warsaw, Virginia. Currently, a plain metal roof hovers over what remains of the Historic House, and a temporary catwalk allows visitors to move through it until more permanent plans can be completed. Rather than being restored back to its original condition, the House will be conserved by dovetailing the ruins to a new steel and glass construction. Sara Dillard Pope, the Executive Director of Menokin, explained the intent: "How do we best protect what remains of Menokin? The Foundation has chosen to use structural glass to recreate an abstract memory of Menokin as it once stood while protecting what remains of it today."[18]

THEREFORE

Realize that there is an authenticity in acknowledging the age of your HHM. Remember that guests like to see things unrestored or still being worked

Figure 5.4: In 2006, we undertook a research project to graphically illustrate the original (*dark lines*), conjectural and replaced (*light lines*) decorative plaster and wood elements in the 1765 Powel House Ballroom. This drawing documents the rarely mentioned, seamless overlap between fuzzy areas of preservation. In 1917 the original elements of the Powel House Ballroom were sold and moved to the Philadelphia Art Museum. Only later was the ballroom restored to look as Fisk Kimbell believed it once looked. *Image: Franklin Vagnone, researched and documented by Vagnone and Greenland, 2006, drawing revised by Kevin Greenland, 2015.*

on. The renovation work that is usually hidden from sight can become the center of public engagement endeavors.

Acknowledge that conservation is an ongoing process and not something that is completed before the HHM's opening. Reveal conservation

efforts as a process, where both decay and restoration are ongoing parts of a cycle. Do not hide the messiness or conjectural quality of these efforts, as they can expand the narrative of the HHM. Make preservation efforts public, common, and obvious. Invite the public to participate in them. Think of ways to overlap the process of conservation with other established programs.

Integrate the process of preservation as part of the House's narrative. Consider ways in which even the smallest conservation project can be made into a learning experience. With the use of social media and the ease of making videos, every stage of the process can be documented and made accessible to the public. We suggest sharing just about everything, even pictures of rotten sill plates.

Mind the Gap

Integrate the built environment surrounding your HHM into your narrative.

RANT

Why are so many preservationists stuck on architectural history? It drives me crazy! I love a great Goodhue or Richardson building as much as anyone else, but the architectural provenance of a building is not what will persuade its owner to work with you to repair it, reuse it, or bring it back to life! We need to talk the language of the owner and the surrounding community. We need to relate our goals—preserving the physical fabric of a great building—to the owner's purpose and priorities—which are probably about something else entirely. In my world of church preservation, we will never get very far talking about architects and styles. Instead, we focus on how the building's current and potential use, and its ability to serve and enliven the larger community, furthers the mission of a congregation. I don't think we preservationists are taught this early enough in our careers.

(anonymous executive director of a national preservation organization)

EVIDENCE

Historic House Museums are preserved and presented as artifacts isolated from their surroundings. Guests typically hear very little reference made to how the demographics of the surrounding neighborhood have changed over time or about how the HHM relates to its current context. Rather than acknowledge the evolution, many HHMs prefer pretending that change has not occurred, no more so than in the presentation of the interior spaces, even though the contemporary world can be seen with just a simple glance out the windows.

We were initially surprised at how many of our students' proposals for HHMs and in period rooms focused on the interpretive potential of the views from inside the House to its outside. UNCC Architecture student Aricelli Bollo proposed a site-specific installation that used remote, real-time cameras to project images of contemporary street life directly in the faux windows of the period rooms at the Metropolitan Museum of Art. Her classmate Angela Scharrer came up with the idea of pull-down, clear acetate window shades on which images of historic vistas would be printed and overlaid on the current views to produce a dialogue between the past and present.

Our students' projects addressed the conceptual, romanticized historic chasm so well illustrated in Virginia Lee Burton's 1942 children's book entitled *The Little House*. What is most intriguing about this book is not its beginning or its ending when the house is sited in a peaceful, natural, and romantic setting, but rather in the middle of the story when readers are taken into an urban world of dirt and decay. The city grows up around the little house, and the once happy home becomes a sad, useless artifact from a lost time in the middle of real life. The house is eventually abandoned, surrounded by tall buildings, subways, and busy people, and no longer has a purpose until a family descendant comes along, finds the long forgotten house, and moves it back to the countryside where it presumably belongs. All is well again as the story ends:

> The windows and shutters were fixed and once again they painted her a lovely shade of pink. As the Little House settled down on her new foundation, she smiled happily. Once again she could watch the sun and moon and stars. Once again she could watch spring and summer and fall and winter come and go. Once again she was lived in and taken care of.[19]

The book has a happy ending, and a story shared by many HHMs that have been through a decline and seemingly improved by being relocated

to a new, fictional setting. Unfortunately, this idealized vision of what a historic home should look and feel like has kept HHMs from embracing change in their context. We often find stewards of House Museums desperate to plant trees and shrubs so that any hint of the contemporary environment will be blocked out of view.

We question the basic assumption that preservation requires visual isolation from the contemporary environment. Instead, we suggest that the neighborhood context and the larger suburban/urban setting be fully integrated into the historic narrative. Our perspective grows from best practices in contemporary community design that reject the old mono-function model of suburbia with its detached and isolated homes for Smart Growth to a philosophy that mixes different land use and building types into more accessible, walkable, and livable communities. This relatively new model removes the artificial and unsustainable gaps between the places people live, work, play, and worship.[20] Just as the traditional, sprawling suburban model with street after street of isolated homes has become outdated, HHMs must update their mission statements to better focus on the neighborhoods that surround them. When HHMs are viewed from this community-centered perspective, they can potentially become a part of, rather than apart from, their surroundings

To further study the potential of contextual juxtaposition, the Historic House Trust of New York commissioned several photographers to take images of HHMs in the context of their contemporary neighborhoods. We were interested in what guests actually saw before entering the doors of our HHMs. We juxtaposed these contemporary photographs with the official press photographs of the same houses.

The series of comparative pictures was amazingly informative. Through the magic of Photoshop and the careful cropping of images, the official press photographs appeared as if the HHMs were just like the little house in the storybook, located in a pristine country setting surrounded by fruit trees and pasturelands. In truth, the Houses that were studied are all located in the midst of the city, only feet away from the gritty reality of recycling facilities, fast food restaurants, and big box retailers, like the Dollar Store. Through this truth testing, it became clear that the goal of having guests step back in time and pretend they were back in the 1700s was asking a lot of people who had just taken the subway and walked up a busy city sidewalk through the chaos of retail stores.

Figure 5.5: Many HHMs are located in neighborhoods that no longer resemble their earlier character. Often times, through Photoshop these new, messy neighborhoods are removed from press pictures of the House so that the romance of the setting is not disturbed by the reality. This image shows a 2010 commissioned collage of the Wyckoff Farmhouse Museum integrated into its light industrial and residential neighborhood. *Photo: Historic House Trust of New City (Mikel Travisano).*

We began to imagine an interpretive narrative that did not ask guests to play pretend, but rather invited them to actually look out the windows in the HHMs and locate contemporary landmarks to juxtapose past and present. We imagined questions like: "Do you see the tire store? What do you think transportation was like in 1652? What kind of wheels did the Dutch Colonialists use?" or "Have you been in the Dollar Store? What do they sell there? How do you think the people who lived here were able to do without that?"

Urbexography, whose work has been described as ruin photography or ruin porn, inspired our interest in dissonant context. The images they record contribute to a photographic subculture that records "patterns of urban and domestic decay; the surreal beauty of deserted man-made structures melted by the weather, and eroded by a lack of maintenance or care."[21] Urbexography's portfolio of *Windows* is particularly applicable to studying HHMs and their context because the images record "places with significant history which now lay [*sic*] dormant for numerous reasons. Slowly eroding from the elements, they are largely 'unseen' and perhaps forgotten."[22]

THEREFORE

Think of Historic House sites as one square in a large quilt that is constantly being re-sewn. Instead of expecting guests to step back in time, ask them to

help make interpretive connections that can integrate the HHM's narrative with the contemporary suburban/urban fabric of your city. Start by looking out the windows. Have each member of the staff go from window to window, record what he or she sees, and consider how that vista could be used as a teaching tool to overlap history with current realities. These vistas can supply a rich, vibrant story all unto themselves if there is a willingness to consider them.

Be open to expanding the historic narrative to include an acknowledgment of your HHM's contemporary context. Embrace a fuller, more accepting view of the immediate neighborhood, and through this effort, a naturally evolving growth of ideas will follow. Recognize that a bit of risk-taking is valuable in these efforts.

Dig Deeper than the Dollhouse

Make preservation about the entire HHM, not just its cosmetics and decorative objects.

RANT

I am also less interested in decorative arts than the human stories. I am going to someone's home, not an antique store. Tell me an interesting story that makes those objects relevant.

(Elon Cook, genealogist and consultant, Their Child Genealogy)

EVIDENCE

Historic House Museums tend to focus on architectural and decorative beauty. A lot of attention and preservation energy seems to go into obtaining reproduction wallpaper and fabrics, but seldom is the social history of the materials, construction, or preservation process conveyed. It seems HHM boards are falling victim to a sort of "keeping up with the Joneses" challenge to source and display the very best decorative arts at their sites.

Many of the discussions on the *Anarchist Guide LinkedIn* site revolve around the dominance of interior and decorative arts tours in Historic House Museums and led to our further research on the topic. In reviewing the Anarchist Research Tools, we noticed that the lowest ratings from our

Figure 5.6: It is easier to understand the value in a measured application of preservation when the process of restoration is visible. Such is the case at the 1768 Hyde Hall in the Glimmerglass State Park, NY. By the HHM not restoring everything, visitors have the opportunity to creatively fill in the blanks and become more deeply engaged beyond simply viewing the decorative objects. *Photo: Franklin Vagnone.*

Imagination, Excitement, and Energy studies came during detailed furniture and decorative arts tours, with the highest ratings showing up in reference to unrestored rooms, outbuildings, and details of human occupation. Could it be that too much attention has been paid to the fancy stuff inside and not enough attention to the site as a holistic artifact?

We were once sitting in a board meeting of an HHM when a well-meaning board member stood up and began telling the others how it had been well over a decade since the curtains and wallpaper had been replaced. In her view, the House looked ratty and needed to look good for their visitors. Her perspective seemed fair enough. The board subsequently voted to allocate funds towards this preservation effort.

There was, however, a backstory. The House, which was very traditionally interpreted with formal period rooms, was situated in a very public area of a historic district. The roof had active leaks that were dripping through the second floor on down to the first floor. The leaks had damaged the wallpaper and the curtains, and they did need to be replaced, just as the well-meaning board member suggested. But until the leaks were resolved, it would be a useless endeavor, and the expenditure for cosmetics would do nothing to further a deeper understanding of the site's occupation.

We see this all of the time, where a House Museum is operated as a sort of dollhouse, waiting to be ornamented with beautiful, period wallpaper and filled with replicas of period furniture regardless of more pressing concerns. What seems to matter most to many HHMs is all the stuff in the House, not the relationship between all of its parts.

As if to draw a metaphorical link, actual dollhouses have now become ubiquitous in HHMs, and why not? Guests like them. But to us, the miniatures stand as microcosms of how visitors see HHMs, where the detachment of Houses' interiors from their exteriors is rarely resolved. The disconnect is often played out in the committee structure of the stewardship organization. Usually, there is a building committee, a separate collections and interior committee, and another separate education and interpretation committee. The groups often operate independently and in isolation.

Heather Benning stunningly illustrated the dollhouse pathology in a contemporary art installation in Sinclair, Manitoba.[23] She built her work within the frame of an abandoned farmhouse, but instead of restoring it

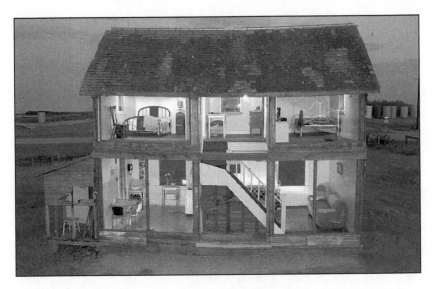

Figure 5.7: Much of visitors' experience with the architecture of HHMs is voyeuristic. The concept of separation is illustrated in Heather Benning's *The Dollhouse*, where habitation and life were isolated and preserved behind a transparent wall. *Photo: The Dollhouse: Dusk # 2 by Heather Benning, courtesy of the artist.*

in a traditional HHM fashion, she removed one entire side of the exterior sheathing and replaced it with Plexiglass. The result was a life-sized dollhouse that invited a voyeuristic experience, while also heightening the awareness of the duplicitous roles that are sometimes played in the world of pretend conservation. The farmhouse stood embalmed like this for six years, until the artist intentionally burnt it down in 2013.

Sometimes, there is meaning and value in the pretend. In 2007, artist Amal Kenawy created *Non-Stop Conversation*, an installation in which she covered the ruins of a building with a handmade pink quilt to draw attention to the monotone, crumbling ruins that exist alongside the rapid growth now occurring in the United Arab Emirates. About her work, Keneawy wrote, "By sensing and exposing a metaphorical world that hides beneath the physical, I attempt to bring the unseen into a visual space."[24] To us, this art project displays a strong understanding of the connectedness between the architecture, interior, and the life found inside.

In many ways, historical narratives can be skewed by inadequate attention given to the overlapped relationship between people, places, and artifacts.

THEREFORE

Embrace conservation as a holistic integration of the exterior, interior, collections, and the HHM's interpretation. Avoid the claustrophobic tendency to treat your House like an empty dollhouse just waiting to be furnished and decorated.

Integrate the conservation of every structural component of your HHM with the conservation of its interior, but do it in a substantial way. We often see small patches of walls removed, then covered with small squares of Plexiglas to show how the house was constructed. This practice is almost worse than seeing nothing at all because it reads as a concession to those people who are not satisfied by the decorative arts and interior decoration.

Using Benning's work as inspiration, we propose taking a room or even the entire house and separating it right down the center when a HHM is undergoing restoration. One side of the room would be totally restored to the highest standards. The other side would have the cosmetics removed to make visible the various layers of change and construction over the years.

Look beneath the cosmetics to expose the social history of materials as a way to expand the process of preservation into the world of conservation. In walking through the Gamble House in Pasadena, we were enchanted with the woodwork and the resultant aesthetic of the spaces, as well as the integration of the architecture with the furnishings. After we left, a teenager turned to us

and asked sincerely, "How much of the rain forest had been cleared to produce this house?" Until then, we had never thought about the new sourcing of old materials or that they might have a history worthy of noting.

Stop filling your house with more and better stuff. Instead, concentrate on better integrating the inside, outside, and innards of the House. Throw open the doors to conservation efforts and invite guests to be fully integrated in the process. If there is a choice between funding new curtains and making preservation an active part of the visitor experience, choose the latter.

The goal is not necessarily to restore a House back to its pristine condition, but rather to manage the complexities of the HHM as place of habitation. Just as you manage your own home and understand the nuances of the life experiences within its walls, begin to appreciate how the Historic House Museum is no different. Keep the water out, mend what is broken, and do not sweat the small stuff. The original owners probably did not, so why should you?

Question the Period of Interpretation

Reduce your reliance on a Period of Interpretation.

RANT

Can someone explain to me who thought that the concept of period of significance—when a house museum is interpreted and decorated to a narrow period of time—was a good idea or why it is still used as preservation standard by many states. I understand the desire to create clarity and accuracy, but history is messy and important houses were used over long periods of time, by many different inhabitants, with many different lives. By removing layers of history in a house museum to present only one time period, we present an artificial sense of how houses were used and we diminish the significance of human existence. The period of significance for any historic house is now—how does the structure relate to and inform contemporary existence. Cleaning up the mess of history by creating a false pastiche of the past has no significance—period!

(Howard Zar, Executive Director, Lyndhurst Estate)

EVIDENCE

Historic House Museums almost always frame their guests' experiences within a Period of Interpretation (POI). The use of it enters into the decision making about larger issues like what to remove, what to replace, and what color it all should be, to minute details like what type of curtain hooks should be used. But ultimately, the POI limits an HHM on just about every level, perhaps most importantly, with the stories that can be shared.

If asked to pick a POI for your personal home, you would probably find it difficult to do. What cultural references would you look to? What style would your home be: Martha Stewart Living, Elle Décor, Apartamento, Target, or CB2 advertisements? How would you factor in the idiosyncrasies of your individuality? And which years of your life would you chose to immortalize? Would it be two years, or twenty? And what would you choose to memorialize? Preservationist Randal Mason writes:

> Period of Interpretation/Significance has too often been used as a blunt instrument—or worse, a black box. Judgments about significance are narrowly drawn, pegged closely to the architectural history canons and historical associations validated by academics. As a field, preservation has shown little appetite for thinking critically about significance, or theorizing a way of handling significance.[25]

HHMs wrestle with these questions all the time, and POIs are consequently drawn narrowly. We have found that it is common for HHMs to limit their POI to less than 5 percent of the total life of the dwelling. In some cases, the building has been a House Museum longer than it was inhabited as a home. In the process, huge portions of personal, social, and political history are sliced off in favor of a sliver of time that marks the years lived by a single individual while he accomplished a significant activity.

There are many stories about preservationists and scholars removing entire sections of buildings, neighborhoods, or cities in order to achieve the illusive POI.

Beginning in the 1920s, John D. Rockefeller created historic Williamsburg by demolishing 720 buildings in the town that were built after 1790, including an elementary school. Of the 500+ buildings there today, only 88 are original. The Governors Palace was also totally reconstructed in a Colonial revival style.

In the mid 1960s, the developers of the Washington Square West Project in Philadelphia's Society Hill caused a similar clearing. Almost

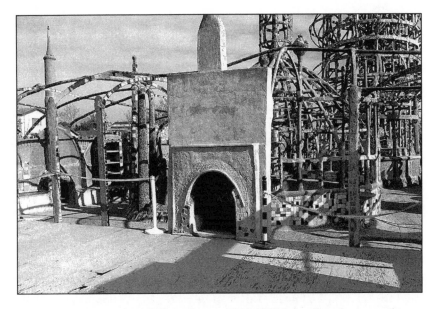

Figure 5.8: Most people visit Watts Towers (1921–1954) in Los Angeles to see the spiraling environmental sculpture that has defined the site. However, we were intrigued with the site because the existing sculpture is the remnant of a fully integrated artistic complex which once unified the site with the humble wood frame house of Simon Rodia. Very little documentation remains of the House, except for a short black and white film of it. Left standing is the fireplace and chimney. This site has gone through so many periods of vitality and importance that it seems almost impossible to simplify its value down to one period. *Photo by Franklin Vagnone.*

every building that was not deemed appropriately colonial in style was demolished. Beautiful Victorian homes were destroyed because they did not fit into the chosen Period of Interpretation. The neighborhood was also rid of all mixed use and rezoned for only residential buildings.

Perhaps one of the most dramatic illustrations of a House Museum being renovated to adhere to a chosen POI is Virginia's Montpelier, family home of President James and Dolly Madison. Years later, it was also the home of William and Anne DuPont, who made their fortune manufacturing prefabricated houses. After much scholarly study and professional debate, the decision was made to remove all parts of the house that were not original from the time of President Madison. It was a significant decision

because numerous restoration projects had since taken place, even one that was overseen by President Madison. The DuPonts had doubled the size of the mansion and stuccoed over the original red brick. To restore the mansion, almost all of that work would have to be removed. It is not that there was anything wrong or shoddy about the successive layers of work done over the years; they just did not fit in the POI that had been chosen by the HHM. The result was that the DuPonts' additions to the house were entirely removed except for a portion of the mansion's formal gardens during a $25M restoration.

In contrast, the Tenement Museum in New York City is probably the most cited example of a historic site that embraces multiple narratives, or what some call an anti-hero preservation ethic. From the initial stages, the founders of the Tenement Museum focused on telling the stories, not from a historian's perspective, but from the immigrants'. They connected the historic stories to current immigrant populations in New York City. In essence, they broke with the standard POI practices and allowed the stories themselves to dictate the Period of Interpretation.[26] For instance, their *Shop Life* exhibit simultaneously features immigrant businesses from different eras, including a 1870s German beer saloon, followed by a succession of owners, like turn-of-the-century kosher butchers Israel and Goldie Lustgarten, 1930s auctioneer Max Marcus, and 1970s undergarment discounters Frances and Sidney Meda.[27]

The Dunham Massey House, a UK National Trust site in Manchester, England, has also widened its POI to include multiple eras and experiences to expand the narrative, refresh visitation, and add to the historic value of the site. The HHM is a moated, aristocratic estate built in the 1730s and would normally only be interpreted as such. However, to mark the centenary of WWI in 2014, parts of the estate were reinterpreted to show how it was used as a hospital during wartime. Now guests can view not only the grand rooms of the estate, they can also visit the dormitories of the wounded. Visitors can peruse the treatment reports at the foot of the beds that recorded the injuries and progress of individual patients and see how some soldiers died, while others recovered; how some men survived the war, but most did not.[28] Further, guests can visit the other parts of the house that were used for storage of the family furniture and other artifacts while the hospital was in place.

Students in our 2013 Columbia University Historic Preservation class wrote an *Anarchist Plan* for the Morris Jumel Mansion in New York City that

would have simultaneously embraced multiple narratives from different eras. The mansion is normally interpreted for the period of Madame Jumel's residence, but the students' plan called for some of the standard period rooms to be replaced with a yearlong reinterpretation of the house as it conjecturally might have looked while being used as George Washington's wartime headquarters. They proposed placing tents throughout the grounds, and turning the Octagon Room into a military courtroom. The *Anarchist Plan* also suggested implementing a series of rotating interpretations for the House over a period of several years, giving guests a reason to return and experience the site under many different interpretive periods.

THEREFORE

Realize that the Period of Interpretation is a guideline, not a law. The desire for a historical absolute should be mirrored by a flexibility in how the POI guides your efforts. Stanley Tigerman, in his postmodern manifesto on architecture of symbolism, *The Architecture of Exile*, writes of the fuzzy conceptual state of existence. "We are in a state of exile, a state brought about by dislocation, by displacement. Our conscious search for truth is disrupted by our unconscious desire to challenge truth, even as we try to edge closer to truth."[29]

Flesh out the entire history of your site's use and occupation over time, and have your preservation work reflect that expanded knowledge. Use the preservation and interpretation of your HHM as a means to engage new audiences through overlapping contemporary issues with your history. Be careful not to erase important parts of your story in the name of a POI.

Acknowledge that your HHM changed many times over its lifetime. Consider the juxtaposition of eras as a means of engaging guests in the passage of time.

APPENDIX A:

ANARCHIST CHART EVALUATION QUESTIONS

Each of the 32 markings includes five questions about Community, Communication, Experience, Collections/Environment, and Shelter, for a total of 160 evaluative components on the *Anarchist Chart/Evaluation Matrix*. Each question should be answered with a score of 0 to 5: with 0 being at the low end of the scale and meaning no consideration has been given to the subject; and with 5 at the high end and meaning an excellent level of implementation, with formal, long-term strategic efforts and numerous achievements over the last six months. Use the chart on page 182 to further determine scoring.

Anarchist's Guide to Historic House Museums by Franklin D. Vagnone and Deborah E. Ryan 181–198. © 2016 Left Coast Press, Inc. All rights reserved.

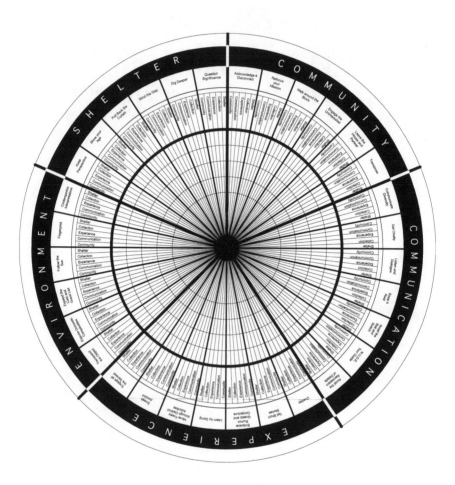

Figure A.1: *Anarchist Chart/ Evaluation Matrix, Anarchist Guide to Historic House Museums:* Franklin D. Vagnone, Deborah E. Ryan creators. (A full-scale and printable version of the Anarchist Chart is available at www.museumanarchist.com.) *May not be reproduced in any form without attribution to the authors.*

0 – No consideration given

1 – Planning, but no implementation

2 – Minor implementation. Informal effort. One attempt or achievement in the last 6 months

3 – Average implementation. Informal effort. Two attempts or achievements in the last 6 months

4 – Above average implementation. Informal, consistent efforts with numerous achievements in the last 6 months

5 – Excellent implementation. Formal, long-term, strategic efforts with numerous achievements in the last 6 months

Community Markings

Community: a social unit of any size that shares common values. Although embodied or face-to-face communities are usually small, larger or more extended communities, such as a national community, international community and virtual community are also studied. In human communities, intent, belief, resources, preferences, needs, risks, and a number of other conditions may be present and common, affecting the identity of the participants and their degree of cohesiveness.

Since the advent of the internet, the concept of community includes not only a geographical limitation, but also technological boundaries, as people can now gather virtually in an online community and share common interests regardless of physical location. Prior to the internet, virtual communities (like social or academic organizations) were far more limited by the constraints of available communication and transportation technologies.[1]

Acknowledge the Disconnect

Openly acknowledge any philosophic, economic or social differences between your HHM's narrative and the immediate community surrounding your site.

A. COMMUNITY: How aggressively does your HHM address any misalignments with its immediate community?

B. COMMUNICATIONS: How responsive are your communications to the immediate neighborhood?

C. EXPERIENCE: Does visiting your HHM reflect and address issues and concepts important to your immediate neighbors?

D. ENVIRONMENT: Does your HHM's physical interpretation reflect the culture and interests of your immediate neighborhood?

E. SHELTER: How aggressively do you integrate your HHM's architecture and landscape into the existing neighborhood?

Refocus Your Mission

Allow the needs of your immediate community to modify your mission, goals, focus, and strategy.

A. COMMUNITY: To what degree does your HHM have a positive impact upon the immediate community?

B. COMMUNICATIONS: How responsive does your HHM seem to community needs?

C. EXPERIENCE: To what degree is your HHM creating a welcoming visitor experience for your immediate neighbors?

D. ENVIRONMENT: To what extent have changes been made to the interior of your HHM in response to your community?

E. SHELTER: To what extent is your usable space made available for community use?

Walk around the Block

Regularly study the demographics and social life of your immediate community.

A. COMMUNITY: How dedicated is your HHM to learning about the demographics and social life of the surrounding community?

B. COMMUNICATIONS: To what extent does your HHM study neighborhood communications (i.e., local papers, flyers, and billboards)?

C. EXPERIENCE: How much effort have you placed on learning what kind of experience your neighbors value?

D. ENVIRONMENT: How often have you provided your HHM as a center for neighborhood activity?

E. SHELTER: To what degree is your HHM considered a cultural center?

Engage the Uninterested

Locate communities of neighborhood residents who are not visiting and engage them.

A. COMMUNITY: To what degree have you made an effort to reach out to immediate communities that have shown no interest and asked what they are interested in?

B. COMMUNICATIONS: How aggressively have you undertaken ways to gather ideas from the un-interested?

C. EXPERIENCE: To what extent have you attempted to learn about the community's perception of your HHM, and how have your operations been modified to respond to their perspective?

D. ENVIRONMENT: How aggressively are you offering an environment that is compelling to your immediate neighborhood?

E. SHELTER: To what extent do you make your HHM available for community programs and events for groups that have no connection to your site?

Leave the House to Find Potential Partners

Create strong and flexible partnerships with community organizations.

A. COMMUNITY: How often does your HHM partner with community organizations?

B. COMMUNICATIONS: How outwardly focused are your communications or are they just about your HHM?

C. EXPERIENCE: How often have you presented your HHM's narrative outside of your site?

D. ENVIRONMENT: To what extent have you integrated partnerships into your regular HHM experience?

E. SHELTER: How aggressively have you physically shown an interest in your community from your site using the architectural, landscape, signage or art installations?

Transposition

In unexpected ways and in unexpected places, implement compelling strategies to introduce your HHM to the community.

A. COMMUNITY: How aggressive have you been in bringing your HHM to the public's attention outside of normative museum practice?

B. COMMUNICATIONS: How aggressively have you tried to place your HHM's name and narrative in unexpected places?

C. EXPERIENCE: How committed have you been to bringing the physical and sensory experience of visiting your HHM to unexpected outside venues?

D. ENVIRONMENT: To what degree have you brought the aesthetic of your HHM into new venues?

E. SHELTER: How committed have you been to using the appearance of your HHM and its site to engage your neighborhood in unexpected ways?

Communication Markings

Communication: a purposeful activity of exchanging information and meaning across space and time using various technical or natural means depending on which are available or preferred. Communication requires a sender, a message, a medium, and a recipient, although the receiver does not have to be present or aware of the sender's intent to communicate at the time of communication; thus, communication can occur across vast distances in time and space. Communication requires that the communicating parties share an area of communicative commonality. The communication process is complete once the receiver understands the sender's message.[2]

Communicating Diversity

The HHM organization should reflect the diversity of your immediate neighborhood in all forms of communications.

A. COMMUNITY: How often do you attend community meetings?

B. COMMUNICATIONS: What percentage of your board and staff reflects the demographics of your immediate neighborhood?

C. EXPERIENCE: What percentage of your guest experience reflects the varying interests of a diverse audience?

D. ENVIRONMENT: To what degree does the HHM environment reflect cultural diversity and social issues?

E. SHELTER: To what degree have you modified your standard presentation and interior set-up to address a more diverse audience?

Get Chatty

Move toward an informal communication style and integrate social media.

A. COMMUNITY: To what degree do you allow informal interaction at the house?

B. COMMUNICATIONS: To what degree are your communications informally presented?

C. EXPERIENCE: To what degree does your standard guest experience allow for social media, informality, and diverse perspectives?

D. ENVIRONMENT: To what degree do your physical environment and collections encourage informality and multiple forms of communication?

E. SHELTER: To what degree are the architectural and landscape communication elements informal?

Listen and Dialogue

Do not take yourself too seriously. Be a good host; don't simply tell guests the answers. Let them bring their own ideas to your conversation.

A. COMMUNITY: To what degree do you include a diverse range of cultural ideas in your standard tour?

B. COMMUNICATIONS: How aggressively do you engage your guests in a public dialogue about a current event?

C. EXPERIENCE: How consistent is your commitment to an interactive guest experience?

D. ENVIRONMENT: How integrated is the use of your collections to create dialogue with your guests?

E. SHELTER: How responsive is the architecture and landscape of your HHM in producing informal discussions with your guests?

Keep It Real

Be selective in the use of pretend forms of communication tactics and methodologies.

A. COMMUNITY: To what degree are you honest about your history and interpretation with your guests?

B. COMMUNICATIONS: To what extent do you openly acknowledge imaginary play in the typical guest experience?

C. EXPERIENCE: If your visitor experience involves a "stepping back in time" or "pretend" construct, to what extent do you also acknowledge the modern realities of your guests' lives?

D. ENVIRONMENT: How honest are you in regards to your HHM collection being used in a way that breaks the imaginary line?

E. SHELTER: To what extent do you communicate the complexities and layers of architecture and preservation actions to your guests?

Bait and Switch

Make sure the guest experience at your HHM matches your communications.

A. COMMUNITY: To what degree does the larger community trust you?

B. COMMUNICATIONS: To what degree are your communications fully inclusive of what a guest will encounter when visiting?

C. EXPERIENCE: To what extent does your HHM's guest experience match your advertising?

D. ENVIRONMENT: How well does your HHM's setup and tour construct reflect the tone of your communications?

E. SHELTER: To what extent does your visual communication of the site match the reality?

N.U.D.E Tour Guide Communication

Look for *traits* in guides, not teach-ability.

A. COMMUNITY: How well do you target potential volunteers with good communication traits?

B. COMMUNICATIONS: How regularly do you speak to your volunteers about creatively communicating?

C. EXPERIENCE: How successful are you producing flexible and creative communication?

D. ENVIRONMENT: To what degree does the staging allow for creative communication?

E. SHELTER: To what extent do your House and landscape adapt to flexible interpretation?

Narcissism of Details

Do not play the game of superlatives. The details only matter to you.

A. COMMUNITY: How dedicated is your HHM to communicating ideas that matter to a larger audience?

B. COMMUNICATIONS: How competitive are you with your friendly neighborhood HHMs?

C. EXPERIENCE: How committed are you to moving past a fact-based narrative (i.e., dates and family genealogy) towards a more emotional experience?

D. ENVIRONMENT: How comfortable are you with invoking a more liberal interpretation of furnishings plans, instead of taking an approach of blind adherence?

E. SHELTER: How willing are you to see past minute architectural details of your site and focus on the greater picture?

Experience Markings

Experience: the process of doing and seeing things and of having things happen to you...[the] skill or knowledge that you get by doing something.[3]

Overlap

Embrace your guests' life experiences and their knowledge, and use them as an interpretive tool.

A. COMMUNITY: How aggressive are your attempts to understand your community's contemporary lifestyles?

B. COMMUNICATIONS: To what extent do your communications address contemporary issues?

C. EXPERIENCE: To what degree does your basic tour include contemporary culture?

D. ENVIRONMENT: To what degree does your HHM's interior relate directly with the life of your community?

E. SHELTER: To what degree have you modified your standard presentation and landscape to reflect the life experiences of your guests?

Tell Short Stories

Be conscious of both the level of detail and overall length of your HHM's basic narrative.

A. COMMUNITY: To what degree do you solicit and use your community's oral history as part of your HHM's narrative?

B. COMMUNICATIONS: To what degree do you regularly evaluate and update the information your guests receive while visiting your HHM?

C. EXPERIENCE: How aggressive are you in limiting the length and content of your HHM's basic tour?

D. ENVIRONMENT: To what degree is your HHM's interior organized to accommodate short discussions?

E. SHELTER: To what degree are your HHM's architecture and landscape portrayed to tell short stories?

Embrace Rumor, Gossip and Conjecture

Integrate fiction into your narrative.

A. COMMUNITY: How aggressive are you in understanding the mythology surrounding your HHM?

B. COMMUNICATIONS: What percentage of your communications invokes rumor, gossip, or conjecture?

C. EXPERIENCE: To what degree does your basic experience involve rumor, gossip, and conjecture?

D. ENVIRONMENT: To what degree is your HHM's interior arranged to portray stories outside the realm of a fact-based history?

E. SHELTER: How integrated is conjectural preservation in your basic tour?

Learn by Doing

Utilize kinetic learning as a component of the guest experience.

A. COMMUNITY: How dedicated is your HHM to discovering tactically focused learning opportunities in your community?

B. COMMUNICATIONS: How clear are your communications in regards to tactile visitor experience?

C. EXPERIENCE: To what degree is your HHM's guest experience based in tactile learning?

D. ENVIRONMENT: To what degree are your HHM's interiors organized to accommodate tactile learning?

E. SHELTER: How aggressive are your attempts to utilize your landscape and building in tactile ways?

Let Them Dance: Encourage Guests to Move Freely

Allow for freedom of movement and a variety of activities in your HHM's experience.

A. COMMUNITY: How aggressive is your HHM in learning about different types of kinetic styles in your community?

B. COMMUNICATIONS: To what degree do your communications accurately reflect the type of movement your basic guest experience involves?

C. EXPERIENCE: To what extent do your guests move around during their visit to your HHM?

D. ENVIRONMENT: To what degree is your interior design plan organized to allow your guests' freedom of movement?

E. SHELTER: How dedicated are you to utilizing the landscape and architectural layout of your HHM to allow for your guests' freedom of movements?

Allow Access to Denied Spaces:
Encourage Guests to Sneak Around

Provide some type of access to the areas of the HHM that are typically off limits.

A. COMMUNITY: How knowledgeable are you of your community's perception of the HHM's denied spaces?

B. COMMUNICATIONS: To what degree do your communications make note of denied spaces in your HHM?

C. EXPERIENCE: How dedicated are you to allowing guests to view/experience/understand all of the spaces in your HHM?

D. ENVIRONMENT: To what degree have you opened up the most denied spaces in your HHM?

E. SHELTER: To what extent have you revealed the denied spaces of your HHM on a basic tour?

Engage All of the Senses

Utilize all five senses in the guest experience.

A. COMMUNITY: How aggressive is your HHM in learning about different types of sensory experience in your community?

B. COMMUNICATIONS: How aggressive are your communications in expressing the sensory qualities of your HHM's visitor experience?

C. EXPERIENCE: To what degree does your HHM guest experience embrace multiple senses?

D. ENVIRONMENT: To what degree do you utilize your HHM's environment to engage all of the senses?

E. SHELTER: How consistently do you use your HHM building and landscape in sensorial engagement?

Collections/Environment Markings

Collection: the act or process of getting things from different places and bringing them together... a group of interesting or beautiful objects brought together in order to show or study them or as a hobby.[4]

Transcend the Object

Reduce the primacy of singular objects. Instead, embrace interaction from a collective environment.

A. COMMUNITY: How intently have you attempted to relate your collections with your community's interests?

B. COMMUNICATIONS: To what degree do you communicate information about your HHM's total collection instead of focusing on specific objects?

C. EXPERIENCE: To what degree do you present the HHM's entire collection to your guests during their visits?

D. ENVIRONMENT: To what degree do your interior spaces portray a collective habitation perspective, rather than an object-based presentation?

E. SHELTER: How intent are you on expressing your HHM's building and landscape as part of a larger community?

Expose Domestic Complexities

Embrace the physical complexity of habitation.

A. COMMUNITY: To what degree have you gained knowledge regarding your neighbors' home environments?

B. COMMUNICATIONS: To what extent do your communications express the complexity of habitation at your HHM?

C. EXPERIENCE: How much of your HHM experience is derived from the expression of complex habitation scenarios?

D. ENVIRONMENT: To what degree does your interior furnishings plan embrace the complexity of habitation?

E. SHELTER: To what degree do your HHM's architecture and landscape portray the complexity of habitation?

Expand the Guest List

Create an expansive list of characters in your HHM narrative. Reduce the primacy of a single inhabitant.

A. COMMUNITY: How aggressive are you in gaining an understanding of historic figures important to your community?

B. COMMUNICATIONS: To what extent do you communicate information regarding marginalized figures in your narrative?

C. EXPERIENCE: To what degree does your guest experience involve typically non-central figures?

D. ENVIRONMENT: To what degree does your HHM's interior environment includes multiple characters?

E. SHELTER: To what degree are your architecture and landscape expressive of multiple characters?

Follow the Sun

Create an interior environment that suggests daily life cycles.

A. COMMUNITY: How dedicated are you to learning about different life cycles and rituals in your community?

B. COMMUNICATIONS: To what degree do you communicate the different life cycles of your HHM?

C. EXPERIENCE: To what degree does your HHM guest experience express different life cycles and daily behaviors?

D. ENVIRONMENT: To what degree does your HHM interior environment express different life cycles?

E. SHELTER: How many different life cycles does your HHM express during the typical guest experience?

Fingerprint

Allow guests to individualize their own experiences and leave a mark at your HHM.

A. COMMUNITY: How dedicated are you to learning about your community's methods of asserting individuality?

B. COMMUNICATIONS: How many of your communications are targeted at individual expression?

C. EXPERIENCE: To what extent does your guest experience allow for individualized interaction with the HHM site?

D. ENVIRONMENT: To what degree is your HHM's interior focused on the needs of the individual?

E. SHELTER: How much of your house and landscape is designed to allow for individual experience and marking?

Contemporary Interpretations

Seek out contemporary reflections and critiques of your HHM site and narrative.

A. COMMUNITY: To what degree do you understand the contemporary and artistic expressions of your neighbors?

B. COMMUNICATIONS: What extent of your communications expresses a contemporary critique of your narrative?

C. EXPERIENCE: To what degree do you fully integrate contemporary happenings and exhibitions into your HHM experience?

D. ENVIRONMENT: To what degree have you allowed contemporary art and happenings into your HHM?

E. SHELTER: To what degree do your house and landscape incorporate contemporary happenings and installations?

Shelter Markings

Shelter: A structure that covers or protects people or things... a place that provides food and protection for people or animals that need assistance... a place to live.[5]

Keep Perspective

Keep the cost of your HHM's preservation in check relative to the value and importance of the site.

A. COMMUNITY: How dedicated are you to considering your community's economic situation when making decisions about the preservation of your HHM?

B. COMMUNICATIONS: To what extent do you communicate the cost of preservation for your site?

C. EXPERIENCE: To what degree does your average guest experience convey the real cost of preservation?

D. ENVIRONMENT: To what degree are the un-renovated spaces inside your HHM publicly viewable/able to be entered?

E. SHELTER: How dedicated are you to sharing the cost of preservation of your building and landscape?

Show Your Age: Don't Go Under the Knife

Embrace age and its effects on your HHM.

A. COMMUNITY: How often do you communicate with your community regarding the effects of aging on your site?

B. COMMUNICATIONS: To what degree do your communications express aging and preservation at your HHM?

C. EXPERIENCE: How much of your HHM guest experience is derived from the expression of substantial preservation concepts?

D. ENVIRONMENT: To what degree does your interior furnishing positively embrace the effects of aging?

E. SHELTER: How comfortable are you with allowing portions of your HHM's architecture and landscape to age?

Pull Back the Curtain

Make the aging and preservation of the HHM an integrated part of your narrative.

A. COMMUNITY: To what extent do you make reference to the neighborhood's physical conditions in your narrative?

B. COMMUNICATIONS: To what degree do your communications deal with preservation concepts?

C. EXPERIENCE: To what degree does your basic experience involve the concept of aging in preservation?

D. ENVIRONMENT: To what degree does the interior environment in your HHM reflect unrestored parts of your HHM?

E. SHELTER: To what degree are your architecture and landscape expressive of various degrees of preservation?

Mind the Gap

Integrate the built environment surrounding your HHM into your narrative.

A. COMMUNITY: How dedicated are you to physically integrating your HHM into the neighborhood that surrounds it?

B. COMMUNICATIONS: To what extent do your communications include direct connections to relationships with the physical neighborhood?

C. EXPERIENCE: To what extent do you reference the physical landscape that surrounds the house during a typical HHM experience?

D. ENVIRONMENT: To what degree do you physically or visually engage the outside environment from inside the HHM during guests' visits?

E. SHELTER: To what extent do you make physical connections with your neighbors?

Dig Deeper than the Dollhouse

Make preservation about the entire HHM, not just its cosmetics and decorative objects.

A. COMMUNITY To what extent do you invite your neighbors into your HHM to witness your preservation efforts?

B. COMMUNICATIONS: To what extent are your communications about preservation updates?

C. EXPERIENCE: To what extent does the typical guest experience involve preservation as a component?

D. ENVIRONMENT: To what extent is your HHM's interior dedicated to the expression of your preservation efforts?

E. SHELTER: To what extent do your house and landscape express preservation efforts?

Question Significance

Reduce your reliance on a Period of Interpretation.

A. COMMUNITY: To what extent does your HHM's Period of Interpretation involve eras and individuals who are considered important by your community?

B. COMMUNICATIONS: To what extent do your communications express expansive periods of importance to your HHM?

C. EXPERIENCE: To what extent do you involve multiple eras in your HHM experience?

D. ENVIRONMENT: To what degree have you allowed multiple periods of habitation into your HHM?

E. SHELTER: To what degree are your house and landscape used to express multiple periods of habitation?

APPENDIX B:

RESEARCH TOOLS

We learned early on in our research that we were interested in ideas that few people had studied. It simply was not possible, for instance, to find any substantial research on Historic House Museums relative to visitors' movement and behaviors. Nor had anyone really studied visitors' comments directly tied to locational data.

When we began our study, our original thoughts were akin to a constellation, only precariously connected like on a Calder mobile. When one idea evolved, all the others changed as well. Consequently, we quickly realized that if the *Anarchist's Guide to Historic House Museums* was to become meaningful and useful, new methods of data collection were needed.

Simply put, if we wanted to learn something new about HHMs, we had to figure out a way to discover it out for ourselves. We started asking lots of different people about their experiences in and around Historic Houses, documenting behaviors, video recording habitation, and observing visitor experience. Very quickly we coalesced these disparate ideas into more concise and replicable studies. Our efforts became more targeted and specific. We now call these research efforts our Anarchist "TOOLS."

These TOOLS are described here in Appendix B. We have attempted to give an overview of how they evolved and were formalized into distinct testing methods, and what conclusions they began to suggest. We are the first to admit that these TOOLS are in many ways subjective and incomplete attempts to capture fuzzy concepts. Nonetheless, we believe that they

Anarchist's Guide to Historic House Museums by Franklin D. Vagnone and
Deborah E. Ryan 199–225. © 2016 Left Coast Press, Inc. All rights reserved.

stand as quantitative and qualitative data collection methodologies that, when combined, begin to form a new paradigm in museum practice for historic sites.

We offer these TOOLS as the beginning of a new language for Historic House Museums and see them (and future experiments that all of you will design!) as a sort of Rosetta Stone for translating what has been so difficult to understand: What is it about Historic House Museums that is not working? And what can we do about it?

University Research Partnerships

HYPOTHESIS

If we want to broaden the HHM audience to include Generations X, Y, and Millennials, it is important to understand their overall perceptions and

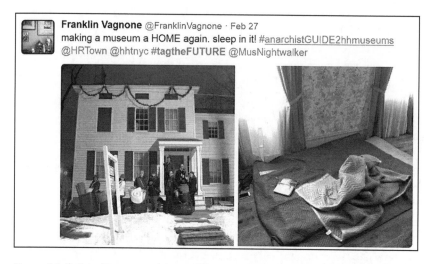

Figure B.1: University partnerships enable intensive research into HHM issues. Students from the University of North Carolina, College of Arts and Architecture (taught by Ryan, with Vagnone serving as a guest critic) participated in an immersive two-day, overnight research event at Historic Richmond Town, Staten Island, NY. As part of the larger studio project, the students were given unprecedented permission to sleep in an HHM. Research project facilitated by Ed Wiseman, Executive Director of Historic Richmond Town, and staff. *Photos: Franklin Vagnone (tweet).*

critiques of House Museums, so that a strategy can be developed to attract them. Given that these groups do not visit Historic House Museums in great numbers, the best method of garnering such data comes from university teaching and student research projects.

TASK

It was fortuitous that we had a relationship with the School of Architecture at the University of North Carolina at Charlotte (UNCC) from the beginning of our initial investigations into the *Anarchist's Guide*. The institution encourages faculty to engage students in their research, but in our case, we wanted the work to be not only theoretical but also applied.

We had some initial concern that architecture students would not be able to make a meaningful contribution to our work because of their lack of experience with HHMs. In a typical architectural design studio at UNCC, only a quarter of the class had ever visited a House Museum, and almost all of those students had visited while on a class trip in elementary school. Very rarely had any of the students visited a HHM on their own as a teenager or young adult before they enrolled in the studio. But what we found was that the students' inexperience with historic sites was actually an asset, because they were not hemmed in by their commitment to best practices in museum studies, or hesitant when we asked them to question them.

In our early classes, we gave the students only vague prompts like "map your experience at an HHM." To their credit and with our encouragement, they came upon interesting ways to record their critiques using their entire arsenal of analysis and design tools, including maps, drawings, diagrams, sound, and video. In subsequent classes, we asked the students to build on these early investigations and offered an emerging version of the *Anarchist's Guide* to frame their studies.

The most significant information we gained through the students' research was when we asked them to study different HHMs, all located within a day's trip from the university. After they presented their experiences back in the studio, we were able to compare and contrast the opportunities and challenges shared by HHMs. This practice became a powerful way to collectively understand the state of local House Museums across the region.

After our very successful teaching at UNCC, we expanded our lessons to other colleges, universities and institutions. These new students were majoring in a broader range of subjects, including Exhibition Design at The New School, Art at the Pratt Institute, Museum Studies

at Cooperstown Graduate Program, and Historic Preservation and Conservation at both Columbia University and New York University. We taught as guest critics, leaders of professional weekend seminars, in short courses, and in semester-long studios.

Many of the research projects our students focused on were HHMs under the umbrella of the Historic House Trust of New York City. They included the Wyckoff Farmhouse and Hendrick I. Lott House in Brooklyn, the Van Cortlandt House and the Edgar Allan Poe Cottage in the Bronx, the Dyckman Farmhouse Museum and the Morris Jumel Mansion Museum in Manhattan, Historic Richmond Town on Staten Island, and the Lewis H. Latimer House in Queens. Beyond those HHMs, our students also investigated other Historic Houses in smaller cities, such as the Billy Graham House and Rosedale Plantation in Charlotte, NC; Körner's Folly in Kernersville, NC; the Nathan Russell House in Charleston, SC; and, the Woodrow Wilson House in Augusta, GA.

Even though these University partners are a sub-set of the larger society, we have gained invaluable insight into HHMs from these relationships and urge Historic Houses to pursue opportunities with area universities. Do not just look for those with preservation or museum studies programs. Get creative and engage students from diverse backgrounds to elicit the widest range of information.

One-Minute Video Mapping

HYPOTHESIS

Most research in the museum profession is shared via a text-based format. This book is no different. But if we employed a broader array of data gathering and reporting media, we could capture and convey more intimate, visceral information regarding HHMs and the people who visit them.

TASK

We created a simple, inexpensive methodology to capture and convey data in a non-text-based manner.

We have had significant success using one-minute videos to explore and explain neighborhood context, house character and access, and the exhibition of collections. We have found that all of our twenty-something

students are very adept using both their smart phones to film videos and their computers to edit what they captured. We discovered quite unexpectedly the ease these millennials have working with this media. In 2010, we were teaching an architectural studio at the University of North Carolina at Charlotte and asked the students to use maps and floor plans to compare the messy reality of their own lives with the overly scrubbed-clean abstractions typical in HHMs. One of the students, Ben Livengood, was having difficulty in conveying this information in the manner we requested. After speaking with him in a group critique, we discovered that he had really enjoyed making videos on his computer for a film class. We suggested that he should complete his map using only video clips, and the video mapping for the *Anarchist's Guide* was born.

Figures B.2 & B.3: The One-Minute Video Mapping exercise is used to capture the minutiae of daily habitation. In our research, we found that traditional documentation, like text-based or diagrammatic furnishings plans, usually removed all of the detritus of habitation from the environment. Another aspect of this exercise is that it can help gain insights into behavioral and environmental interactions in real time. Shown is the domestic space of Vagnone. *Photos: Franklin Vagnone.*

After a few years of working with this research tool, we have found it to be one of the best ways to articulate nuanced information about habitation and experience—far better than text or two-dimensional diagramming. So successful has this research tool become that we now use it throughout our *Anarchist's Guide* research process to complete

1. Community and neighborhood mapping, including demographic and social data;

2. A communication style and language survey;

3. A recording of the existing conditions of visitor experience at Historic House Museums;

4. Personal habitation studies to uncover use and behaviors;

5. Personal collections mapping to study artifacts and their functions; and

6. The personal expression and qualities of preservation.

Logistically, video mapping exercises are very simple. Students/staff/ volunteers are asked to use their smartphones to capture moving images of the assigned project, download it to their computers, and edit what they captured down to one minute. We have asked people of all ages to do this exercise, and all of them have been able to produce good results, although a few needed a bit of help from friends on the editing end of the process.

The one minute limit may seem short, but the brevity makes it possible to gain a quick and direct understanding of the important issues meant to be conveyed in the video clip. The time constraint necessitates a clear focus and point of view, and we have found that encouraging the communication of depth is far more successful than breadth. We have seen memorable videos that feature people dancing in their kitchen while drinking their morning coffee, as well as showing off their personal collections of miniature objects, rocks, postcards, hats, and penguin-themed items. By watching how they handle each piece and hearing about how they use and feel about it, we get a sense of how much their collections are valued.

While these one minute clips are effective in documenting concepts and ideas, they are also useful as part of a comparative analysis. Following Livengood's first video for us, we have seen many insightful comparisons made between the visitor experience at HHMs and guests' real life habitation patterns. We have also seen memorable videos that compare the white-glove treatment of House Museum collections and their environments

against the hard and sometimes dirty use of an actual dwelling space. Many of these comparisons have significantly contributed to the *Anarchist's Guide* lexicon of markings.

Habitation and Museum Movement Studies

HYPOTHESIS

There is a significant difference between how people move through their own homes and how they move through Historic House Museums. The contrast between the two patterns reveals a conceptual disconnect that limits guests' experiences.

TASK

We created a methodology to document the everyday patterns of movement through real-life, personal living spaces, and compare those with the patterns of movement through Historic House Museums.

We undertook this study because of the many negative comments we heard regarding the Historic House Museum experience that centered on the expectation that visitors should stand and listen in one room, follow the tour guide into the next room, stand and listen in it, follow the tour guide into the next room, stand and listen in it, etc. This follow-the-leader movement through the House has resulted in a distant and abstract guest experience, one that is very unlike what it feels like to be in a lived-in home.

We decided to test those anecdotal observations. As part of a larger effort to understand what it meant to inhabit a space, we isolated the act of movement through it, believing that the study of an individual's path could produce some useful information.

We asked our student researchers to document their normal movement through their own homes, and then to document their movement through an HHM. The results of their mapping ranged from hand-scribbled diagrams to stylized, poetic presentations of movement. Yet, regardless of the level of the craft of the drawings, we found consistent results and further validation after a review of scholarly research about movement in museums.

Our research validated our hypothesis. We saw stark differences between how people lived and how they were allowed to experience a Historic House Museum.

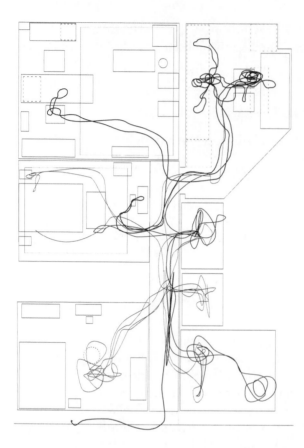

Figure B.4: House Movement Study of a personal dwelling showing the first two hours after awakening. This mapping exercise provides an excellent comparison to the linear path of a typical tour in a House Museum. Columbia University Historic Preservation Seminar (taught by Vagnone, with Ryan and Olivia Cothren as guest critics) 2013. *Photo: Franklin Vagnone.*

In their own homes, the patterns of the students' movements consisted of a series of looping switch-backs and fluid, overlapping lines. Further, they tended to enter and occupy the main living space of their own home the least, while smaller or more private rooms like kitchens, bedrooms, bathrooms and closets were repeatedly visited.

In comparison, the movement patterns that were recorded in HHMs were linear and one directional. Guests' access was typically limited to only a few rooms on the first floor with the bulk of time being spent in hallways and parlors.

Seeing the disconnect between the two distinct experiences in HHMs and the students' homes, we began to realize there was an opportunity for Historic Houses to build interpretive plans that were based upon flowing movement through their rooms, rather than the stand-in-place room survey that occurs now. Clearly, the movement within a private dwelling would

express unique situations that would not be desirable in a House Museum (i.e., entering a bathroom five times!), but studying such movements can give us a clue as to ways that museums can become more intimate.

Perhaps one of the best overlaps between our research tools and practice is when we have undertaken Movement Studies at House Museum Workshops. While on site, we have been able to test the fluidity of movement as a means of interpretation and have found that a great deal of nuanced and latent information regarding a House can be conveyed by alternate means.

Distinct Activities Study

HYPOTHESIS

HHMs are best understood when guests are given the opportunity to experience the House through a series of distinct activities that mirror their own lives in their own homes. In order for your guests to feel comfortable and have an intimate experience in your HHM, they must engage it in a tactile way. They cannot feel "at home" in your HHM if their experience is limited to standing in the hallway.

TASK

We wanted to understand what the distinct activities are that take place in a house to make it feel like a home, where they occurred and how often. So we asked our participants to record the number and location of distinctly different activities they undertook in their own homes over a two-hour period and compare them in type and number with their experience in an HHM.

Consequently, the *Distinct Activities Study* is intended to quantify the number and type of activities that contribute to a feeling of domesticity in a home. In creating the methodology, we were also interested in measuring *tactility* as an attribute and recording the number of experiences in which the sense was involved.

Initially, we asked our participants to sketch a floor plan of their home and then record their path as they moved throughout it during their morning ritual. These first results gave us interesting data about movement, as paths were drawn that doubled back on themselves in almost scribble-like configurations. There were also some notable differences in the mappings, due largely to age and gender, but we were unable to draw any conclusions

about the relationship between the size of the space and the number of distinct activities that typically occurred within them.

In our second iteration of the study, we asked the students to approximate the square footage of their home and to label each room so that their path and the distinct activities along it were shown in some quantifiable context. We asked that they place a dot on the floor plan where each distinct activity occurred, from waking up in bed to leaving the house in the morning, over the same two-hour period of our initial study. We then asked the participants to record their path between their distinct activities dots so that we could quantify their experiences.

We defined a *distinct activity* to be an activity that required a change in:

1. Location

2. Movement of the body, and

3. Tactile engagement with the environment.

We asked participants to start their recording in bed (lying down) as the first distinct activity and to move forward from there. We also stipulated that if they stood in one place and facilitated several activities without substantial body movement, then all of those movements would be considered one distinct activity. For instance, if they stood in front of a mirror in a bathroom to brush their teeth, floss, rinse with mouthwash, and put on makeup, but never really change their physical location, then all four of those activities would be considered one distinct activity. However, if they took a shower or sat on the toilet, each of those would be recorded as separate activities since they required movement to a different place in the room. Further, if they left the room, and returned later in the morning, that, too, would be recorded as an additional activity.

Through this tool we were able to determine that more distinct activities were needed in our HHMs if our guests were to more viscerally understand it as a lived-in home.

While our research continues, our data to date suggest that for every 47.6 square feet of habitable space, a person on average participates in one distinct activity.[1] The rooms with the most activities were the bedroom, bathroom and kitchen. Interestingly, the rooms with the least distinct activities were the more formal living rooms and dining rooms. Yet, those are the rooms that HHMs most often have open for viewing and interpretation and are perhaps the least engaging and tactile for guests.

What does this mean to an HHM? Perhaps nothing, or everything.

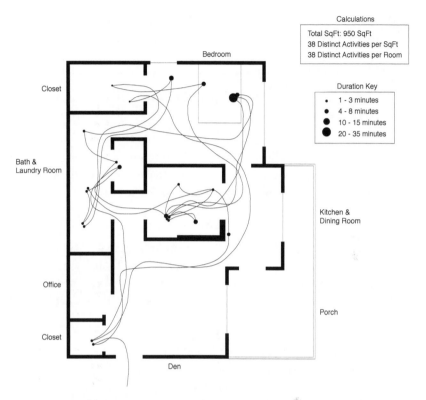

Figure B.5: Distinct Activities study, personal domestic situation showing location and duration of activity. Lauren Lindsey, University of North Carolina at Charlotte, College of Arts and Architecture, 2015.

While visiting HHMs, most guests experience the house through only one distinct activity: standing and listening to a tour guide. To make HHMs feel more like a home, the visitor experience should be designed using the concept of distinct activities. Combine HHM narratives with the physical requirements of providing distinct activities. Doing so will drastically change the very nature and substance of a guest's Historic House encounter.

Distinct activities can include anything done in real life while at home, like opening doors, sitting down on furniture, making bread, answering the phone, carrying a tray up the stairs, lying on a bed, changing into clothes, reading a book or newspaper, combing through books, playing a game, making and having tea, making a bed, or doing laundry. Better still, consider engaging guests in some community effort that re-presents the lives of the

HHM's former occupants. If the family helped feed the homeless, then design a way to have guests engage, in some way, in this activity as a part of their visit.

Imagination, Excitement and Energy (IEE) Graph

HYPOTHESIS

The visit to a Historic House Museum should be tactile, immersive and special, yet we often hear that the HHM experience is boring. But without a comparative metric, it is impossible to break down the cause of the problem.

TASK

To gain a clearer picture of what excites, bores and compels HHM visitors, we developed a methodology to both quantitatively and qualitatively measure their experiences, while taking into account the specificity of location, activity and behavior. The metric is based on the earlier work of Kevin Schaffner, one of our early architecture students from UNCC.

We became interested in the comparative understanding of the location, causes, and the subsequent effects of the peaks and valleys that take place during an HHM visit. Through multiple attempts, we developed a model that guests can use to track their own imagination, energy and excitement while moving through the House. The model is in the form of a graph that we call the IEE, and it allows a synthesis of three different analyses.

In practice, we ask HHM visitors/research participants to take a standard tour and track their relative degree of imagination, energy and excitement through some very broad prompts.

1. **Imagination**—To what degree (before, during and after) does your imagination play into the experience? To what degree does pre-existing knowledge play into your imagination? How did your expectations compare to what you actually got out of the visit? How did your level of imagination change as the visit proceeded? Was it made more full, or sapped of creativity?

2. **Excitement**—Is there anticipation of things unknown? What degree of emotional reactivity and involvement does the tour give you? How does this change throughout the visit? Does the Historic House leave you with an expansive view of the world, or did the narrative deaden your interest in learning more?

3. Energy—How is your physical energy modified by the trip to the HHM? Were you equally energized before, during and after the visit? Did the visit and experience enliven you or drain your ability to be integrated with your surroundings?

We ask our students to graph their relative experiences and note where and when they specifically occurred on their tours. Following the visit, they are to expand on their locational data with a text-based poetic interpretation of the experience, because we are interested in the relationship of the intellectual to the experiential. For instance, Ivy Tsai, a University of North Carolina College of Architecture student, wrote this stream of conscious description of her experience at the Billy Graham House in Charlotte:

Time to go in, here I go.
Can't go in the Dining Room?
A lot of effort to rope off the living room.

Guide lady has still, but upright posture.

Hungry.
Pay attention.
Déjà vu.

The results of the IEE Graph specifically show what caused or affected a particular high or low relative to the visitor's imagination, excitement and energy. Admittedly, the data can be cursory and subjective, but they still allow a quantifiable connection to be made between location, object and experience.

Figure B.6: *Pages 212–213:* Imagination, Excitement, and Energy Graph of the Nathan Russell Historic House in Charleston, SC showing the relationship of artifacts, experience, location, and activity by Taylor Jarrell, University of North Carolina at Charlotte, College of Arts and Architecture, 2015.

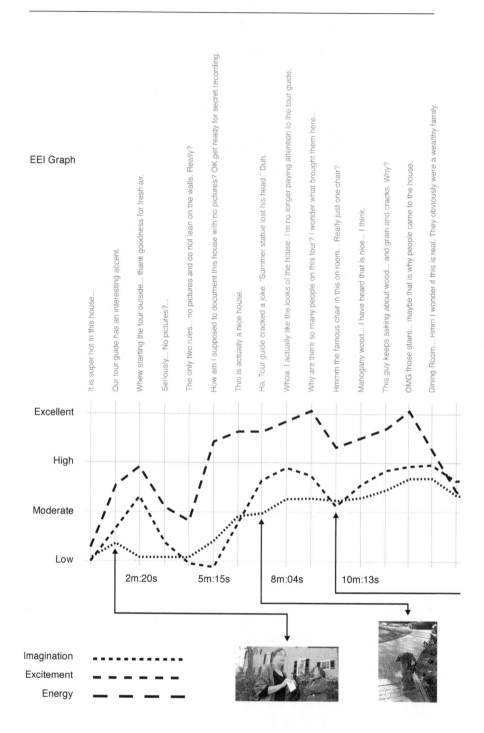

EEI Graph

It is super hot in this house...

Our tour guide has an interesting accent.

Whew starting the tour outside... thank goodness for fresh air.

Seriously... No pictures?...

The only two rules... no pictures and do not lean on the walls. Really?

How am I supposed to document this house with no pictures? OK get ready for secret recording.

This is actually a nice house.

Ha. Tour guide cracked a joke. "Summer statue lost his head." Duh.

Whoa. I actually like the looks of the house. I'm no longer paying attention to the tour guide.

Why are there so many people on this tour? I wonder what brought them here...

Hmmm the famous chair in this on room... Really just one chair?

Mahogany wood... I have heard that is nice... I think.

This guy keeps asking about wood... and grain and cracks. Why?

OMG those stairs... maybe that is why people came to the house.

Dining Room... Hmm I wonder if this is real. They obviously were a wealthy family.

Excellent

High

Moderate

Low

2m:20s 5m:15s 8m:04s 10m:13s

Imagination
Excitement
Energy

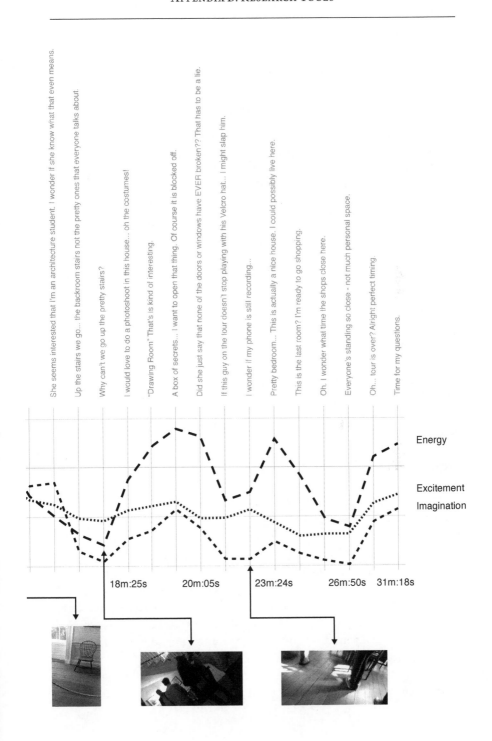

She seems interested that I'm an architecture student. I wonder if she know what that even means.

Up the stairs we go... the backroom stairs not the pretty ones that everyone talks about

Why can't we go up the pretty stairs?

I would love to do a photoshoot in this house... oh the costumes!

"Drawing Room" That's is kind of interesting.

A box of secrets... I want to open that thing. Of course it is blocked off.

Did she just say that none of the doors or windows have EVER broken?? That has to be a lie.

If this guy on the tour doesn't stop playing with his Velcro hat... I might slap him.

I wonder if my phone is still recording...

Pretty bedroom... This is actually a nice house. I could possibly live here.

This is the last room? I'm ready to go shopping.

Oh. I wonder what time the shops close here.

Everyone's standing so close - not much personal space.

Oh... tour is over? Alright perfect timing

Time for my questions.

Energy

Excitement

Imagination

18m:25s 20m:05s 23m:24s 26m:50s 31m:18s

Sound Mapping

HYPOTHESIS

The sounds of daily life are missing from HHMs, and their absence limits guests' abilities to have an empathetic understanding of the homes' earlier inhabitants. The lack of familiar sounds also negates the possibility of visitors' shared experience through their own memories. But if we map the sounds in HHMs, and compare them to what is typically heard in today's homes, we can begin to discover how to improve the auditory experience of the Historic House.

TASK

In watching hundreds of One-Minute Videos of HHMs, their context, or their collections, we began to realize how important sound was in conveying an idea or a mood. Whether it was a contemporary song used as background to a student's habitation video, or a recording of the quiet shuffling of feet throughout a Historic House Museum tour, we found that the obvious inclusion or absence of sound made a significant contribution to the Home's narrative.

To focus our study on guests' auditory experiences, we asked students to consciously map sounds from their own lives, and then overlap those recordings with the sounds heard in an HHM. In the historic property, they primarily heard creaking floorboards and the sounds of heating and air-conditioning systems, highlighted by the unexpected but welcome chimes from grandfather clocks, or a new guest knocking on the front door. Regardless of the abundance of fireplaces, there were no sounds of cracking fires, nor was there music arising from the often seen, but silent, pianos. There were no sounds of bells summoning servants, or the clatter from their cooking and cleaning. They never heard glasses clinking or dinners being eaten, much less people talking or children playing. In almost all cases, HHMs were absent of the sounds of habitation. These comparative sound maps further highlighted the startling contrast between the digital and technological sounds of today and the more muted, mechanical and tactically made sounds of the past.

The students also compared the sounds from outside the HHM to those within and, not surprisingly, found the quiet interiors in sharp contrast to

the noise from trains, planes and automobiles, loud conversations, scream-
ing children, music from radios, dogs barking, birds singing, and the gen-
eral din from ambient noise. In some cases, they recorded the welcome rush
of sound emanating from outside when the HHM's doors were opened.

Almost all the students noted the dreary silence of HHMs as a defin-
ing memory of their HHM experience. Correspondingly, we found that the
intentional but rare presence of sound or music in Historic Houses caused
a stack of positive comments on *Anarchist Tags* (see next section) to be left
where it occurred.

Once we understood the important relationship of sound to experi-
ence, we were better able to creatively formulate possible ways that sound
could become a larger part of the HHM experience. Our students pro-
posed a number of sound installations that included mashups of new and
old sounds, and they ranged from the far off giggling of children; the quiet,
nighttime sobbing of servants; to the approaching footsteps of horses on
gravel outside the HHM.

The beauty of these auditory proposals is in how minimally invasive
they are. After all, sounds do not pose a threat to collections or preservation.
The non-threatening nature of sound makes this element a prime choice for
a hesitant HHM looking to take that first step towards better representation
of habitation at its site.

Anarchist Tags

HYPOTHESIS

To understand what guests really think about on their visit to a Historic
House Museum, the staff needs to be able to unobtrusively track visitor
response in situ and in real time. Exit surveys are not immediate enough to
tease out a location or artifact-based critique.

TASK

We created a means for guests to leave their thoughts when and where they
had them while moving through HHMs.

On ordinary 2" x 3" paper tags, we created whimsical *Anarchist Tags* and
invited our guests to drop them around the HHM wherever they wanted,

to share what they liked or did not like about the House, so we could learn from them how to improve the visitor experience.

The creation of the *Anarchist Tags* grew out of our desire to collect visitor comments in such a way as to allow for the highest degree of freedom and independence. Because we believe so strongly in the de-centralizing of the House Museum experience, it seemed a bit too controlling to have a person with a clipboard waiting for a guest at the back door, or only allowing for comments to be posted on those ubiquitous yellow sticky notes within a framed area.

Most museum professionals think of the interior of an HHM as an abstract organization of rooms, used to explain a carefully chosen historic narrative. In contrast, we think of rooms in HHMs as places for experiences to be had, where emotional consequences can drive behavior. The *Anarchist Tags* allow for the documentation of these place-based experiences. We sought out various age, ethnicity, and economic differences so that we could see many perspectives. We have tested the *Anarchist Tags* with elementary school, high school, and college students; museum professionals of almost all ages; walk-in visitors; and dedicated House Museum people.

We first tested the *Anarchist Tags* with a preservation class at Columbia University in 2013. On the front of each tag, we stamped: "I am a museum anarchist and I think this is _____ ." We sent our students out with a handful of Tags and asked them to visit art museums and HHMs and leave behind their thoughts and feelings at the exact spot that they had them. Once the Tag was dropped, we also asked them to tweet a picture of the Tag in context back to us so that we could understand the relationship of the Tag to the location.

In this first round of using the *Anarchist Tags*, we were already able to see a visceral level of engagement that we had not typically seen in surveys. Students recorded a wide range of responses, ranging from their perspective on inappropriate housing of artifacts outside their original culture to the worry about being watched by security. Given that the study was done surreptitiously, the concern was understandable.

In our pilot experiments at HHMs and at *Anarchist Workshops* (see next section), we have distributed the Tags to participants and guests, and asked that they record their thoughts and leave them where the ideas struck them, whether it was on a work of art, a piece of furniture, a doorknob, or an artifact. We have found that the Tags work best when guests are allowed to move freely, and where they do not feel as if they are being monitored or have to keep up with a tour. Over the course of a busy day, the Tags can

build up. But rather than seeing them as clutter, think about them as a conversation starter as other guests read and react to them.

Since that first trial use of the *Anarchist Tags*, we have experimented with several prompts:

1. "I am a museum anarchist and I think this is _____

_____. "

2. "I like _____

_____. "

3. "I didn't like _____

_____. "

4. "If I ran the Historic House I would _____

_____. "

In a pilot experiment with the Tags at the Morris Jumel Mansion, Executive Director Carol Ward and Project Manager Danielle Hodes documented both the comments on the tags and the exact location where they were left. They encouraged Tags to be left during both guided and self-guided tours. They also collected comments when the access to a period room was denied, as well as when free access was allowed.

In every House Museum workshop we now hold we use the *Anarchist Tags* and document the comments and locational data.[2] What we learned has significantly influenced the *Anarchist's Guide*. Specifically, visitors commented that they:

- *Dislike standing in the entrance hall and listening to an orientation speech*
- *Like roaming freely and at their own pace (not crammed in a hallway)*
- *Wish they could go into the rooms (not just view them), want full access (no locked doors or "do not" signs)*
- *Want to be engaged in a tactile way with the environment (not text-based)*
- *Want to ask questions instead of being talked to (decentralize educational experience)*
- *Want to feel welcomed or "good enough"—(class and wealth awareness)*
- *Are very receptive to contemporary art integrated with the historic interior*
- *Seek photo albums and family books (can't see things from afar)*
- *Dislike all of the regulatory signage*

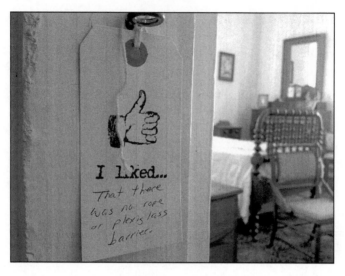

Figure B.7: *Anarchist Tag* from the hands-on Anarchist workshop at the Mabry-Hazen House, Knoxville, TN, in 2014. The *Tags* are a de-centralized method of obtaining visitor reactions and thoughts. Unlike traditional exit surveys, the participants are asked, during the visit, to write their thoughts on a *Tag* and drop it exactly where they felt the issue was pertinent. Workshop facilitated by Knoxville Heritage and Calvin Chappelle, Executive Director of Mabry-Hazen House. *Photo: Calvin Chappelle, 2014.*

House Museum Workshops

HYPOTHESIS

Since our *Anarchist* ideas are based in the concept of tactile habitation, they must be tested in situ in an actual Historic House Museum.

TASK

We have been experimenting with ways that the visitor experience at HHMs can be tested and expanded, in a manner that is inexpensive and safe but potentially expansive.

Initially, the ideas we explored in the *Anarchist's Guide* remained theoretical. To evaluate their applicability in the field, we began by holding

Anarchist's Guide Historic House Museum Workshops. The workshops have specifically provided opportunities to test other research tools as well, in ways that both refined and expanded our ideas.

We begin our on-site *Anarchist Workshops* with an intensive walk-through of the HHM with the executive director, and outline together the limits of risk they are willing to accept, as well as their comfort in our use of the collections. We agree to what is off-limits and what is okay to physically engage.

Once we come to that understanding, we ask the staff to open up their HHM from the basement to the attic, unlock all of the doors, and make as much of the collections as possible available for viewing and experiencing in ways that are not usually allowed.

Workshop participants have included staff and volunteers, seasoned museum professionals, board members, local and state historic preservation officers, and walk-in visitors. Through them, we have been able to witness real-time *Movement Studies;* gather location-based critiques through

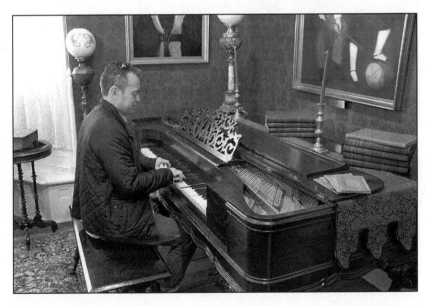

Figure B.8: During a House Workshop at the Mabry-Hazen House in Knoxville, TN, John F. Yeagley extemporaneously began playing the piano. The sounds of the out-of-tune piano broke the silence of the House interior and brought a level of enjoyment to the workshop, facilitated by the Knoxville Heritage and Calvin Chappelle, Executive Director of Mabry-Hazen House. *Photo: Franklin Vagnone.*

Figure B.9: In a unexpected move, a workshop attendee reoriented a rocker and opened a window at the Mabry-Hazen House in Knoxville, TN. Surprise is a common reaction during the workshops, as participants begin to see the House not as a stage set defined by a curatorial furnishings plan, but as a place of habitation. Workshop facilitated by the Knoxville Heritage and Calvin Chappelle, Executive Director of Mabry-Hazen House. *Photo: Franklin Vagnone.*

one-on-one conversations and the use of *Anarchist Tags*; and have a resultant discussion about the opportunities and challenges involved with opening up the HHM in a more immersive manner.

The Workshop experiences have been active, engaging, boundary pushing, and occasionally confrontational. Some of the comments from these workshops include:

"This is the best Historic House Museum experience I have ever had."

"I loved going at my own pace."

"I have been a Board Member at this house for ten years, and I finally understand it."

"I hated standing in the hallway listening to the tour guide."

"I have never understood this room until today."

"If we VANGON-IFY everything, nothing will be left to preserve."

"The problem is that history is no longer taught in schools, not that House Museums need changing."

For many, *Anarchist Workshops* can be quite frightening. But to date, wherever we have offered them, the HHM was able to embrace the experimentation of openness, even if it was for just one day. Only through constant experimentation in actual House Museums will these *Anarchist* ideas continue to evolve and prove their worth. Therefore, we champion even the most short-lived of these experiences, as the sites that are willing to take even the smallest steps are already on the path towards a more inclusive visitor experience.[3]

Social Media Communication

HYPOTHESIS

HHMs are geographically isolated from each other, and there is typically little sharing that takes place between professional and volunteer staffs except at annual conferences. In order to more quickly learn and apply lessons from other Historic House Museums, it is beneficial to have an informal, readily available, and easily accessible network where conversations can occur about current opportunities and challenges shared by HHMs.

TASK

We created a series of social media platforms to share comments and ideas with a wide, geographically dispersed audience of like-minded professionals.

We have long been interested in the power of social media to both connect people and support their work. Wikiplanning™ was one of our earlier efforts, where we created an internet-based platform that allowed people to participate in the community planning process from the comfort of their homes. Among other activities, the site contained a discussion blog that was populated by short answers from online surveys, and participants could read each other's comments, but there was little conversation between the users themselves.

With the goal of building a more participatory forum, we set up the *Anarchist's Guide to Historic House Museums Discussion Group* on LinkedIn.

We created the site in December 2012 in hopes of quickly building an international online place where shared challenges could be identified and theoretical ideas could be discussed and evaluated in the field. By the end of 2014, we had over 1,000 international members, 98 percent of whom are senior museum staff. We have been able to attract individuals with significant institutional affiliations with whom we can pose questions, send links, and ask for comments regarding any number of museum topics. Further, the site has allowed many of the LinkedIn participants to make new personal and professional connections.

We soon realized that the LinkedIn Discussion Group provided a good place to research ideas. If we had an interest in learning more about a particular aspect of the visitor experience, we could simply pose the question to the worldwide group, and they would quickly share their ideas and experiences. Some of that input is included in this book.

The discussions on the LinkedIn site are often lively and filled with many constructive disagreements. The topics that have been discussed range from the some of the most granular topics in Historic House management (i.e., should guests wear booties over their shoes?) to broader conversations about the presence of racism and ageism at historic sites.

Along with LinkedIn, we have also used the social media site MeetUp in an attempt to identify new audiences that could be interested in HHMs and better understand the types of programs that might bring in non-traditional groups. For instance, in testing the potential interest of niche audiences, we organized an LGBT MeetUp group called *LGBT Historic House Nerds UNITE!* Started in May 2013, the group had 197 members at the end of 2014, who responded to the call:

> Do you love wandering through an historic house museum? Looking at all of the stuff? Want to go behind the scenes? Are you someone who drags their friends to every historic house museum you run by? ODD—yes, but there are others just like you! Culture, fun and new friends.

Past MeetUps of the group have included daylong HHM experiences that involved multiple *Anarchist Guide* concepts. We focused the outings at House Museums that would allow freedom of movement throughout the house, picture taking, immersive experiences, the tactile use of selected collections pieces, and most importantly, had a welcoming spirit.

In another test using new forms of communication, we have held several social media-based contests on Facebook, Twitter, YouTube and LinkedIn.

These tests resulted in successful and creative community engagement happenings—like the Poe Cottage Plaster Party and the *Voice of Poe* contest. Both garnered a significant amount of good press coverage .

Mobile Kiosks

HYPOTHESIS

HHMs cannot expect neighborhood residents to come to them if they never have shown any previous interest. Instead, the board, staff and volunteers must go into the community, introduce neighbors to the House and the opportunities it provides, invite them to visit, and begin a conversation about shared history and interests.

TASK

We created engaging mobile kiosks and took them to places where people in the community already gathered, so that they could be introduced to our HHMs. We were careful not to just talk about ourselves. Instead, we gave neighbors a reason to talk to us, primarily about themselves, so that we could identify shared interests and potential commonalities.

The idea of immersive community engagement is borrowed from urban design, tactical urbanism, guerrilla art, activists, and site-specific contemporary art installations. Since the 1960s, when urban renewal strategies obliterated neighborhoods in the name of progress and without neighborhood input, urban designers have tried all sorts of techniques for engaging residents in decision making about their communities. While many municipalities take their message outside city hall and hold public meetings in affected neighborhoods, many others try to more specifically target their efforts. One fairly common strategy is the use of *Meetings in a Box* where presentation materials are packaged in an easy to carry container, with the intent that the Box be passed from one small group to another, even if it is simply from one kitchen table to another, to share information and gather community input in a relaxed, unintimidating manner.

Tactical urbanists have been even more imaginative, expanding the idea of mobility to include temporality by creating fun opportunities that cause people to gather, talk to each other, and build community around local issues. For instance, *National Parking Day*, a grassroots movement

that turns on-street parking places into pocket parks, was initially started in part to lobby for more green spaces in cities. Tactical urbanists have also promoted container architecture, which uses shipping containers as ready-made enclosures for shops, cafés and housing that can readily be delivered wherever a short-term need arises.

At a more modest scale, we designed and built three mobile kiosks for the Lewis H. Latimer Historic House Museum in Flushing, New York. Our goals were to share Latimer's legacy outside the house and to uncover shared aspirations of the surrounding immigrant community through civic engagement. The first installation, entitled *Trunk of Treasure,* was encased in an old steamer trunk, the type of which Lewis Latimer or his wife Mary might have used on their trips across the Atlantic on one of his many business trips. The rolling kiosk contained books the Latimers might have read that revealed their interests, sheet music they were practicing, Latimer's flute, Mary's knitting needles, her hats, his reading glasses, pictures of their family, pillboxes, clothing, and other domestic items needed for the weeks-long journey, all displayed in a sort of touchable cabinet of curiosities. An iPad was attached onto a fold down tray (once used to secure clothing), and participants were asked to record their answers to prompts like: "If you could do anything now, what would you do and why?" or "If you could go anywhere, where would you go and why?"

The second installation, entitled *Carried Away,* was created inside a briefcase removed from the original steamer trunk that became the *Trunk of Treasures.* The piece was an assemblage of items that hinted of Lewis Latimer's professional life: copies of his patents, drafting tools, poetry books from the period he was alive, his own handwritten, unfinished poetry, and a framed picture of his wife Mary. Participants were asked to respond to the prompt, "If there was a briefcase filled with artifacts that described my life and interests, it would contain _____ ."

What Brightens Your Day, inspired by Monica Whitmore, UNCC Fall 2013, was the third installation. It featured a bicycle-pulled cart back lit by the sort of light bulbs Lewis Latimer helped Thomas Edison to invent. *What Brightens Your Day* is pulled out to public places where local residents are asked to respond to the titled prompt on translucent paper, then attach and layer their written answers to the cart's metal and Plexiglass frame. Our intent was to identify shared interests, which we discovered to be family, food, music, crafts, gardening, pets, and faith. These gathered data then provided direction relative to future initiatives at the Latimer House while also introducing Latimer, an important historic figure, to his neighbors.

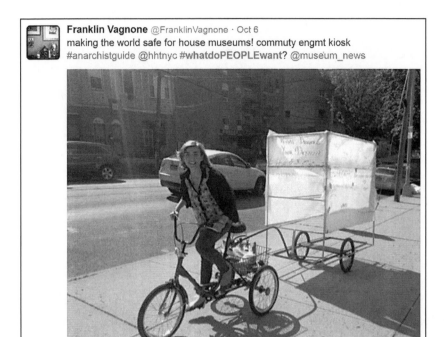

Figure B.10: Mobile Kiosks can invite a conversation with community members outside of the House Museum. Shown here is a tweet highlighting Olivia Cothren maneuvering the streets of Flushing, Queens, as part of the LatimerNOW pilot project, funded by The New York Community Trust. We rode the kiosk up to bus stops and asked people to write on the kiosk "What Brightens Your Day?" It proved a welcomed distraction while waiting for a bus. The Mobile Kiosk was derived from a University of North Carolina at Charlotte, College of Arts and Architecture studio project by Monica Whitmire (taught by Ryan, with Vagnone serving as a guest critic) investigating methodologies for community engagement for HHMs. 2013. *Photo:Monica Montgomery.*

NOTES

FOREWORD

1 Roy Rosenzweig and David Thelen, *Presence of the Past: Popular Uses of History in American Life* (New York: Columbia University Press, 1998).

PREFACE

1 J. Hejduk, personal correspondence with Franklin Vagnone, August 1, 1996. Although these lines of poetry were later published, Hejduk sent a copy to Vagnone in celebration of a house warming for the residence shown in the photos.

2 John R. Stilgoe, *Outside Lies Magic: Regaining History and Awareness in Everyday Places* (New York: Walker and Co., 1998), 2.

3 Ibid.

4 twistedpreservation.com

INTRODUCTION

1 F. Scott Fitzgerald, *The Beautiful and Damned* (New York: Charles Scribner's Sons, 1932), 135–136. The authors wish to thank Alice (Nonnie) Frelinghuysen for contributing to our Anarchist efforts by making note of this passage.

2 Randy C. Roberts, "Questions of Museum Experience: Being, Being With and Finding Connection on Conversation," *Museums and Social Issues*, 8:1 & 2 (2013): 89–101.

3 Peter Burke, "Fuzzy Histories," *Common Knowledge*, 18:2 (2012): 239–248.

4 Gaston Bachelard, *The Poetics of Space* (Boston: Beacon Press, 1994), XXI.

5 Roberts, "Questions of Museum Experience," 89–101.

6 Luc Vanackere, Director, Kasteel van Gaasbeek, e-mail correspondence with Franklin Vagnone, September 3, 2014.

7 Steven Raeburn, "Frost Designs 'Sydney Living Museums' Brand Campaign," *The Drum*, April 21, 2013, 11:34, accessed June 15, 2014, www.thedrum.com/news/2013/04/21/frost-designs-sydney-living-museums-brand-campaign

8 "About Us," Sydney Living Museums, accessed June 15, 2014, sydneyliving museums.com.au/about-us#

9 John Gustafsson, "Invigorating Our World," in Historic House Trust of New York City #2012 Annual Report (New York: Historic House Trust of New York City, 2012): 2, www.historichousetrust.org/assets/attachments/HHT-Annual-Report-2012.pdf

10 Alexander Dru Burckhardt, ed.,"Letter to Willibald Beyschlag, 1842," *The Letters of Jacob Burckhardt* (London: Routledge and Kegan Paul, 1955), 73, from Peter Burke, "Fuzzy Histories," *Common Knowledge,* 18:2 (2012), 239–248, doi: 10.1215/0961754X-1544923.

11 Peter Burke, "Fuzzy Histories," *Common Knowledge,* 18:2 (2012): 239–248.

12 George M. Trevelyan, *Clio: A Muse,* (London: Longmans, 1913), 140–176, from Peter Burke, "Fuzzy Histories," *Common Knowledge,* 18:2 (2012): 239–248.

13 Paul Reber, personal interview with Franklin Vagnone, March 11, 2015.

14 John Stilgoe, "Writing History for the Mainstream: Liberal Arts Panel," Harvard Extension School, from a recorded lecture at Harvard University, February 19, 2010, www.youtube.com/watch?v=ECXo4utFwvc

15 arts.gov/publications/2008-survey-public-participation-arts; www.urban.org/nonprofits/; www.pewinternet.org/fact-sheets/mobile-technology-fact-sheet/. Reports and data surrounding these types of statistics modulate often. Although there is disagreement within the museum profession regarding analysis of such data, we have chosen to move past this and address possible internal relationships.

16 James Vaughn. "Introduction: The Call for a National Conversation," *Forum Journal: America's Historic Sites at a Crossroads,* 22:3 (2008).

17 Jessica Donnelly, *Interpreting Historic House Museums* (Walnut Creek, CA: AltaMira Press, 2002).

18 Claire Robins, "After-Image: The Museum Seen through Fiction's Lens," *Photographies*, 7:2 (2014): 149–162, doi:10.1080/17540763.201 4.930921.

19 "Discourse and Truth: The Problematization of Parrhesia," from a series of six lectures given by Michael Foucault at the University of California at Berkeley, October–November 1983, from Joseph Pearson, ed. *Michel Foucault, Fearless Speech* (New York: Semiotext(e) Foreign Agents, 2001).

20 Doris Ashe and Judith Lombana, "Reculturing Museums: Working Toward Diversity in Informal Settings," *Journal of Museum Education*, 38:1 (2013): 69–80.

21 Thao Mai and Doris Ash, "Tracing Our Methodological Steps: Making Meaning of Families' Hybrid 'Figuring Out' Practices at Science Museum Exhibits," *Putting Theory into Practice: Methodologies for Informal Learning Research* (Rotterdam: Sense, 2012), 97–118.

22 Chandler Battaile, "Cultural institutions giving out food, social services, & HAIR CUTS! True anarchy of traditional functions of museums," comment on *Anarchist Guide to Historic House Museum Discussion Group Blog*, March 20, 2013, www.linkedin.com/grp/post/4770082-224748966

23 Patricia West, *Domesticating History, The Political Origins of America's House Museums* (Washington, DC: Smithsonian Institution, 1999). The book offers a clear and perceptive understanding of the formation of American House Museums. See particularly the chapters on Mount Vernon and Monticello.

24 Ruth Taylor, comment on *Anarchist Guide to Historic House Museum Discussion Group Blog*, www.linkedin.com/grp/home?gid=4770082

CHAPTER 1. COMMUNITY MARKINGS

1 Robert Janes, *Museums in a Troubled World: Renewal, Irrelevance, or Collapse?* (New York: Routledge, 2009), 16.

2 "Inspiring the Next Generation Workforce: The 2014 Millennial Impact Report," Youth Economic Opportunities, accessed April 25, 2015, cdn.trustedpartner.com/docs/library/AchieveMCON2013/MIR_2014_ExecSummary.pdf

3 Douglas Worts, "Culture and Museums in the Winds of Change," *Reinventing the Museum:The Evolving Conversation on the Paradigm Shift*, Gail Anderson, ed. (Lanham, MD: AltaMira Press, 2012), 250–264.

4 Gregory Rodriguez, "Towards a New Mainstream," American Alliance of Museums, accessed April 15, 2015, www.aam-us.org/resources/center-for-the-future-of-museums/demographic-change

5 Doris Ashe and Judith Lombana, "Reculturing Museums: Working Toward Diversity in Informal Settings," *Journal of Museum Education*, 38:1(2013): 69–80.

6 "About Us," Cool Culture, accessed April 1, 2015, www.coolculture.org/about-us/about

7 Mark Weiner, "House Passes Bill That Establishes Harriet Tubman National Historical Park in Auburn," *Syracyuse.com*, December 4, 2014, accessed February 12, 2015, www.syracuse.com/news/index.ssf/2014/12/house_passes_bill_that_includes_harriet_tubman_national_historical_park_in_aubur.html

8 HOOKEDONHOUSES, August 12, 2011, "Houses as Art: The Heidelberg Project in Detroit," *Hooked on Houses Blog*, August 12, 2011, hookedonhouses.net/2011/08/12/houses-as-art-the-heidelberg-project-in-detroit

9 Lynn D. Dierking, "Being of Value: Intentionally Fostering and Documenting Public Value," *Journal of Museum Education*, 35:1 (2010): 9–20.

10 Ibid., 9–20 .

11 Randy C. Roberts, *Museums as Sites of "Being In Conversation": A Hermeneutic Phenomenological Study*, PhD Dissertation, Antioch University, June 2013, 7, aura.antioch.edu/cgi/viewcontent.cgi?article=1054&context=etds

12 Janine Marchessault, Chloe Brushwood Rose, Jennifer Foster, Aleksandra Kaminska, *LAND/SLIDE: Possible Futures* (Friesen, Canada: PUBLIC Books, 2015), 6.

13 Brandi Levine, email message to Franklin Vagnone, December 2014. One of the assets to this program was that Ms. Levine lives in the community the program was serving, allowing for a deep understanding of the need.

14 "Preservation Through Practice," Heritage Square Museum, accessed January 15, 2015, heritagesquare.org/events/programs/preservation-through-practice

15 Dierking, "Being of Value," 9–20.

16 Ibid., 9–20.

17 Randy C. Roberts, "Being, Being With, and Finding Connection in Conversation," *Museums and Social Issues*, 8:1 & 2 (2013): 89–101.

18 Dierking, "Being of Value," 12.

19 Roberts, "Being," 89–101.

20 J. Freedom du Lac, "Struggling to Attract Visitors, Historic Houses May Face Day of Reckoning," *Washington Post*, December 22, 2012, accessed January 12, 2015, www.washingtonpost.com/local/struggling-to-attract-visitors-historic-houses-may-face-day-of-reckoning/2012/12/22/349116b6-4b93-11e2-a6a6-aabac85e8036_story.html

21 Miranda Joseph, *Against the Romance of Community* (Minneapolis: University of Minnesota Press, 2002).

22 Frank Vagnone and Kevin Greenland, "Pedestrian and Carriage Visitors Passing Powel and Physick Houses: An Executive Summary" (unpublished study for the Philadelphia Society for the Preservation of Landmarks, 2007).

23 Eilean Hooper-Greenhill, *Museum and Gallery Education* (London: Leicester University Press, 1994).

24 Deborah Ryan and Franklin Vagnone, "The Anarchist Guide to Historic Rooms and House Museums," *ARCC Conference Repository*, North America, August, 2013, accessed April 25, 2015, www.arcc-journal.org/index.php/repository/article/view/140

25 Personal interview, Franklin Vagnone, July 25, 2015. Also see www.nytimes.com/2015/06/14/nyregion/the-memory-keeper-of-soho.html?_r=0

26 "Neighbor Doorknob Hanger: Hang and Share Resources, 2010," Candy Chang, accessed September 16, 2014, candychang.com/neighbor-doorknob-hanger/

27 Jane Jacobs, *The Death and Life of Great American Cities* (New York: Random House, 2011), 146.

28 Anwar Tlili et al.,"New Labour's Socially Responsible Museum: Roles, Functions and Greater Expectations," *Policy Studies*, 28:3 (2007): 269–289. doi:10.1080/01442870701437634.

29 Cangbai Wanga, "How Does a House Remember? Heritage-ising Return Migration in an Indonesian-Chinese House Museum in Guangdong, PRC," *International Journal of Heritage Studies*, January 13 (2013): 13.

30 Nina Simon, "Co-Creating with Visitors," *The Participatory Museum*, accessed November 1, 2014, www.participatorymuseum.org/chapter8

31 Amanda Loder, "Living Above the Past: Museum Opens Up to Tenants," National Public Radio Blog, August 19, 2012, accessed December 1, 2013, www.npr.org/2012/08/19/159037992/living-above-the-past-museum-opens-up-to-tenants

32 Kevin Hetherington, "Museums and the 'Death of Experience': Singularity, Interiority and the Outside," *International Journal of Heritage Studies*, 20:1(2014): 72–85, doi:10.1080/13527258.2012.710851.

33 "Thomas Hampson, Opera Singer," BBC HARDtalk, July 29, 2013, accessed April 1, 2015, www.youtube.com/watch?v=A8Nyc833IqA

34 "Opera Flash Mob," NUVO Indy, accessed September 1, 2014, www.youtube.com/watch?v=oxq48Lpb9Fw

35 "Les Misérables Flash Mob," Orlando Shakespeare Theater, accessed September 1, 2014, www.youtube.com/watch?v=Cn8PiqIXEjQ

36 "The Five Best—and Worst—Moments from 1,000 Random Acts of Culture™," Knight Arts, Accessed September 1, 2015, www.knightarts.org/community/the-five-best-and-worst-moments-from-1000-random-acts-of-culture and "Flash opera at Macy's," Philly.com, accessed September 1, 2014, www.philly.com/philly/video/106492678.html

37 *Opera Attendance Drops, Digital Engagement Rises*, National Public Radio WQXR Blog, September 22, 2013, WQXR Blog, www.wqxr.org/#!/story/report-opera-attendance-drops-digital-engagement-up/

38 Tammy S. Gordan, "Heritage, Commerce, and Museal Display: Toward a New Typology of Historical Exhibition in the United States," *The Public Historian* (2008): 27–50, and Lucie Matejková, "*Past to Present: Creative and Alternative Programming in Historic House Museums*," Thesis (M.A. in Arts Administration and Policy, School of the Art Institute of Chicago, 2009).

39 Larissa Zimberoff, "Salvage Supperclub: Feeding People, Not Landfills," *Civil Eats Blog*, December 31, 2014, accessed January 19, 2015, civileats.com/2014/12/31/salvage-supperclub-feeding-people-not-landfills

40 "Mobile Museum," FabricaFeatures, accessed January 5, 2015, www.fabricafeatures.com/2012/mobile-museum/

41 "100 Urban Trends: A Glossary of Ideas from the BMW Guggenheim Lab," BMW Guggenheim Lab, accessed August 5, 2015, www.bmwguggenheimlab.org/100urbantrends

42 Mike Lyndon et al., *Tactical Urbanism 2* (Miami: The Street Plans Collaborative, 2012), accessed February 22, 2013, issuu.com/streetplanscollaborative/docs/tactical_urbanism_vol_2_final

CHAPTER 2. COMMUNCATIONS MARKINGS

1 Robert M. Krauss, "The Psychology of Verbal Communication," in *International Encyclopedia of the Social & Behavioral Sciences*, ed. Neil Smelser and Paul Baltes, (Oxford: Pergamon, 2002).

2 Emily Dawson, "Not Designed for Us": How Science Museums and Science Centers Socially Exclude Low-Income, Minority Ethnic Groups, in *Science Education*, 98:6 (November 2014): 981–1008, onlinelibrary.wiley.com/doi/10.1002/sce.21133/abstract;jsessionid=BA320D2CA5B7781EBD5274653804A6A7.f04t03?deniedAccessCustomisedMessage=&userIsAuthenticated=false

3 Franklin Vagnone, *"The Formation of the Philadelphia Society for the Preservation of Landmarks"* (unpublished public lecture at the Powel House, Philadelphia, PA, 2007, based on Amy Elizabeth Hillier, "Redlining and the Home Owners' Loan Corporation" (PhD diss., University of Pennsylvania, January 1, 2001), repository.upenn.edu/dissertations/AAI3003637

4 theGrio, October 26, 2009, 11:40, "Uncle Remus Museum Still Grapples with Race Issues," *The Grio blog*, thegrio.com/2009/10/26/uncle-remus-museum-still-grapples-with-race-issues

5 Timothy Rawles, "Saving San Diego's LGBT historic sites," *SDGLN.com*, December 22, 2014, accessed January 5, 2015, sdgln.com/news/2014/12/22/saving-san-diego-lgbt-historic-sites#sthash.Gqwpealq.c8sK5ffr.dpbs

6 Nina Simon, "On White Privilege and Museums," *Museum 2.0 Blog*, March 6, 2013, museumtwo.blogspot.com/2013/03/on-white-privilege-and-museums.html. Italics ours.

7 "American Latino Heritage Fund Announces New Initiatives," National Park Foundation, accessed April 1, 2015, www. nationalparks.org/connect/npf-news/american-latino-heritage-fund-announces-new-initiatives

8 "Mobile Technology Fact Sheet," Pew Research Center, accessed on December 1, 2014, www.pewinternet.org/fact-sheets/mobile-technology -fact-sheet/

9 Mark Lopez, Ana Gonzalez-Barrera and Eileen Patten, "Closing the Digital Divide: Latinos and Technology Adoption, III. Cellphone Use," Pew Research Center, accessed on December 1, 2014, www.pewhispanic. org/2013/03/07/iii-cellphone-use/

10 Dejin Zhao and Mary Beth Rosson, "How and Why People Twitter: The Role that Micro-blogging Plays in Informal Communication at Work," *Proceedings of the ACM 2009 International Conference on Supporting Group Work* (New York: ACM, 2009), 244–252, pensivepuffin.com/dwmcphd/syllabi/insc547_wi13/papers/ microblog/zhao.rosson.Twitter.GROUP09.pdf

11 Mary Ann Giordano, "New Frontier for Topics in Science: Social Media," *New York Times*, January 1, 2013, accessed March 1, 2014, www.nytimes.com/2013/01/01/science/science-topics-go-viral-on-social-media.html?_r=1&

12 Michael Beschloss, "George Washington's Weakness: His Teeth," *New York Times*, January 1, 2013, accessed March 1, 2014, www.nytimes. com/2014/04/29/upshot/george-washingtons-weakness-his-teeth.html

13 "Commissioned Projects," the Happy Museum, accessed April 1, 2015, www.happymuseumproject.org/?page_id=500

14 Stephen D. Brookfield and Stephen Preskill, *Discussion as a Way of Teaching: Tools and Techniques for Democratic Classrooms* (San Francisco: John Wiley & Sons, 2005).

15 Jan Meyer and Ray Land, *Threshold Concepts and Troublesome Knowledge: Linkages to Ways of Thinking and Practising within the Disciplines* (Edinburgh: University of Edinburgh, 2003).

16 "Come, Sit a Spell: Memories from a Forgotten Neighborhood," Providence Public Library, accessed April 1, 2015, www.provlib.org/events/come-sit-spell-memories-forgotten-neighborhood

17 Pravina Shukla, *Costume: Performing Identities through Dress* (Bloomington: Indiana University Press, 2015), 15.

18 Angeline S. Lillard et al., "The Impact of Pretend Play on Children's Development: A Review of the Evidence," *Psychological Bulletin,*139:1 (2013): 1–34.

19 Rahel Gruninger et al., "Fragile Knowledge and Conflicting Evidence: What Effects Do Contiguity and Personal Characteristics of Museum Visitors Have On Their Processing Depth," *European Journal of Psychology of Education,* 29:2 (2014): 215–238.

20 Neil Genzlinger, "Homies in Verona, Gangstas in Elsinore: Thug-Notes and Other Sites Translate Literature Into Rap," *New York Times,* January 24, 2014, accessed February 1, 2014, www.nytimes.com/2014/01/25/arts/thug-notes-and-other-sites-translate-literature-into-rap.html?_r=0

21 Darby Maloney and Cameron Kell, "'Hamilton Is the Talk of New York Theater," *The Frame Blog,* February 19, 2015, accessed on April 15, 2015, www.scpr.org/programs/the-frame/2015/02/19/41610/hamilton-is-the-talk-of-new-york-theater/

22 "Ask A Slave: The Web Series," accessed April 1, 2015, www.askaslave.com/about-azie.html. Italics ours.

23 Thomas Hawk, "The Dunsmuir Estate's Bait and Switch Admission Scam," *flickr blog,* August 2, 2009, accessed December 15, 2014, www.flickr.com/photos/thomashawk/3783052742/, permission granted.

24 Nina Simon, "Avoiding the Participatory Ghetto: Are Museums Evolving with Their Innovative Web Strategies?" *Museum 2.0,* April 20, 2009, accessed on January 15, 2013, museumtwo.blogspot.com/2009/04/avoiding-participatory-ghetto-are.html

25 Nina Simon, "Avoiding the Participatory Ghetto," 2009.

26 Malandinara, "Bait and Switch: Review of Whitney Museum of American Art," *TripAdvisor Blog,* October 26, 2007, accessed April 20, 2014, www.tripadvisor.com/ShowUserReviews-g60763-d106189-r10362932-Whitney_Museum_of_American_Art-New_York_City_New_York.html

27 Likesheet, "Bait and Switch," *TripAdvisor Blog,* June 14, 2011, accessed April 20, 2014, www.tripadvisor.com/ShowUserReviews-g60954-d103632-r113409624-Salem_Witch_Museum-Salem_Massachusetts. html

28 Chris Hubbuch, "1970s Museum Display Targets GenX Audience," *LaCrosseTribune.com,* November 14, 2014, 00:00, accessed December 15, 2014, lacrossetribune.com/news/local/s-museum-display-targets-genx-audience/article_733e2386-a1a8-564b-9df0-988d52f5391c.html

29 Peter High, "Forrester: Top Technology Trends for 2014 and Beyond," *Forbes Magazine Blog,* November 25, 2013, 8:21, accessed December 15, 2014, www.forbes.com/sites/peterhigh/2013/11/25/forrester-top-technology-trends-for-2014-and-beyond/

30 Paula J. Owen, "Fitchburg Art Museum One of First in New England to Go Bilingual," *NEWS telegram.com,* August 27, 2014, accessed/December 15, 2014, www.telegram.com/article/20140827/NEWS/308279519/1116?utm_content=buffer2a9b3&utm_medium=social&utm_source=twitter.com&utm_campaign=buffer

31 Frances Picabia, *I Am a Beautiful Monster, Poetry, Prose, and Provocation,* Marc Lowenthal, trans. (Cambridge, MA: MIT Press, 2007), 302. If read upside and backward, the philosophic basis for the *Anarchist's Guide to Historic House Museums* may become apparent.

32 Curtis Bunn, "Historic House of the Civil Rights Movement in Selma Is Rotting," *Atlanta Black Star,* January 2, 2015, accessed February 4, 2015, atlantablackstar.com/2015/01/02/historic-house-civil-rights-movement-selma-rotting/

33 Victor, "Hitler's Birthplace in Braunau am Inn: Austria Agonises Over the Building's Future," *Brittania Blog,* December 31, 2014, 23:09, accessed February 4, 2015, southendpatriot.blogspot.com/2014/12/hitlers-birthplace-in-braunau-am-inn.html

34 Coimbatore K. Prahalad and Venkat Ramaswamy, "Co-creating Unique Value with Customers," *Strategy and Leadership,* 32:3 (2004): 4–9.

CHAPTER 3. EXPERIENCE MARKINGS

1 Maura Craig, *Maya Angelou: 365 Quotes and Sayings of Phenomenal Woman* (BOOKSReadr Ebook), accessed December 15, 2014, books.google. com/books?id=UKiiBAAAQBAJ&printsec=copyright&source= gbs_pub_info_r#v=onepage&q&f=false

2 Hans-Georg Gadamer, *Truth and Method*, J. Weinsheimer and D. Marshall, trans. (New York: Continuum, 1989).

3 Quoted in Eugenio Donato, "The Museum's Furnace: Notes Toward a Contextual Reading of Bouvard and Pecuchet," 221, in Josue Harari, ed., *Textural Strategies: Perspectives in Post Structural Criticism* (Ithaca, NY: Cornell University, 1979), 214.

4 Kevin Hetherington, "Museums and the 'Death of Experience': Singularity, Interiority and the Outside," *International Journal of Heritage Studies,*" 20:1 (2014): 82.

5 Michael Morpurgo, "Rules for Writers," *Guardian*, last modified June 16, 2014, 20.00, accessed April 1, 2015, www.theguardian.com/ books/2010/feb/23/michael-morpurgo-rules-for-writers

6 "Elizabeth Edwards," BrainyQuote.com, accessed March 29, 2015, www.brainyquote.com/quotes/quotes/e/elizabethe474239.html

7 Georges Perec, *An Attempt at Exhausting Place in Paris* (Cambridge, MA: Wakefield Press, 2010), 5.

8 Claire Robins, "After-Image: The Museum Seen through Fiction's Lens," *Photographies*, 7:2 (2014), 158. doi: 10.1080/17540763.2014.930921.

9 Tamara Kisha Tan, "57 Years of Marriage Celebrated in Photo Series," *Design Taxi*, March 16, 2013, accessed January 1, 2015, designtaxi. com/news/356571/57-Years-Of-Marriage-Celebrated-In-Photo-Series/?interstital_shown=1

10 Franklin Vagnone, "Perhaps a bit of humor, conjecture and out-right lies is "OK"? What do you think?" *Anarchist's Guide to Historic House Museum Discussion Group Blog*, August 19, 2013, www.linkedin.com/ grp/post/4770082-266876828

11 Jeff Riggenbach, "Conjecture and History," *MISES INSTITUTE*, August 5, 2011, accessed January 5, 2015, mises.org/library/ conjecture-and-history

12 "Lincoln's Bedroom," Skylar Fein, accessed January 15, 2014, skylarfein. tumblr.com/post/64364786779

13 Douglas Feiden, "Corset Shows: Artist Reimagines Beauty of Burr's Loves," *New York Daily News*, April 26, 2013, accessed April 30, 2013, www.nydailynews.com/new-york/uptown/corset-shows-artist-re-imagines-beauty-burr-loves-article-1.1328096

14 Ibid.

15 Eva-Maria Reuter et al., "Effects of Age and Expertise on Tactile Learning in Humans," *European Journal of Neuroscience*, 40 (2014): 2589–2599.

16 "An Interactive Exhibit Chronicles the History of Building Blocks," Fastco Design, November 27, 2012, accessed January 5, 2015, www. fastcodesign.com/1671326/an-interactive-exhibit-chronicles-the-history-of-building-blocks?goback

17 Jay D. Vogt, ed., "The Kykuit II Summit: The Sustainability of Historic Sites," *History News*, (2007): 21, accessed January 19, 2013, download. aaslh.org/history+news/VogtHNSmr07.pdf

18 Michelle Moon, January 8, 2013, comment on Franklin Vagnone, "Guided Tours of historic house museums, mixed Feelings? What does research say?" *The Anarchist's Guide to Historic House Museums Blog*, January 4, 2013, www.linkedin.com/groupAnsw ers?viewQuestionAndAnswers=&discussionID=201059659& gid=4770082&commentID=112320286&trk=view_disc&fro mEmail=&ut=3Ix0cxDb4NHSI1; www.linkedln.com/groups/ Anarchist-Guide-Historic-House-Museums

19 Randy C. Roberts, "Being, Being With, and Finding Connection in Conversation," *Museums and Social Issues*, 8:1 & 2, (2013): 89–101.

20 Catherine M. Cameron and John B. Gatewood, "Seeking Numinous Experiences in the Unremembered Past," *Ethnology* (2003): 55–71.

21 Jay D. Vogt, ed., "The Kykuit II Summit: The Sustainability of Historic Sites," *History News* (Autumn 2007): 21, accessed January 19, 2013, download.aaslh.org/history+news/VogtHNSmr07.pdf

22 Randy C. Roberts, "Questions of Museum Essence: Being, Being With

and Finding Connection in Conversation," *Museums and Social Issues,* 8:1 & 2 (2013): 89–101.

23 Abigail Hackett, "Zigging and Zooming All Over the Place: Young Children's Meaning Making and Movement in the Museum," *Journal of Early Childhood Literacy,* 14:1 (2014): 5–27. doi: 10.1177/1468798412453730.

24 Ibid, 23.

25 Ibid.

26 Ibid.

27 Hans-Joachim Klein, "Tracking Visitor Circulation in Museum Settings," *Environment & Behavior,* 25 (1993): 782–800.

28 Martin Tröndle et al., "An Integrative and Comprehensive Methodology for Studying Aesthetic Experience in the Field: Merging Movement, Tracking, Physiology, and Psychological Data," *Environment and Behavior,* August 9, 2012. doi: 10.1177/0013916512453839.

29 Siobhan Burke, "Always Moving, Even in One Place: A Museum Show for Aunts, the Roving Dance Party," *New York Times,* December 19, 2014, accessed January 1, 2015, www.nytimes.com/2014/12/21/arts/dance/a-museum-show-for-aunts-the-roving-dance-party.html?_r=0

30 Ibid.

31 "Then She Fell," Third Rail Projects, accessed April 1, 2015, thenshefell.com/info

32 "Morris Jumel Mansion Pilot Research Project," Historic House Trust of New York City, October 11–14, 2014, unpublished.

33 Franklin Vagnone, "How Rudolph Schindler's bathroom changed my life," Twisted Preservation: An intimate portfolio of ideas by the Museum Anarchist, August 10, 2014, twistedpreservation.com/2014/08/10/how-rudolph-schindlers-bathroom-changed-my-life

34 Jonathan Metzl, "From Scopophilia to Survivor: A Brief History of Voyeurism," *Textual Practice,* 18:3 (2004): 415–434.

35 "Saskia Olde Wolbers: Yes, these Eyes are the Windows (2014)," Artangel, accessed December 1, 2014, www.artangel.org.uk/

projects/2014/yes_these_eyes www.artangel.org.uk//projects/2014/ yes_these_eyes/about_the_project/yes_these_eyes

36 Ibid.

37 Becky Barnicoat, "Jeffrey Brown: a Look Inside the Cartoonist's Sketchbook—in Pictures," *Guardian*, August 16, 2013, 18.50, accessed November 1, 2014, www.theguardian.com/books/gallery/2013/aug/16/ jeffrey-brown-sketchbooks-in-pictures

38 F. T. Marinetti, "The Joy of Mechanical Force," *The Foundation of Futurism*, University of Pennsylvania, accessed January 30, 2015, www. english.upenn.edu/~jenglish/English104/marinetti.html

39 Fiona Candlin, *Art, Museums and Touch* (Manchester, UK: Manchester University Press, 2010).

40 Jack Neely, "The Anarchist Guide," *Jack Neely: The Scruffy Citizen*, November 13, 2014, accessed November 30, 2014, jackneely.com/ wordpress/2014/11/13/the-anarchist-guide/

41 Sally Wagner, "EVERYTHING is available for you to interact with— including the most valuable thing we have—Gage's original desk," *The Anarchist Guide to Historic House Museums Blog*, January 6, 2013, www. linkedin.com/grp/post/4770082-201540186

42 "THE LULLABY FACTORY," StudioWeave, accessed January 30, 2015, www.studioweave.com/projects/detail/lullaby-factory/

43 Mark Prigg, "The macabre museum exhibit designed to recreate the smell and sounds of the deaths of JFK, Princess Diana and even Whitney Houston," *DailyMail.com*, updated December 27, 2014, 07:09, accessed December 30, 2014, www.dailymail. co.uk/sciencetech/article-2887903/The-macabre-museum- exhibit-designed-recreate-smell-sounds-deaths-JFK-Princess-Diana- Whitney-Houston.html#ixzz3YoeiMGUS

CHAPTER 4. COLLECTION/ENVIRONMENT MARKINGS

1 Hilde S. Hein, *The Museum in Transition* (Washington DC: Smithsonian Books, 2000), Chapter 4.

2 Ibid., 55–56.

3 "Darren Waterston: Uncertain Beauty," MASS MoCA, accessed February 1, 2015, www.massmoca.org/event_details.php?id=847

4 Susana Dinis et al., "Evaluating Emotional Responses to the Interior Design of a Hospital Room: A Study in Virtual Reality," *Design, User Experience and Usability*, 8014 (2013): 475–483.

5 Stephen Kaplan et al., "The Museum as a Restorative Environment," *Environment and Behavior*, 25 (2013): 725.

6 Andrew D. Scrimgeour, "Handle with Care," *New York Times*, December 28, 2012, accessed January 15, 2014, www.nytimes.com/2012/12/30/books/review/handled-with-care.html?pagewanted=all&_r=1&

7 Ellen Gamerman, "EveryBody's an Art Curator: As More Art Museum Outsource Exhibits to the Crowd, Is It Time to Rethink the Role of the Museum?" *Wall Street Journal*, October, 23, 2014.

8 Orhan Pamuk, *The Innocence of Objects*, (New York: Abrams, 2012), 15.

9 Martin Heidegger, *What Is a Thing?* (South Bend, IN: Gateway Editions, 1967).

10 Pedro E. Guerrero, *Calder at Home: The Joyous Environment of Alexander Calder* (New York: Stewart, Tabori & Change, 1998), Introduction.

11 "Inside the Collyer Brownstone: The Story of Harlem's Hermits and Their Hoarding," *New York Daily News*, accessed April 1, 2014, www.nydaily news.com/new-york/collyer-brothers-brownstone-gallery-1.1187698?pmSlide=1.1187690

12 Neil Harris, "Period Rooms and the American Art Museum," *Winterthur Portfolio*, 46:2/3 (2012).

13 Mary S. Lockwood and Emily Lee Sherwood, *Story of the Records, D.A.R.* (Washington, DC: George E. Howard, 1906), 24, accessed April 1, 2012, archive.org/details/storyofrecordsda00lock

14 R. W. Emerson, *Representative Men: Seven Lectures* (New York: Hurst, 1850).

15 Nina Simon, "On White Privilege and Museums," *Museum 2.0 Blog*, March 6, 2013, museumtwo.blogspot.com/2013/03/on-white-privilege-and-museums.html

16 John Hanc, "At Historic Homes, Unearthing a Deeper View of Slavery," *New York Times*, November 3, 2013, accessed January 19, 2014, www.telegram.com/article/20131103/NEWS/311039936/1052

17 Brian Kaszuba, "Council Member Calls for Designation of Jackie

Robinson's Former Brooklyn Home," *CityLand,* May 1, 2014, accessed January 20, 2015, www.citylandnyc.org/council-member-calls-for-designation-of-jackie-robinsons-former-brooklyn-home

18 Douglas J. Herrmann et al., eds., *Basic and Applied Memory Research: Volume 1: Theory in Context: Volume 2* (London: Psychology Press, 1996), 319, italics in original.

19 Claire Robbins, "After Image: The Museum Seen through Fiction's Lens," *Photographies* 7:2 (2014): 149–162.

20 Ibid.

21 Mac King, "New York's Smallest Piece of Private Land," *My FoxNY,* updated August 7, 2014, 19:13, accessed September 1, 2014, www.myfoxny.com/story/26167597/new-yorks-smallest-piece-of-private-land#.U9xsqyF-N-o.facebook

22 John Yong, "Japan Turns Last Surviving Tree from the 2011 Tsunami into a Massive Sculpture," *Taxi,* March 13, 2013, accessed April 15, 2014, designtaxi.com/news/356469/Japan-Turns-Last-Surviving-Tree-From-The-2011-Tsunami-Into-A-Massive-Sculpture/?interstital_shown=1

23 Doreen Carvajal, "Paris Falls Out of Love with the Padlocks on Its Bridges," *New York Times,* September 20, 2014, accessed November 15, 2015, www.nytimes.com/2014/09/21/world/europe/paris-falls-out-of-love-with-the-padlocks-on-its-bridges.html?_r=1

24 "Struggling Museum Now Allowing Patrons to Touch Paintings," *ONION,* October 5, 2009, accessed April 1, 2013, www.theonion.com/articles/struggling-museum-now-allowing-patrons-to-touch-pa,2821

25 Edwin Slipek, "Time Warp: The Wilton House Museum Goes Contemporary with an Art Show Featuring the 18th and 21st Centuries Happily Coexisting," *Style Weekly,* January 6, 2015, accessed January 10, 2015, www.styleweekly.com/richmond/time-warp/Content?oid=2162732

Chapter 5. Shelter Markings

1 Writing in anonymity, a prominent international preservation conservator, e-mail message to Franklin Vagnone, November 14, 2014.

2 Econsult, *The Economic Impact of Historic Preservation in Philadelphia,*

Philadelphia: Preservation Alliance of Greater Philadelphia, 2010, accessed April 15, 2014, www.preservephiladelphia.org/wp-content/uploads/Econ_Report_Final.pdf

3 Loke Shi Ying, "Soon-to-Be Demolished Buildings Brought Back to Life With Digital Art," *Taxi*, March 6, 2013, accessed April 1, 2014, designtaxi.com/news/356327/Soon-To-Be-Demolished-Buildings-Brought-Back-To-Life-With-Digital-Art/?interstital_shown=1

4 Christopher Jobsen, "Fifty Street Artists Descend on Condemned Parisian Nightclub 'Les Bains,'" *Colossal: Art, Design and Visual Culture*, April 24, 2013, accessed May 1, 2013, www.thisiscolossal.com/2013/04/fifty-street-artists-descend-on-condemned-parisian-nightclub-les-bains

5 The Manifesto," The Society for the Protection of Ancient Buildings, accessed April 1, 2014, www.spab.org.uk/what-is-spab-/the-manifesto

6 Ibid.

7 Paul Valéry and William Stewart, *Eupalinos: Or, the Architect* (London: Oxford University Press, 1932), 21.

8 Paul Reber, personal conversation with Franklin Vagnone, March 11, 2015. Special thanks for his thoughts on this *AGHHM* marking.

9 "More than a house," Drayton Hall, accessed April 15, 2015, www.draytonhall.org

10 "William Aiken House," Charleston, SC, accessed April 15, 2015, www.charleston-sc.com/william-aiken-house.html

11 "International Charter for the Conservation and Restoration of Monuments and Sites (the Venice Charter 1964)," International Congress on Monuments and Sites, Article 11, accessed April 15, 2014, www.icomos.org/charters/venice_e.pdf

12 Jack McLaughlin, *Jefferson and Monticello: The Biography of a Builder* (New York: Henry Holt and Company, 1990), 383.

13 William Peden, "A Book Peddler Invades Monticello," *The William and Mary Quarterly*, 6:4 (1949): 631–636.

14 McLaughlin, *Jefferson and Monticello*, 383.

15 Nathan Silver, "Lost New York Regained: Transformational Conservation," lecture given for the New York Preservation Archive Project, Bard Birthday Breakfast Benefit, New York City, December 10, 2014.

16 Writing in anonymity, a prominent international preservation conservator, e-mail message to Franklin Vagnone, November 22, 2014.

17 Katy Lomas and Paul Ring, "Restoration: Authenticity and Deception," *Built and Natural Environment Research*, 5 (2012): 41–51.

18 Sara Dillard Pope, interview with Franklin Vagnone, December 10, 2014.

19 Virginia Lee Burton, *The Little House* (Boston: Houghton Mifflin, 1942).

20 "Smart Growth America: Making Neighborhoods Great Together," accessed January 18, 2012, www.smartgrowthamerica.org

21 Isabel Bird, "Remains of the Day Spotted," *Examiner,* January 26, 2014, accessed January 30, 2014, www.examiner.com.au/story/2046144/remains-of-the-day-spotted

22 "Urbexography," accessed January 26, 2014, www.urbexography.com/about

23 "The Dollhouse," Heather Benning, accessed March 5, 2014, www.heatherbenning.ca/the-dollhouse.html

24 Maymanah Farhat, "Amal Kenawy (1974–2012)," Jadaliyya, accessed March 10, 2014, www.jadaliyya.com/pages/index/7182/amal-kenawy-(1974-2012)

25 Randal Mason, "Fixing Historic Preservation: A Constructive Critique of 'Significance.'" *Places,* 16:1 (2003): 64–71.

26 Special thanks to Lisa Ackerman for guiding our understanding of the early formation of the Tenement Museum.

27 "Tenement Museum," accessed January 19, 2015, www.tenement.org/shoplife.html

28 "Stanford Hospital Revisited," Treasure Hunt: National Trust Collections, accessed December 5, 2014, nttreasurehunt.wordpress.com/2014/05/23/stamford-hospital-revisited

29 Stanley Tigerman, *The Architecture of Exile* (New York: Rizzoli International, 1988), 9.

APPENDIX A: *ANARCHIST CHART* EVALUATION QUESTIONS

1 en.wikipedia.org/wiki/Community
2 en.wikipedia.org/wiki/Communication
3 www.merriam-webster.com/dictionary/experience
4 www.merriam-webster.com/dictionary/collection
5 www.merriam-webster.com/dictionary/shelter

APPENDIX B: RESEARCH TOOLS

1 Data: continuing data collection, *Anarchist Guide to Historic House Museums,* as of 2014.

2 Special thanks goes to all of the executive directors, staff, and board representatives who allowed us such unprecedented access, photographed the Tags in situ, and took the time to compile the data: Calvin Chappelle (Mabry-Hazen House, Knoxville, TN), Ilene Frank (Rensselaer Historic Society/Hart-Cluett House, Troy, NY), Conrad Hanson (Clermont Historic Site, Germantown, NY), Jonathan Poston (Hay House, Macon, GA), Carol Ward (Morris Jumel Mansion, New York City).

3 Ibid.

INDEX

A

abandoned houses, 50, 173
Abbott, Rachel, 31, 67, 81
Ackerman, Lisa, 27, 29, 244
advertising, 77, 89–91, 136, 188
African-American, 50, 73, 78, 132
aging, 11, 38, 159, 162, 196
Aiken-Rhett House, 159
Alice Austen House, 30
Alice's Adventures in Wonderland, 120
American Alliance of Museums (AAM),
 39, 230
American Folklife Center at the Library of
 Congress, 83
American for the Arts: Arts Index, 68
Anarchist Chart/Evaluation Matrix, 43, 45,
 181–183, 185, 187, 189, 191, 193, 195,
 197, 245
Anarchist Tags, 88, 94, 96, 121, 130, 142,
 215, 216, 217, 220
Anarchist Workshops, 25–26, 88, 106,
 119, 123, 125–126, 130, 142, 153, 207,
 216–221
An Attempt at Exhausting a Place in Paris,
 106, 237
Anderson, Max, 89
Anti-Scrape Society, 159
Anywhere but Now, 153
Arcades Project, 67–68,
architectural
 alterations, 158; drawings, 19;
 history canons, 176; masterpiece,
 161; value, 156
architecture, 19, 24–26, 29, 31, 41, 62, 69,
 89, 104, 125, 130, 134, 138, 144, 150,
153, 158, 161–162, 168, 173–174, 179,
184, 188, 190, 193–194, 196, 200–201,
209–211, 213, 224–225, 244, 256
The Architecture of Exile, 179, 244
archive(s), 19, 20, 29, 78, 82, 104,122, 241,
 243
artifacts, 9, 36, 41, 45, 50–51, 55, 67,
 80–81, 89, 93, 103–104, 114–115,
 130–136, 145, 151, 162–163, 168, 174,
 178, 204, 211, 216, 224
artists, 26, 52, 62, 67, 118, 139, 157, 243
Art This House, 152
Ask a Slave, 86, 87, 235
attic, 16, 20, 23, 79–80
audience, 13, 47, 49, 58, 59, 60, 61, 68, 69,
 70, 78, 82, 111, 118, 123, 149, 179, 222,
 255
AUNTS Group, 118, 119, 239
Austen, Alice, 73, 75
Austenland, 113
authenticity, 13, 34, 85, 104, 144, 165, 244
Avery Library, 19, 20

B

background(s), 58, 83, 107, 202, 214, 255
Baird, Seth, 126
bait and switch 5, 44, 89, 91, 188, 235, 236
Ballantine House, 30, 92
barriers, 8, 13, 49, 94, 118
basement, 20, 23, 79, 80, 219
Battaile, Chandler 39, 229
The Beautiful and Damned, 34, 227
behaviors, 19, 43, 46, 93, 102, 114, 139,
 145, 194, 199, 204
behind-the-scenes, 16, 124, 222

Bender, Kimberly, 30, 163
Benitez-Ruiz, Paula, 69
Benning, Heather, 28, 173, 244
Bernie Michels House, 73
best practices, 38, 42, 46, 72, 137, 158, 201
Between Worlds, 151
Billy Graham House, 202, 211
BMW Guggenheim Lab, 69, 233
board of directors, 11, 26, 29, 58, 72, 156, 163, 171, 255
Bober, Natalie S., 110
Bollo, Aracelli, 104, 168
Bosely, Ted, 149
Boujoulian, Dan, 77
Boynton, Amelia Platts, 99
British Society for the Preservation of Ancient Buildings, 159
Brown-Nesbit, Parker, 105
Burckhardt, Jacob, 37
Burns, Ken, 110
Burroughs, William S., 108–109
Burton, Virginia Lee, 168, 244

C
c24gallery, New York City, 110
cabinet of curiosities, 224
Cairnwood, 19, 20
Calder, Alexander, 135, 241
Carol Ward, 31, 47, 49, 94, 111, 217, 245
Carpenter, Laura, 32, 79
Carried Away, 224
Cejka, Ann, 112
cell phone, 17, 58, 77, 78, 234
census, 58, 139
Center for Public Humanities, Brown University, 97
Center for the Future of Museums (CFM), 48, 230
Century Speaks, 83
Chang, Candy, 61, 231
chaos, 5, 119, 169
Chappelle, Calvin, 31, 218, 219, 220, 245
character, 18, 44, 111, 170, 202,
Characteristics of Excellence for U.S. Museums, 39
characters, 78, 102, 104, 106, 107, 138, 140, 194

Charlotte Community Design Studio, 24, 256
chimney, 21, 96, 177
Christchurch Normal School Campus, 157
Christmas in 1850, 153
Citizens Advisory Group (CAG), 83
Civil Rights Movement, 73, 236
Clivden, Germantown, 64
closets, 20, 123, 134, 206
co-creating, 65, 232, 236
collaboration(s), 63, 64, 115, 151
collaborative, 32, 38, 42, 69, 119, 233, 255
collections, 6, 8, 12, 19, 25, 35, 41, 43–46, 51, 64, 67, 81, 88, 103–104, 115, 124–127, 129, 131–139, 141, 143, 145, 149–151, 153, 156, 173–174, 181, 187, 193, 202, 204, 214–215, 219, 244
College of Arts and Architecture, University of North Carolina Charlotte (UNCC), 26, 200, 209, 211, 225
Collyer Brothers, 136, 241
Colonial America, 125, 151
Colonial Williamsburg, 23, 128
Coltrane, John, 12
Columbia University, 19, 25, 178, 202, 206, 216, 227, 256
Columbus Circle, 165
Come Sit a Spell: Memories from a Forgotten Neighborhood, 82, 235
communication(s), 6, 38, 44, 46, 55, 59, 61, 64, 71–73, 75, 77–81, 83–85, 87–89, 91, 92, 93, 95–99, 106, 181–198, 204, 221–223, 233, 234, 245
community, 5, 10–13, 19, 20, 24–26, 29, 32, 39, 43, 44, 46–61, 64–67, 69, 72, 73, 76, 80, 81, 83, 91, 100, 133, 140, 141, 157, 158, 167, 169, 181–197, 204, 209, 221, 223–225, 229–232, 245, 255, 256
 building, 25, 44, 50–51, 60, 63, 66, 81, 83, 91, 223, 256; centered perspective, 53, 169; design, 24, 169, 256; goals, 25, 50, 54, 65, 167, 184; engagement, 13, 25, 44, 51, 61, 63, 65, 66, 69, 76, 158, 192, 223–225, 255, 256; meetings, 61, 66, 67, 141, 187, 223; methods, 39, 43, 50, 61, 188, 194, 225; needs, 12, 13, 19,

50, 52–54, 59, 65, 67, 69, 76, 140, 141, 183, 184, 195; organizations, 48, 49, 53, 63, 64–67, 72, 73, 76, 80, 167, 183, 185, 186, 255; outreach, 24, 65, 67, 70, 82, 91, 187, 223, 256; planning process, 5, 61, 221, 256; programming, 61, 133, 185, 255; stewards, 20, 39, 41, 53; use, 13, 51, 167, 184, 188, 190, 204, 223
complexity, 9, 43, 88, 131–137
of domestic life, 135, 136, 144; of habitation, 193
conjecture(al), 6, 8, 36, 44, 72, 108, 159–161, 164–167, 182, 191, 237
habitation, 102; histories, 109; possibilities, 111; relationships, 75; reproduction, 164–165
conservation, 38, 41, 61, 145, 159–163, 165–167, 174, 175, 202, 243
as an ongoing process, 166; deceptive practices, 41; spectrum, 159; variation, 161
conservator, 129, 155, 158, 165, 242, 244
contemporary art, 36, 37, 62, 119, 136, 149–154, 168, 173, 195, 217
contemporary interpretations
of collections, 6, 8, 45, 149, 150, 152, 179, 195; reflections, 149, 195; street life, 168; subversions, 151
context(ual), 9, 25, 43, 48, 53, 59, 62, 64, 65, 82, 104, 117, 130, 131, 133, 135, 143, 150, 151, 168–171, 202, 208, 214, 216, 230, 237, 242
awareness, 48, 82; cues, 143; dissonant, 170; juxtaposition, 8, 102, 169, 179
continuing education, 93
Cook, Elon, 171
cool culture, 49, 230
Coons, Bruce, 73
Cooperstown Graduate Program, 5, 14, 25, 29, 138, 202
cosmetics, 45, 171, 172, 174, 197
costume, 7, 23, 44, 84–88, 113, 114, 214, 235
Cothren, Olivia, 3, 4, 26, 28, 142, 206, 225
crowd sourced, 94–95, 131, 133

cultural(ly), 11, 15, 25, 37, 41, 32, 48–50, 57, 60, 64, 67, 68, 70, 72, 76, 89, 91, 103, 116, 141, 149, 176, 185, 187, 229, 255, 256
center, 48, 57, 60, 68, 72, 185; disconnect, 49–50; diversity, 72, 76, 141, 187, 229; elite, 48, 68; old-fashioned, 12, 41, 59
Curry, Jessica, 128
cycles, 8, 50, 57, 142, 144, 145, 159, 167, 194, 224
of life and death, 8, 142, 144, 159, 194; of the sun, 142, 145, 194; of use, 57, 145

D

daily behaviors/rhythms/life, 45, 51, 107, 142–145, 161, 194, 203, 214, 241
Dana, John Cotton, 51
Daughters of the American Revolution (DAR), 23, 139
Dawson, Emily, 72, 233
decay, 33, 45, 140, 161, 162, 167, 168, 170
de-centralizing the HHM experience, 133, 216, 218
Declaracion, 125
declining attendance, 39, 68, 91, 96
decorative arts, 71, 151, 171, 172, 174
Dennis Severs House, 36, 10
demographic(s), 12, 39, 54, 57, 58, 70, 71, 76, 139–141, 168, 184, 187, 204, 230
denied spaces, 45, 120–123, 192, 217
DePew, Candy, 151
detritus of habitation, 134, 136–137, 144, 203
Deuchars, Marion, 61
Dickerson, Patrick, 57
Dietz, Ulysses, 27
digital media, 68, 91, 147
Dilling, Matt, 154
Discovering Columbus, 165
distinct activities, 6, 9, 94, 105, 117, 145, 182, 207–209
diversity, 71, 76, 187
of audiences, 49; of communication, 186; of docents, 97; of neighborhood, 141, 186

docent(s), 5, 8, 9, 17–19, 44, 85, 87, 92–95,
 97, 108, 111–113, 115, 117, 125, 127
 boring, 17, 44, 108, 111, 112,
 125; communication, 5, 87, 92;
 costumed, 85;
 shaming, 19; tours, 97, 112, 113,
 115, 117
dollhouse, 41, 171, 173–174, 197
domestic(ity), 143–144, 207
 complexity, 45, 134–136, 193;
 decay, 170; dwellings, 36, 38, 130,
 203; experience, 37, 130, 209;
 history, 40; items, 19, 224; quirky, 80
Domesticating History, 40
Downton Abbey, 84
Drabik, Caroline R., 101
Drayton Hall, 159
Dungey, Azie, 86
Dunham Massey House, 178
DuPont, William and Anne, 177–178
Dyckman Farmhouse Museum, 57, 134, 202

E
Eames House, 30
economic(s) of preservation, 41, 160, 195
Edwards, Elizabeth, 106, 237
Edwards, Greg, 86
Elcin, Marie H., 151
embrace complexity, 134
 interaction, 129, 193; rumor, gossip,
 and conjecture, 108, 182, 191
Emerson, Ralph Waldo concept of
 'representative men,' 139, 241
emotional engagement, 89, 133, 143, 146, 216
 abstraction, 142; experience(s),
 35, 89, 105, 131, 189, 133, 142, 143,
 146, 189, 216, 241; response(s), 35,
 131, 241
engage(ment), 5–8, 11, 13, 39–41, 45, 48,
 63, 65–70, 76, 78, 81, 89, 93, 94, 99,
 102, 109, 112, 113, 115–117, 119, 120,
 124, 126, 127, 128, 131, 133, 137, 143,
 146–149, 153, 176, 166, 172, 182, 185–
 187, 201, 202, 207–208, 210, 216–217,
 219, 223–225, 232, 255–256
 bottom-up, 69; civic, 25, 51, 108,
 224, 256; of communities, 25,

38–39, 44, 51, 55, 61, 80, 158, 185,
 223; in deceptive conservation
 practices, 41; in Propaganda, 40;
 new audiences, 70, 149,179; the
 senses, 6, 45, 124, 126–128, 182
 192; the uninterested, 5, 7, 58,
 184, 185; in truth stretching, 109;
 a wider audience, 65; with the
 environment, 185, 192, 197, 208, 217
English as a second language, 51, 58, 66
Eristy, Steven, 129
ethnic(ity), 49, 58, 76, 139, 216, 233
everyday living, 100, 144, 145
exclusion(ary), 72, 86, 122, 145
executive director, 26, 27, 29, 37, 40, 47, 49,
 64, 73, 79, 89, 94, 111, 134, 139, 144,
 149, 163, 165, 167, 175, 200, 217, 218,
 219, 220, 245, 255
exhibition, 52, 60, 62, 69, 70, 80, 82, 110,
 111, 131, 151, 152, 153, 157, 195, 201,
 202, 232
experience(s), 6, 12, 15–20, 23, 34,
 35–37, 39, 41–46, 50, 59, 65, 67–68,
 72, 80–82, 84–89, 91, 92, 94, 97, 101,
 103, 105–109, 111–128, 131, 133, 134,
 136, 137, 141–143, 145–150, 156, 163,
 165, 167, 173–179, 181, 182, 184–199,
 201, 204–211, 214–222, 227, 228, 232,
 237–239, 241, 245, 255
 based projects, 150; the HHM as
 a home, 8, 9, 19, 20, 25, 35, 62, 85,
 117, 125, 136, 137, 143, 145, 163,
 165, 175, 193, 205, 206–210, 214,
 221; booms, 13, 20, 36, 45, 62, 89,
 95, 112, 116, 122, 124, 130, 206,
 208, 212, 216
experiential, 25, 89, 211
 habitation, 19, 25, 102, 130;
 juxtaposition, 62, 102, 169, 179
experiment(ation)(al), 13, 14, 26, 36, 42,
 88, 93, 95, 114, 115, 162, 200, 216, 217,
 218, 221
expose, 86, 121, 136, 137, 174
 domestic complexities, 6, 45, 134,
 182, 193

F

Fabrica, 69, 233
Facebook, 20, 78, 80, 91, 222, 242
Fallingwater, 150, 156, 158
farm(ers) stand/market, 13, 51–53
Farnsworth, Dr. Edith, 144, 145
Farnsworth House, 30, 144, 145
fashion, 68, 86, 111, 124, 149, 174
 fashionistas, 62; shoots, 62
Fein, Skylar, 110, 238
festival(s), 65–67
fiction(al), 36, 87, 106, 133, 191, 229, 237, 242
 flash, 106; narrative, 86, 191, 122; setting, 169
Filthy Lucre, 131
fingerprint(ing), 6, 8, 45, 146–149, 182, 194
the first house, 98
Fitchburg Art Museum, 91, 236
Fitzgerald, F. Scott, 34, 38, 227
flash mob, 68, 232
flexible(ity), 46, 63, 88, 92–94, 179, 185, 189
follow the sun, 6, 45, 142, 145, 182, 194
food, 13, 62, 69, 85, 113, 137, 146, 169, 195, 224, 229
 carts/trucks, 62, 69; cooperative, 66; desert, 53, 170; fresh, 53; related businesses, 66
Fort Snelling, 51
Foucault, Michel, 39
fourth wall, 85, 114
fourtier categorization for conservation, 161
French Quarter houses, 103
frustration(s), 5, 15, 16, 18, 24, 25, 90, 92, 108, 134
fundraising, 70, 76, 99, 255
furnishing plan(s), 10, 41, 130, 137, 143, 189, 193, 203, 220
furniture, 13, 17, 20, 69, 70, 96, 103, 105, 106, 111, 114, 120, 124, 131, 136, 137, 141, 144, 162, 173, 178, 209, 216
The Futurist Manifesto, 124
fuzzy existence/preservation, 166, 179

G

Gaasbeek Castle, 36
Gadamer, Hans-Georg, 102, 237
Gage, Matilda Joselyn/Gage Center 8, 126, 127
Gallier House, 103
Gamble House, 30, 149, 150, 153, 156, 158, 174
Ganondagan, 12
gardens, 13, 30, 37, 53, 178
genealogy, 17, 106, 171, 189
Germantown, 30, 52, 64, 245
good citizenship, 38, 139
Granados, Kathleen, 153
Gration, Jonathan, 84
Great Camp Sagamore, 30
Great Ormond Street Hospital, 128
Greenbelt Historic House Museum, 30, 144, 145
Greenland, Kevin, 28, 42, 55, 57, 94, 118, 119, 165, 166, 231
good, better, best standards of preservation, 156, 158
Grumblethorpe, 31, 52, 53
guerilla art (*see* tactical urbanism)
Guerrero, Pedro E., 135, 241
guest(s), 6–9, 15, 16, 35, 36, 39–41, 44, 45, 60, 68, 69, 8, 81, 83, 85–89, 91–94, 101, 102, 104, 105, 107, 108, 111–123, 126, 127, 130–133, 136, 138, 142–143, 145–148, 150, 151, 154, 159, 163–165, 168–170, 173, 175, 176, 178, 179, 182, 187, 188, 190–197, 200, 202, 204–210, 214, 215–217, 222, 225
 expectations, 15, 41, 89, 93, 97, 119, 210, 232; interests, 83, 101, 142, 187
guide, 1, 3–5, 7, 9, 12–18, 20, 22, 24–28, 30, 32–36, 38, 40–48, 50–52, 54, 58, 60, 62, 64, 66, 68, 70–72, 74, 76, 78–84, 86, 88, 90–98, 100–102, 104–106, 108–110, 112–114, 116, 118, 120–124, 126, 128–130, 132, 134, 136, 138, 140, 142–144, 146, 148, 150, 152, 154–156, 158, 160, 162–164, 166, 168, 170–172, 174, 176, 178, 179, 181, 182, 184, 186, 188, 190, 192, 193, 196, 198–206, 208–212, 214, 216–224, 228–232, 234,

236–238, 240, 242, 244, 245, 248, 250,
 252, 254, 255
guided tours, 13, 93, 94, 95, 113, 143, 217,
 238
Guyton, Tyree, 50

H
habitation, 19, 21, 25, 41, 45, 102,
 116–117,121,130–131, 134–137,142–
 145,160,173–175,193, 198–199,
 203–205, 214–215, 218, 220, 222
Hackett, Abigail, 116
Hale, Shannon, 113
hallway, 41, 106, 112, 116, 118–119, 121,
 206–207, 217, 220
Hamilton, 86
Hancock Shaker Village, 51
Happy Museum, 81
*Harmony in Blue and Gold: The Peacock
 Room*, 131
Harris, Joel Chandler, 73
Haus in Schwarz (House in Black), 157
Hay House, 30, 123
Hedrick I. Lott House, 160
Heidelberg Project, 50, 147–148
Heidegger, Martin, 135
Hejduk, John, 21
Hemmings, Sally, 109
Hempstead, New York, 139
Heritage Laboratory, 36
Heritage Square Museum, 53
Herman-Grima House, 103
Hess Triangle, 146
Heurich Historic House Museum, 67, 163
Hewson, Mike, 157
historic(al)
 absolute, 179; artifacts, 51, 133,
 149; character, 158; context, 62;
 district, 157, 172; etchings, 137;
 exactitude, 37, 179; information,
 40, 44, 82, 84; narratives, 38, 59,
 61, 73, 76, 84, 108, 169, 171, 174;
 neighborhood, 57; photography,
 143; plaque, 108–109; preservation,
 25, 53; significance, 156; structures,
 54, 155; values, 39, 178; vandalism,
 109; vistas, 168

Historic House Trust of New York City
 (HHT), 26, 29, 37, 39, 65–66, 70, 73,
 75, 78, 80, 101, 110, 134, 141–142,
 151–152, 158, 160, 169–170, 202,
 255–256
Historic Newport Society, 40
Historic Rosedale Plantation, 30, 202
Hitchcock, Alfred, 102
Hitler, Adolph, 99
Hodes, Danielle, 31, 49
Hoffmeister, Peter, 152
holistic approach, 34, 41, 43, 76, 91, 115,
 172, 174
Homage to Lost Spaces, 157
homogeneity, 18, 146, 165
 of collection, 165; of experience,
 142
Hopper, Edward, 90
Horsford, Meredith Sorin, 134
Houston, Whitney, 128
Huey, Camilla, 110

I
imaginary
 narrative, 85; play, 188; theater, 87
immersive experience(s), 62, 143
 tactile interaction, 115, 150
immigration, 58, 72 140
inclusive, 25, 76, 141, 188
Indianapolis Museum of Art, 89
individual(ity) 194
 experience, 146–147, 195;
 expression, 194; interaction, 195;
 momento, 148; perceptions, 37;
 transactions, 107
Indonesian Heritage Society, 51
informal communication, 77, 187–188
International Council of Museums
 (ICOM), 36
intimacy/intimate, 16, 21
 attire, 110; behaviors, 145;
 experience, 207; occupation, 19;
 relationship, 143; signatures, 145;
 spaces, 134
Isabel Anderson Comer Museum and Arts
 Center, 98
isolated, 168, 221

J

Jackie Robinson House, 140, 242

Jacobs, Jane, 64, 231

Jane Addams Hull-House Museum, 12, 51, 54, 138

Janes, Robert, 48, 229

Jefferson, Thomas, 40, 109, 110

J. M. Brewer's map of Philadelphia, 72

Joseph, Miranda, 55, 231

Josey, Richard M., Jr., 108

Joslyn Gage Foundation, 30

juxtapose(d) 93, 103, 169

eras, 179; past and present, 170

K

Kemp, Lu, 122

Kenawy, Amal, 174, 244

Kerouac, Jack, 108

Kimball, Fisk, 165

King Manor Museum and Old Stone House, 52

King, Ro, 51

kitsch, 125, 153

Klein, H. J., 117, 239

Körner's Folly, 30, 202

Kykuit II Summit on the Sustainability of Historic Sites (2007), 113, 115, 238

L

La Borinqueña, 125

lack of, 15, 44, 53, 55, 71, 100, 106, 108, 112, 121, 136, 140, 145, 161, 170, 201, 214

access, 49, 53, 121, 126; connection, 142; conversation, 126; civersity, 44, 71–72

LAND/SLIDE: Possible Futures, 52, 230

language, 49, 51, 58, 66, 70, 76, 86, 139, 140, 167, 200, 204

Latimer, Lewis, 31, 51, 69, 70, 114, 141, 152, 202, 224

LatimerNOW, 29, 114, 116, 141, 152, 225, 256

layered, 24, 158

change, 160, 174; history, 24, 158, 175

learn(ing), 12, 13, 18, 34, 38, 51, 55, 58, 62, 67, 83, 111, 112, 116, 117, 122, 124, 133, 163, 167, 184, 185, 191, 192, 194, 210, 222, 229, 238

about community, 83; about guests, 83, 102; by doing, 44, 113, 115, 191; environment, 117, 133; events, 58; from others, 68; interactive, 12; lifelong, 51; kinetic 112, 142, 191; styles, 124

leave a mark, 146–148, 194

Le Corbusier, 150

lesbian, gay, bisexual, transgender, and queer community (LGBTQ), 73, 76, 79–80, 140, 222

LGBT Historic House Museum Nerds Unite! Group, 79, 222

Lettuce and Lovage, 111

Levine, Brandi, 52–53

Lewis H. Latimer House, 141, 152, 202, 224

liberty/liberté, 103

light, 20, 121–122, 127–128, 134, 142, 145, 150, 154, 224

Lincoln, Abraham bedroom/sexuality, 110

Lindsey, Lauren, 209

LinkedIn, 26, 43, 84, 92, 105, 108–109, 112, 121, 171, 221, 222

listening campaigns, 82

Lite Brite Neon Studio, 154

The Little House, 168

livable communities, 169

Livengood, Ben, 203

local knowledge/issues/organizations, 44, 66–67, 69, 100, 156–157, 256

locational data, 211, 217

Lopez, Lisa Junkin, 54

The Loves of Aaron Burr: Portraits of Corsetry & Binding, 110–111

Lower East Side Tenement Museum, 12, 51, 178

Lullaby Factory, 128

Lyndhurst Historic House Estate, 31, 175

M

Mabry-Hazen Historic House Museum, 87–88, 118–120, 126, 218–220

The Machine Project, 153
Madison, President James and Dolly, 177–178
maintenance, 11, 159, 161, 170
Maksymowicz, Virginia, 150
Malcolm X-Ella-Collins-Little House, 140
mapping, 117, 126, 145, 202–206, 214
Marinetti, F. T., 124
Markham Historical Village, 52
Marion Anderson House, 12
Martin Luther King House, 12, 138
Maryland Historical Society, 103
Material World: A Global Family Portrait, 136
Matisse, Henri, 150
May, Lizzie, 86
meaning making, 65, 116–117
Meeting in a Box, 61, 223
MeetUp, 79–80, 222
Megawords, 151
Mellon, Jonathan, 158
memory, 101, 104 143, 145, 161–162, 165, 215
Menokin, 51, 165
Menzel, Peter, 136
Merchants House Museum, 80
messy, 45, 72, 99–100, 102, 110, 130, 134, 137, 167, 170, 175, 203
Metropolitan Museum of Art, 168
 Haverhill Period Room, 104
micro-blogging, 78
Mikhail Bulgakov House, 36
Mill #5 in Lowell, Massachusetts, 108
Millennials, 48, 106, 200, 203
Mind the Gap, 167, 197
Mining the Museum, 103
Minnesota Historical Society, 67, 81
minority population, 72, 76, 140
Miranda, Lin Manuel, 86
mission statement, 13, 37, 40, 149, 158–159, 163, 167, 169, 184
mobile kiosks, 48, 69, 223–225
Monger, Janice, 73
Monroe County Historical Society, 90
Montgomery, Monica 114, 116, 225,
Monticello, 31, 40, 109–110, 156, 158, 161
Montpelier, 177

Moon, Michelle, 113
Morris Jumel Mansion, 31, 47, 49, 62, 94–95, 110, 150–153, 178, 202, 217
Morris, William, 159
Mount Vernon, 40, 78, 86, 155
movable feast, 66
move freely, 45, 115, 117–118, 120, 117–118, 191, 206, 216
The Museum, 9
museum accreditation, 38–39
Museum Association of New York, 66
Museum in a Box, 69
The Museum of Innocence, 106, 133
Museum of the Image, 128

N
The narcissism of details, 44, 97–100, 189
narrative(s), 36, 61, 72, 102, 210, 214, 216
 aging as a part, 160, 162–164, 167, 196; collective, 131; complex, 88, 137; current Events, 76, 149, 152 195; distinct activities, 209; embellishments, 111, 189; expand, 12, 45, 73, 99, 108, 120, 138, 140–141, 171, 194; fact-based, 36, 77, 191; fictional, 36–37, 85, 122, 191; guests' connection to, 50, 89, 97, 111, 142, 145; multiple, 44, 76, 93, 103–104, 178–179; neighborhood as a part, 47, 55, 76, 167–171, 184, 190, 196; photographic, 107; shorten, 44, 105, 190; slave, 77, 139; traditional, 38, 52, 81, 92, 106, 141; unflattering, 108, 140; update, 140; white, male-dominated, 122, 138, 140
Nathan Russell House, 202
National Endowment of the Arts, 68
National Park(ing) Day, 69, 223
National Register for Historic Places, 157
National Society of Colonial Dames, 32, 79, 139
Neely, Jack, 121
neighborhood(s), 48, 50, 53, 66, 176–177, 184–186
 activity, 185; context, 43, 169, 202; design, 256; diverse, 62, 71, 73; evolution, 45, 55, 64; groups,

141; input, 223; mapping, 204; obliterated, 223; residents, 59, 223; study the, 54, 57–58, 70; surrounding, 44, 48, 68, 139, 141, 158, 168–171, 196–197; underserved, 53
Neighborhood Doorknob Hanger, 61
NEON CHANDLIER, 153
Newark Museum, 92
New Museum for Contemporary Art in New York City, 119
New York City Educator's Roundtable Annual Meeting (2015), 94
New York City Gay Pride Parade, 73
nonprofits, 20, 38, 63–66, 80, 89, 157, 255
Norris, Linda, 36
nostalgia, 101, 154, 163
N.U.D.E. Tour Guides, 44, 92–93, 97, 188
Nutting, Wallace, 136

O
off-limits areas, 16, 121–124, 192, 219
Ohta, Yukie, 60
Once, 114
One Day One Artist, 157
one-minute video, 58, 134, 202–204, 214
The Onion, 149
oral histories, 82–83, 122, 141, 190
Orlando Shakespeare Company, 68
other(s), 84–85, 140–141, 222–223
overlap(ping), 44, 66, 86, 101–104, 117–119, 122, 134, 141, 143, 145, 166–167, 171, 174, 179, 190, 207, 214

P
paint analysis, 156
Pamuk, Orhan, 106, 133
Parks, Janet, 9
participation 13, 25, 59, 73, 83, 112, 120, 130, 145, 147, 167, 221
 activity, 66–69; dialogue, 81; experiences, 81, 85; forum, 221; museum, 65
Participatory City: 100 Urban Trends, 69
partner(ships), 53, 63–67, 70, 73 133, 151, 185, 200, 202, 255
patriotic, 40, 138–139

Peabody Essex Museum, 113
Pemberton, Daniel, 122
Pena, Eleña, 122
Perec, Georges, 106
Perez-Mendez, Roxanna, 125
performance, 68–69, 84, 112–113, 115
Perkin, Caitlin, 151
Period of Interpretation (POI)/ Significance, 40, 45, 175–179, 197, 204
period rooms, 11, 104, 131, 147, 141, 151, 153–154, 165, 168, 172, 217
Pham, Phuong X, 151
Philadelphia Museum of Art, 164
Philadelphia Society for the Preservation of Landmarks (PSPL), 20, 52, 57, 150–151, 179, 165, 255
Philagrafika, 151
photography, 18, 88–89, 143, 146–147 149
Physick House, 57, 151
Picabia, Francis, 95
picture houses, 136
PIMA Dance Group, 151
placemaking, 116–117
play, 88, 111–114, 124–125, 141, 149, 169–170, 188, 209, 213–214, 219, 256
Playing with Ghosts, 151
Play Work Build, 113
Plimoth Plantation/Plymouth Colony, 86
Poe Cottage, 156, 202, 223
poetic preservation, 35, 37
Pont de Arts Bridge, 149
Pope, Sara Dillard, 165
Pop-Up Town Hall/Retail, 69
Potvin, Ron, 97
poverty 110, 151; pimping, 76
Powel, Elizabeth Willing, 151
Powel House, 25, 57, 150
preservation, 41–42, 45, 53, 72, 76, 97, 115, 133, 140, 148–149, 155–156, 159, 162–167, 169, 171–172, 174, 179, 188, 191, 195–197, 202, 204, 215
 anti-hero, 256; awards, 255; as a creative act, 164; collections, 15, 41, 50, 115, 156; cost of, 155–156, 195–196; education, 38, 53; grants, 157; officers, 219; philosophy statement, 158; poetic, 35, 37;

purist model, 18; standards, 137,
 156, 158, 175–176; updates, 197; as
 part of visitor experience, 175
pretend, 84–87, 113–115, 168–170, 174
 City Children's Museum,
 85; communication, 84, 188;
 conservation, 174; pretense of, 85
privileged, 48, 124
propaganda, 40

R
racial bias, 72, 104
Reach Advisors, 92
Rear Window, 102
Reber, Paul, 27, 37
reconstruction, 164–165
re-enactors/re-enactment, 36, 73, 75, 84,
 86–88
remnant, 23–24, 107, 145, 161, 177
Renaissance Fairs, 85
repeat visitation, 41, 44, 89, 206
replicas, 70, 99, 173
reproduction(s), 124, 136, 158, 164–165,
 171
research tools, (*see* tools)
residue, 36, 135
restoration, 20, 21, 34, 45, 131, 147–148,
 156–157, 159, 161–165, 172, 174, 178
reverse affinity groups, 44, 60–61, 63
Rico, Alli, 146
Riggenbach, Jeff, 109
ritual(s), 22, 143, 145, 194, 207
Robbins, Claire, 143
Roberts, Randy C. 34–35, 53, 116–117
Rodia, Simon, 177
Roll, Jarrod, 90
romance, 87, 113, 144
 of the setting, 170
romantic(ized), 40, 72, 136, 168
 past, 136; setting, 168
room escape, 122
room-setting fairy, 142
Rosso, Marina, 107
ruin photography/porn, 170
Rules of Civility, 150

S
Salem Witch Museum, 90
Salvage Supperclubs, 69
Sanchis, Frank III, 124
San Diego Gay and Lesbian Center, 73
Santa Cruz Museum of Art and History,
 89, 139
Save Our Heritage Organization (SOHO),
 73
Scesney, Danielle, 62
Scharrer, Angela, 168
Schindler Studio and Historic House
 Museum, 31, 121
scoring matrix/system, 43, 46, 181
Scrimgeour, Andrew, 131
season(ally), 55, 107, 145
secrets, 111, 120, 213
selfie, 126, 148
sensory, 36, 124–125
 engagement, 192; experience, 128,
 186, 192; immersion, 36; qualities,
 192
servant(s), 13, 96, 99, 105, 112, 138, 140,
 214–215
 narrative, 139; stairs, 113; wing, 153
seven touches, 63
Seward House, 31
sex(ual)(ity) 111
 deviation, 122; exploits, 110;
 orientation, 73, 76; rumors, 110
Shakespear, Lain, 73
shared
 aspirations, 224; bed, 110;
 commonalities, 66, 102, 201,
 221–222; connection to the place,
 116; experience, 18, 35, 85, 116,
 126; frustration, 24; ground, 66;
 interests, 44, 63, 67, 78, 223–224;
 narrative, 72, 85, 108, 140, 163,
 168, 176; purpose, 25, 39; secrets,
 111, 164
shops/stores, 58, 62, 70, 213, 224
short stories, 44, 62, 105, 190
shrine, 40, 100, 161
Shukla, Pravina, 84
sidewalk(s), 57, 64, 66, 169
Sidney Lanier Cottage, 31

sign(s), 33, 62, 77, 88, 121, 149, 186, 217
silence, 121, 127, 163, 215, 219
Silver, Nathan, 161
Simon, Nina, 65, 89, 139
simultaneity, 102, 104
site-specific art/happenings, 37, 52, 118, 125, 150–152, 165, 168, 223
slave(s)/slavery, 13, 66, 71, 82, 86–87, 96, 103–104, 109, 132, 138–140, 152, 161
 burial, 132; narratives/Stories, 73, 139; transport, 125; quarters, 139
Sleep No More, 114, 120
Slipek, Edwin, 153
Smart Growth, 215
smartphone(s), 17, 58, 77–78, 80, 104 204
smell(y)/scent, 23–24, 34, 85, 127–128
Smith, Dame Maggie, 111
Soan, John, 150
social advocacy, 50
 capital, 25, 64, 66, 256; differences, 47, 49, 70, 76, 184, 204; history, 134, 171, 174, 176; life, 54, 184; justice, 51, 81; propaganda, 40; relevance, 48; service providers, 67
social media, 44, 77–79, 106, 119, 167, 187, 221–222, 255
Society Hill, 55, 72, 176,
 Interpretive Center, 57
SoHo Memory Project Portable History Society, 60
Sorin, Dr. Gretchen, 11–14, 27
sound(s), 24, 42, 69, 105, 122, 125–128, 147, 201, 214–215, 219
 bites, 99; booth, 83; mapping, 126, 214; soundscape, 82
space(s), 19, 36, 37, 67, 91, 114, 116, 118–123, 126, 128, 131, 134, 137, 141, 143, 145, 147–148, 162–163, 168, 174, 186, 192, 203, 205, 206, 208, 213, 224
special events, 57, 91
special needs, 70, 141, 153
speculation, 26, 37, 108, 110
Speed, Joshua, 110
stabilization, 157–159,
staff, 26, 41, 55, 57–58, 63, 65, 67, 72, 73, 76–77, 80, 82, 91, 93, 100, 106, 113, 141 156, 158, 163–164, 171, 187, 204, 215, 219, 221–223

stage-set(s), 41, 92, 127, 131, 150, 220
stairway/stair hall, 17, 25, 34, 36, 66, 106, 131, 121, 165, 209, 212–213
stakeholders, 57, 255
standards of preservation, 137, 156, 158, 161, 174
stand(ing), 12, 94, 106, 114, 116–117, 147, 205–206, 209, 213, 217, 220
Stasis, 151
Staten Island (Historical Society), 60, 75, 200, 202
step back in time, 169–170
stewardship, 39, 41–42, 45, 51, 115, 137, 147, 158, 173
Stilgoe, Dr. John, 24, 38
stoops, 55, 57
StoryCorps, 83
Stowe House, 51
Stratford Hall, 31, 37, 39, 163–164
Strawberry Banke Museum, 31, 66
Streetmuseum, 104
street(s), 64, 82, 86, 107, 169, 225
 art, 148, 157; life, 168; parking, 224
StudioWeave, 128
superlatives game, 44, 97–98, 100, 189
surprise, 15, 20, 142, 220
surrounding(s) community(ies)/
 neighborhood, 13, 19, 41, 50, 58, 61, 66, 76, 83, 167–169, 184, 191, 197, 211, 224,
sustainability, 58, 81, 113, 149
Sweets, Sparky, PhD, 86

T
tactical urbanism, 50–51, 61, 69, 223–224
tactile, 20, 36, 115, 121–122, 126, 142, 147, 150, 153, 207–208, 210, 217, 222
 engagement, 142–143, 208; experience(s), 109, 126, 191; habitation, 218; interpretation, 114; learning, 112, 191
Tate, Gertrude, 73
Taylor, Ruth, 40
temporary installation, 69, 142, 154, 165
ten-minute walk/drive, 44, 58
territorial, 64, 99
theater(s) 24, 58, 68, 70, 85–87, 118, 120, 125, 151

theatrical
 experience, 36; methods, 36;
 perspective, 85; productions, 114;
 programs, 13;
Then She Fell, 120
the thingness of the thing, 135
Thug Notes, 86
Tigerman, Stanley, 179
Tinkering Studio, 70
Tlili, Anwar, 64
tools, 43, 59, 85, 101, 114, 143, 171,
 199–201, 203, 207, 209, 219, 224
touch, 23, 35, 63, 112, 115, 120, 122,
 126–127, 130, 149, 224
Touch History, 120, 151, 153
Toy Story, 134
traditional(ists), 11, 14, 38, 42 137
 audience, 38; documentation, 203;
 experience, 91; guides, 93, 96;
 interpretation, 147, 172; limits, 108;
 messaging/media, 78, 113, 255;
 models, 13, 48, 69, 115, 133, 150;
 narrative, 140–141; religion, 140;
 survey, 218; venues, 68
training, 93
 camps, 124; job, 51, 53; tour guide,
 93, 95
traits of volunteers, 92–93, 97, 188
transcend the object, 45, 129–130, 186,
 189, 193
transposition, 67–70, 186
Treuhaft, Josh, 69
TripAdvisor, 89–90
Tröndle, Martin, 117
Trunk of Treasure, 224
truth(s), 36, 39–40, 104, 109–110, 179
 stretching, 109; testing, 169
Tsai, Ivy, 211
Tubman, Harriet, 50
tweet, 61, 77–80, 200, 216, 225
Twisted Preservation, 26, 149, 255
Twitter, 62, 78, 80, 106, 222

U
unbiased reporter, 40
The Uncatalogued Museum, 36
Uncle Remus stories, 73
Underground Railroad, 66

unexpected, 15, 45, 67, 69–70, 154, 186,
 203, 214, 220
un-interpreted, 137, 147
University of North Carolina at Charlotte
 (UNCC), 19, 24, 25, 26, 62, 69, 104,
 125, 168, 200–201, 203, 209–211,
 224–225, 256
University Partnerships, 200–202
Unpacked, 151–152
urban, 148, 168–169
 decay, 170; design, 24–25, 223, 256;
 farm, 51; history, 69; renewal, 223;
 space/fabric, 50, 128, 148, 171, 256;
 street language, 256
Urbexography, 170
Ushers Ferry Historical Village, 112
U.S. Secretary of the Interior's Standards
 for Treatment of Historic Properties
 (STHP), 156

V
Vagnone, Claire, 17, 18, 27
Vagnone residence, 21
Van Cortlandt House Museum, 32, 40, 62,
 79–80, 202
Vandalism of Completion, 165
Van Gogh, Vincent, 122
Venice Charter for the Conservation and
 Restoration of Monuments and Sites
 (1964), 160, 243
video recordings/mapping, 58, 167, 199,
 201–204, 214
Villa Savoye, 150
visceral engagement 34, 89, 127, 143, 202,
 208, 216
vision, 80, 129, 138, 145, 153, 169,
visitor(s), 12–13, 16, 18–20, 35–36, 39, 47,
 52, 55, 59, 63, 78, 80, 84–86, 89–92, 94,
 97–100, 104, 107–113, 115–116, 119,
 121–122, 124, 127–128, 131, 136–137
 access, 46; behavior, 46; circulation,
 117–119; engagement, 51, 126, 136,
 225; experience, 16, 36, 41, 50, 67,
 87–88, 91–92, 94, 112–113, 124,
 133–134, 137, 184
voice(s), 23–25, 65, 80, 82
 give, 65; opinions, 59; singular, 80
Voice of Poe contest, 223

volunteers, 58, 61, 72, 78, 92–93, 95, 97,
113, 156, 189, 204, 219, 223
boards, 156; diverse, 76, 97; project,
57; recruitment, 97; staff, 221;
youth, 52–53
voyeur(ism), 41, 86, 113, 122, 124, 138, 173

W
Wagner, Sally, 30, 126
Walbers, Olde, 122
walkable/walked 169
walk by, 55, 57; walk-in/on, 47, 52,
115, 124, 126, 216, 219; walk-out,
126; walk-through, 15, 219
walk(ing) 44, 116–117, 174,
around the block/neighborhood,
44, 54, 58, 99, 184; as a process,
116; away, 69; on tiptoes, 34
Wanga, Cangbai, 65
Washington, George, 11, 40, 78, 97–98, 179
Washington Square West Project, 176
Waterston, Darren, 131
Water, Water, Everywhere, 151
Watts Towers, 32, 177
wealth(y), 48, 84, 103, 110, 138, 151
welcomed guests, 16, 62, 127, 141, 147,
217, 212
West, Patricia, 40
What Brightens Your Day? 224–225
Whistler, James McNeill, 131
Whitcomb, Samuel Jr., 161
The White Guard, 36
white male/men 24, 47, 71, 73, 139
conquest, 139; dead, 140;
dominated, 141; narrative, 140
white privilege, 76, 139
Whitmore, Monica, 224
Whitney Museum, 90

Wikiplanning, 25, 221, 256
Williams, Margarite, 27, 59
Wilson, Fred, 103–104
Wilson, Michele, 150–151
Wilson, President Woodrow, 202
Wilton House, 153
window(s), 121, 142, 168, 170
broken, 52, 213; faux, 168; marked
on, 96; open, 220; restored, 20;
shades, 168; sill, 121; view out, 168,
170–171
Windows by Urbexography, 170
Wiseman, Ed, 200
women, 24, 33–34, 110, 113, 151
role of, 151; health, 66; rights, 126;
stories about, 103, 140–141
Woodrow Wilson House, 202
Worts, Douglas, 48
Wren's Nest, 73
Wright, Frank Lloyd, 150, 156
Writing on It All—LatimerNOW, 152
Wuilfe, Robert, 125, 150
Wunderkammer, 69
Wyckoff Farmhouse Museum, 32, 170, 202

Y
yarn bombers, 61, 153
Yeagley, John, 27, 65, 98, 109, 123, 219
yellow fever epidemic, 17, 96, 138, 151
Yellow House, 147–148
Ye Olde English, 84
Yes, These Eyes Are the Windows, 122
Young, David, 64
YouTube, 68, 222

Z
Zar, Howard, 175
Zimmerman House, 114

ABOUT THE AUTHORS

Franklin Vagnone has professional experience in cultural organizational management, architecture, design, landscape architecture, preservation, archive formation, creative place-making, and community engagement. He has managed both single cultural sites and complex, multiple site umbrella organizations. He has won numerous awards, including two Lucy G. Moses Awards from the New York Landmarks Conservancy, the Award of Excellence from the Greater Hudson Heritage Network, and the Award of Merit from the Museum Association of New York. He serves on numerous nonprofit boards, such as the Mid-Atlantic Association of Museums, the Greater Hudson Heritage Network, and the Advisory Board for the national organization, Partners for Sacred Places. His expertise and knowledge are utilized as a grant reviewer for the New York State Culture and Arts Panels. In addition to his passion for architecture and preservation, Vagnone also paints and sculpts; regularly writes on his blog, TWISTED PRESERVATION; moderates the international LinkedIn Discussion group, The Anarchist Guide to Historic House Museums; and tweets about museums on @Franklinvagnone and @museumanarchist.

Deborah Ryan is a practicing landscape architect and an Associate Professor of Architecture and Urban Design at the University of North Carolina Charlotte, where she founded the Charlotte Community Design Studio as the community outreach arm of the College of Architecture. While leading that effort, her focus was on activating urban places and encouraging local residents to participate in the life of the city. Towards that goal, she and her students designed award-winning playgrounds and developed the initial design for Charlotte's two new urban parks. Through her own collaborative practice, she completed the initial urban design plans for Charlotte's Cultural District as well as neighborhood design plans for large parts of uptown Charlotte, including two plazas in the city's government district.

As Director of the Mayor's Institute for City Design: South and the Open Space Leadership Institute, she led symposia that taught local leaders how to increase civic engagement, build social capital, and face growth issues in their communities. In Charlotte, she chaired the Public Art Commission and serves as a member of the city's Planning and Zoning Commission. She has also served as a faculty member at the Graduate School of Design at Harvard University and as a visiting critic at Columbia University. She designed and developed Wikiplanning™, one of the first online sites to increase civic engagement in the community planning process from a remote location. She has published and lectured widely on the subject of community engagement, and in 2013 she was named a Senior Edward I. Koch Fellow by the Historic House Trust of New York City to lead civic engagement efforts for the LatimerNOW project.